ATMA
BUDDHI
MANAS

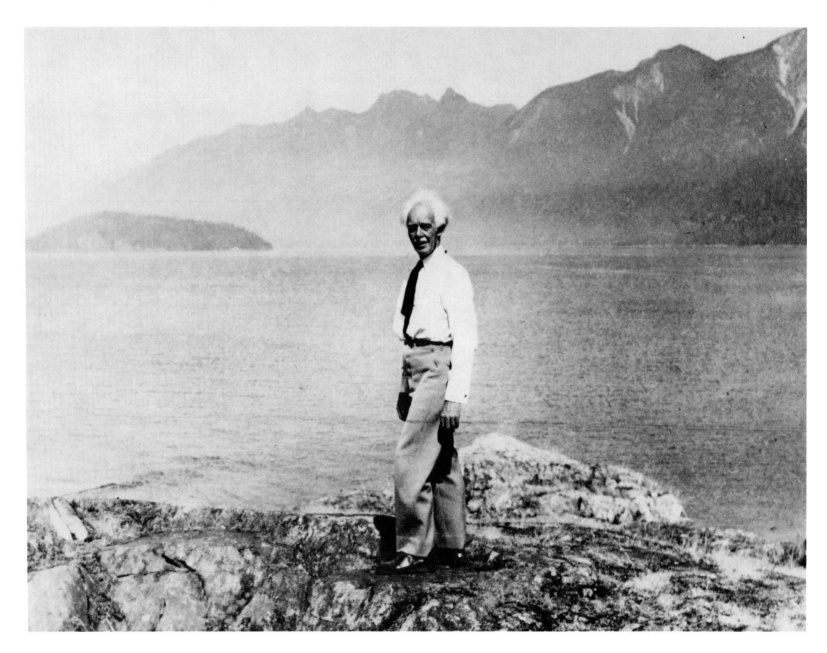

At Howe Sound, near Vancouver, c. 1948.

Dennis Reid

ATMA
BUDDHI
MANAS

THE LATER WORK OF
LAWREN S. HARRIS

ART GALLERY OF ONTARIO/MUSÉE DES BEAUX-ARTS DE L'ONTARIO

TORONTO/CANADA

Made possible by a generous grant from the Chemical Bank of Canada, and with the help of the Government of Canada through the Insurance Programme for Travelling Exhibitions.

COVER:
No. 79

Atma Buddhi Manas 1962
Oil on canvas, 101.8 x 139.4 cm
LSH Holdings Ltd.

Canadian Cataloguing in Publication Data

Reid, Dennis.
 Atma buddhi manas : the later work of Lawren S. Harris

(The later works of the Group of Seven)
Catalogue to accompany an exhibition held at the Art Gallery of Ontario, Sept. 27–Nov. 24, 1985, and travelling to other galleries.
Bibliography: p.
ISBN 0-919777-20-1

1. Harris, Lawren, 1885–1970 — Exhibitions.
I. Harris, Lawren, 1885–1970. II. Art Gallery of Ontario.
III. Title. IV. Series.
ND249.H37A4 1986 759.11 C86-093287-7

GRAPHIC DESIGN: Margot Boland
TYPESETTING: Canadian Composition
PRINTING: The Bryant Press Limited
BINDING: The Bryant Press Limited

PHOTO CREDITS

PLATES:
Carlos Catenazzi/Art Gallery of Ontario: cover, 1, 2, 5, 8; Robert Keziere, Vancouver: 3; E. Lazare/Edmonton Art Gallery: 4; Diane McConnell/Art Gallery of Ontario: 6, 7.

CATALOGUE:
Art Gallery of Greater Victoria: 6, 30, 35, 43, 62; Art Gallery of Hamilton: 50; Art Gallery of Windsor: 19; Dominion Gallery, Montreal: 65, 69, 70; Joseph Erdelac, Cleveland, Ohio: 39; Jim Gorman/Vancouver Art Gallery: 25, 29, 34, 48, 57; Tod Greenaway, Vancouver: 9; Robert Keziere, Vancouver: 45, 49, 59; E. Lazare/Edmonton Art Gallery: 56; Herbert Lotz, Santa Fe, New Mexico: 12, 52; McMichael Canadian Collection: 8, 36; Brian Merrett, Montreal: 47; Trevor Mills, Victoria: 26; National Gallery of Canada: 13, 22, 32, 41; Jeffrey Nintzel, Hanover, New Hampshire: 5; Larry Ostrom, Perth, Ontario: 17; Victor Sakuta, Kingston, Ontario: 2; Sheila Spence/Winnipeg Art Gallery: 11; Ellen Page Wilson, New York, New York: 20; Yale University Art Gallery: 18. All other photographs by Carlos Catenazzi and Diane McConnell/Art Gallery of Ontario.

ADDITIONAL PHOTOGRAPHY:
Public Archives of Canada: fig. 1. All other figures, frontispiece, and back cover, Art Gallery of Ontario, courtesy Peggie Knox, Vancouver.

ITINERARY OF THE EXHIBITION
Art Gallery of Ontario, Toronto,
September 27–November 24, 1985

Vancouver Art Gallery, February 7–March 16, 1986

Winnipeg Art Gallery, April 5–May 18, 1986

Art Gallery of Nova Scotia, Halifax, June 5–July 13, 1986

Contents

Foreword

"Art...interprets the spirit of a nation's growth."
Lawren Harris's declaration in the foreword to
the catalogue of the first Group of Seven
exhibition in May 1920 shows a patriotism and
a nobility of intent to which all Canadians still
respond.

A profound love for the Canadian land-
scape unites all of Lawren Harris's work. These
late paintings reveal a mystical projection of
Harris's vision. Their originality surprises and
fascinates.

Chemical Bank of Canada is proud to
honour this great artist on the occasion of the
centenary of his birth. Participation in this
exhibition underlines our commitment to
Canada and the Bank's expanding role and
presence here.

W. Terrell Upson

President
Chemical Bank of Canada

Preface

Atma Buddhi Manas: The Later Work of Lawren S. Harris is the third in a series of exhibitions conceived by Dennis Reid, Curator of Canadian Historical Art at the Art Gallery of Ontario. Each exhibition focuses on the work of a member of the Group of Seven during the years following the demise of the Group as an association of exhibiting artists. This exhibition marks the centenary of the birth of the acknowledged leader of the Group and picks up the story of his artistic development where the last major show of Harris's work left off. This was, of course, the historic retrospective exhibition held in 1978 at the Art Gallery of Ontario, curated by Mr. Reid's predecessor, Dr. Jeremy Adamson.

As Dennis Reid makes clear in the following pages, Lawren Harris painted for thirty-five years after the last exhibition of the Group of Seven, yet the impressive accomplishments of these years are unknown to most Canadians. Those who are aware of the later work have too often regarded it as a strange departure from the stylistic canon of the Group, if not an outright aberration. In this catalogue, Mr. Reid addresses the persistent neglect and misunderstanding of the work of Lawren S. Harris during the years 1934 to 1967.

We are once again in Mr. Reid's debt for the adventurous concept of this series of exhibitions, and we are especially moved in this case, as his lucid text guides us on the spiritual quest of this remarkable artist. Lawren Harris struggled through a complex artistic evolution that almost parallels the development of twentieth-century art, through geometric abstraction to the spiritual and material freedom of the radiant, non-objective paintings of the late 1960s. In the early 1930s, the artist wrote, "...old phases must die in us before the new can fill our being.... The results in art will be its last manifestation, not the first." He was obviously prescient.

In conclusion I would like to express our thanks to the many lenders, both private and corporate, who have generously allowed us to borrow their precious works for this important Canadian tour.

William J. Withrow

Director
Art Gallery of Ontario

Lenders to the Exhibition

Acknowledgements

This exhibition of the later work of Lawren S. Harris is the culmination of plans first set afoot almost ten years ago. As it has slowly grown to fruition, it has benefited greatly from the assistance, advice, and encouragement of many people. Pride of place in this regard must be given to the Harris family, and in particular to the two surviving children of the artist, Peggie Knox of Vancouver, and Lawren P. Harris and his wife Anne, of Ottawa. They have been patient and unfailingly helpful even in the face of a number of disappointing changes in the schedule over the years. A few surviving friends of Lawren and Bess Harris have also been supportive; in particular, Doris Huestis Mills Speirs. Martin and Harriette Diamond of Martin Diamond Fine Arts in New York assisted me in many ways with my research in the United States.

Peter Larisey, who is currently completing a full-scale critical biography of the artist, has been another constant source of assistance and kindly agreed to prepare a chronology for this publication. Nancy Ryley, whose CBC film, *Lawren Harris: Journey Towards The Light* was first broadcast in 1985, has also been a valuable resource. Conversations with her have helped clarify my thoughts, and she has made freely available transcripts of taped interviews and other research material prepared for her own work.

I have as well benefited directly over the years from the work of a number of my graduate students. These include Linda Street when she was at Carleton University in Ottawa, and more recently Douglas Worts, Julia Gorman, and Susan Armstrong at the University of Toronto. The staffs and resources of the Public Archives of Canada, National Gallery of Canada, and Vancouver Art Gallery have also contributed in a significant way to the outcome of the project. David Zuk and Richard Ayres of the Toronto Theosophical Society, and Beth Hayes of the Far Eastern Department of the Royal Ontario Museum were always ready with definitions or other explanation whenever requested.

At the Art Gallery of Ontario the following have been closely involved: Anthony Jones, Deputy Chief Curator/Administration; Douglas Todgham, Development Manager; Maia-Mari Sutnik, Coordinator of Photographic Services, and her staff, particularly Carlos Catenazzi, Head Photographer; Barbara Keyser and John O'Neill, Conservators; the staff of Promotion, particularly Ivan Holmes, Design Supervisor, and Alan Terakawa, Production Coordinator; Barry Simpson, Registrar, and his staff, particularly Kathy Wladyka, Assistant Registrar; Cynthia Ross, Traffic Coordinator; Bernie Oldcorn, Manager of Technical Services, and his staff, particularly John Ruseckas, Chief Preparator, and his crew; Karen McKenzie, Chief Librarian, and her staff; Peter Gale, Senior Education Officer, Adult Programmes, and his staff. Carol Lowrey, until recently Technical Services Librarian, has been closely involved with the project. Charis Wahl as editor, and Margot Boland, who as designer has adapted Frank Newfeld's series design to the particular requirements of this publication, have helped make all the effort a pleasure. Nancy Breen, until recently my secretary, and Leila Jamieson, her successor, have with enthusiasm brought order and efficiency to their key role.

Dennis Reid
Curator of Canadian Historical Art

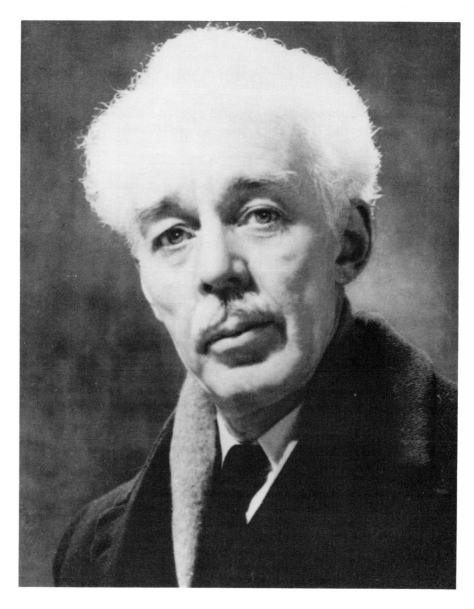

National President of the Federation of Canadian
Artists, November 1944.

The Later Work of Lawren S. Harris

The Group of Seven elected no executive officers, needed neither president nor secretary, never knew aligned voting factions, nor suffered internal power struggles. They functioned by consensus. All would have agreed that they had a leader, however: Lawren Harris. Born into a wealthy business family — the Harrises of the Massey-Harris farm implement firm — a knowledge of business affairs and the efficient management of finances were as much a part of his breeding as were his impeccable dress and flawless manners. He was authoritative and decisive; he also had vision. He knew that the only measure of a nation or people is its creativity, its capacity to know itself, and to find in that knowledge a sense of place, purpose, and potential. Other members of the Group had vision, of course, and drive, and taste, and knowledge. They were all remarkable men. But Lawren Harris and his powerfully dramatic, austere landscapes of Lake Superior, the Rockies, and the Arctic are what we see when we think of the Group of Seven. His images have enhanced, enlarged what it means to be Canadian.

It is remarkable, then, that the work that followed a brief hiatus during his mid-forties is today virtually unknown to the general public, and misunderstood by specialists. He painted for thirty-five years following the last exhibition of the Group of Seven, yet we are ignorant of half the creative life of one of Canada's most important and influential artists.

Harris left Canada in 1934 in the midst of a divorce and remarriage that shocked the Toronto social establishment. He had not painted for two years, and he was deeply, and very publicly, involved with what was perceived by many to be an esoteric religious sect that seemed related to the break-up of his marriage. When he resettled in Canada six years later, in Vancouver, he was committed to abstract painting, painting that seemed the antithesis of those stirring icons of the 1920s that had attracted so much praise and some scorn. Yet this pioneering work in abstraction seems never to have been understood or appreciated except by a few.

Even though Harris was soon again at the centre of things as the National President of the Federation of Canadian Artists (1944–47), was deeply involved with the Vancouver Art Gallery, was a member of the Board of Trustees of the National Gallery of Canada from 1950, and was honoured by two full-scale retrospectives, any attention his abstract painting received was due entirely to his own considerable efforts. When he died early in 1970 there were in public Canadian collections only ten of these paintings, none more recent than 1949. Of these, eight had been gifts. The Vancouver Art Gallery, which he served continuously from June 1941 until his death, had purchased a canvas in 1950, and the Art Gallery of Ontario had purchased a small oil sketch in 1959. Granted, Harris did not need to sell pictures, and for tax reasons he sometimes preferred not to. But he did hold commercial exhibitions and sold Group of Seven·period paintings throughout these years.

Nineteen eighty-five marks the centenary of Harris's birth, and we have mounted this exhibition to see what we have missed over the past half-century. It represents an impressive body of work. Harris was throughout his life a brilliant technician with paint. His work is always notable as evidence of his awareness of form, his great skill and subtlety with colour, his sensitivity to surface and finish. But as important to the stirring effectiveness of his work is the fact that he was always motivated by a strong need to contribute something substantial and significant in his painting.

Harris and his second wife, Bess, were Theosophists, and the principles of that modern philosophical-religious association provided the basis for the way they pursued their own creativity, and their interaction with others. Theosophy teaches that everything that exists is inextricably interconnected in a great cosmic movement of becoming. Thus, every action, good or bad, carries infinite repercussions, or 'karma.' Theosophists also believe that everything is governed by one immutable law, which is truth, and that man once had direct knowledge of this essential unity, but lost it through divisive sectarianism and an intemperate pursuit of materialism. Only by turning every effort to understanding the unity of all things, to knowing the essential motivating spirit of all being, can one aspire again to the perfect condition of pure spirituality, entirely free of gross matter. Since karma is cumulative, spiritual progress can be achieved through reincarnation.

We know that Harris meant his landscapes of the Group of Seven period to embody the ability of certain landscapes to inspire a sense of elevated spirituality, an awareness of the oneness of all things. He believed that the central function of art was to elucidate the spiritual path, and he devoted his life to this goal. During the early thirties he was unsure how to accomplish this in the face of public indifference or implicit hostility. He had come to feel that his landscape paintings were, in spite of their generalized, heightened depiction, still too specific and incidental. He desired to address higher principles with images that would express 'everything.' The careful viewer will see that the earliest abstracts, painted during a three-and-a-half-year retreat in Hanover, New Hampshire, grew

directly from his concern to describe more effectively than before the effect of sublime landscape. These early experiments were refined — particularly during the two and a half years he spent in Santa Fe, New Mexico, where in 1938 he helped found the Transcendental Painting Group — until he had abandoned all reference to landscape. Precise, geometrical abstractions, they celebrate the elegant order Harris believed underlies the whole universe. Contemplating them, even if they appear hermetic or arcane, we can begin to feel the meaning inherent in their form.

During the forties Harris was again able to frequent the Rocky Mountains, and this overwhelming landscape gradually turned him away from the geometrical purity of his Santa Fe pictures. He sought a more organic idiom that would satisfy both the precise nature of his vision and the experiences of wild, spiritualizing nature that nurtured it.

In the more than quarter-century that Harris lived in Vancouver, his work continued to be focused on spiritual idealism. Among distinct groups of paintings are the almost flamboyant, and certainly ecstatic, abstract expressionist pictures of the mid-fifties, and the more hieratic, flame-like mandalas of 1957 and early 1958, a particularly prolific period. Following open-heart surgery in April 1958 came the increasingly large images of the early sixties, with their specific references to esoteric guideposts along the spiritual journey.

Harris became physically frail in his later years, but he continued painting until about three months before his death. The grand, light-filled, and joyous paintings of the mid-sixties, in many ways unlike his earlier pictures but glowing with the intensity he brought to all his work, anticipate approaching yet another phase in the journey, one that promised freedom at last from encumbering matter.

"I am not painting. I am at a crossroads where the entire problems of a lifetime meet," wrote Lawren Harris to the Victoria-based landscape artist Emily Carr in an undated letter of early 1932.[1] It must have seemed to her a remarkable admission. She and Harris had for some years enjoyed a special relationship. Begun following her first visit to Toronto in 1927, and sustained largely through a regular and deeply personal correspondence, it was based in large part on Carr's great admiration for Harris, who seemed to her not only the natural leader of the Group of Seven, but of all its members the one most concerned with the spiritual implications of creativity.[2] His example, his active encouragements and forthright advice were principal factors in her emergence in 1928 from a fifteen-year creative hiatus.

As unsettling as Harris's news of his own creative block may have been to Carr, it likely did not come as a complete surprise. There had been hints of some sort of disruptive internal turmoil in earlier letters, and evidence of a crisis in his painting was widely recognized and discussed in Toronto circles. His friend Bertram Brooker, for instance, informed the Winnipeg painter, L.L. FitzGerald, early in 1932 that "Lawren has done no painting for six months and very little for a year.... The general impression, freely voiced, seems to be that he is repeating himself and has got to the end — of a phase, at least."[3]

Harris had hardly succumbed to inertia and depression, however, and went on in his letter to Carr to explain that he knew what he had to do. "I do see the way. Oh it is difficult because the life problems of others are involved — and yet I do see the way even though I encounter the commonplace and its power of disintegration."

The way was so clear to Harris because it arose from a world-view he had embraced with increasing conviction over the past decade or more, an antimaterialistic world-view that had

as a goal the attainment of a profound inner peace based on the maintenance of one's emotions in a state of constant equilibrium, and a selfless and total commitment to correct action. How this could be employed is revealed in a letter to Carr later in the year:

Now listen again, don't you weaken or get discouraged where you once did. If and when that comes go right to the heart of it, that place, and say, I, Emily Carr, command quiet here, there will be new growth, a new fruition, no old weeds, but the spring of a new life. Make everything within quieter than it has ever been before... — so that the new vision, the new life, the new conviction can arise without disturbance. It will then.[4]

This ability to concentrate on the cultivation of an inner life was the result of an intense focusing of will, of course, and resulted directly from Harris's close involvement with the activities and practices of the Toronto Theosophical Society.

The essential role of Theosophical teachings in the development of Harris's thought and art has been understood for some years

1. Emily Carr papers, British Columbia Provincial Archives, Victoria (on permanent loan from the Public Archives of Canada, Ottawa); henceforth 'Carr papers.'

2. See Linda M. Street, "Emily Carr: Lawren Harris and Theosophy, 1927–1933," M.A. thesis, Carleton University, 1980.

3. Bertram Brooker to L.L. FitzGerald, January 10, 1932, FitzGerald Study Collection, School of Art, University of Manitoba, Winnipeg.

4. Harris to Carr, November 4, 1932, Carr papers.

(handwritten margin notes:) commitment to correct action
Tremendous Advice
Imp. of real "Peace"

now.[5] It is described most effectively and at length by Jeremy Adamson in his *Lawren S. Harris: Urban Scenes and Wilderness Landscapes, 1906-1930*,[6] and so can be simply summarized here. Founded in New York in 1875 by Madame H.P. Blavatsky and a small group of associates, the Theosophical Society is best remembered today for its work in introducing many of the sacred books of the East to western intellectuals and artists during the early years of this century. The basic motivating aims of the Society, however, go far beyond that. They have been listed as follows:

1. To form a nucleus of the Universal Brotherhood of Humanity.
2. To encourage the study of Comparative Religion, Philosophy, and Science.
3. To investigate the unexplained laws of Nature and the powers latent in man.

The central idea of universal brotherhood is based upon the mystical concept of "the One Life," the belief, derived primarily from Buddhist and Vedic thought, that everything that exists is interdependent. The concept of karma — the sum of a person's bodily, mental, and spiritual growth, often accumulated through numerous reincarnations — is also taken from Buddhist and Brahmanist teachings. So too is the Theosophical sense of the 'Path' to the ultimate goal of nirvana or enlightenment and emancipation from materiality. The Theosophical mission is to free humankind from the pervasive materialism of our age, to direct all thought and action towards the realization of the essential unity of all being, which is the pure truth, a goal which Mme. Blavatsky describes through the image of a ray of pure white light.

Theosophy presented an attractive guide to those who, primarily before and after the devastating brutality of the First World War, sought fulfillment in spiritual values. It was perceived to be without dogma, openly enquiring in nature, positive in direction, and while ultimately seeking the loss of self in freedom from all material dependency, nonetheless predicated entirely upon personal resolve, understanding, and action. In practice, over the years, Theosophy generated its share of factionalism, and, in some respects, dogmatism,[7] and its commitment to the belief that the new age of spiritualism its researchers heralded would be marked by an increasing incidence of clairvoyance, associated it in some people's eyes with the more exploitative forms of occultism. It was precisely this promise of clairvoyance, however, of a transcending vision of the underlying order of the cosmos, as well as the fact that in the twentieth century it seemed to offer a range of attitudes and practices directed to a constant, ideal goal, that made Theosophy attractive to creative individuals. Among the most celebrated of these artist adherents were the Irish poets AE (G.W. Russell) and W.B. Yeats, and two pioneers of abstract painting, the Russian Vasily Kandinsky and the Dutchman Piet Mondrian.

The eldest of two boys, Lawren Harris was raised in a devoutly Christian environment (both grandfathers and two uncles were ministers), and so a concern for spiritual well-being was always a part of his life. Shortly before his ninth birthday his father died, and his mother soon turned to Christian Science, which leavened to some degree the fundamentalism of his earlier upbringing and broadened his tolerance. Fatherless and often poor in health, he was close to his mother, a warm woman who was remarkably positive and understanding in her relations with others. She remarried in January 1910, the same day that Lawren took Beatrice Phillips as his wife, but lost her second husband to pneumonia within five days of the wedding. Lawren and his wife Trixie, as she was known, had three children: Lawren Phillips, born in October 1910; Peggie; and Howard, named after Lawren's brother, who was lost in action in France in February 1918.

Harris likely became a member at large of the International Theosophical Society at some point near the end of the war, and in March 1923 he joined the thriving Toronto branch. A number of friends were also members, and his involvement in the activities of the Society grew through the years. His ideas concerning creativity grew as well, and as might be expected, they were influenced by mystical concepts. This is evident in an article he published in *The Canadian Theosophist* in July 1926, although as Adamson has pointed out, this essay "is not a sectarian tract but a

5. The earliest critical examinations of Harris's thought avoid making direct connections with Theosophical concepts: see Russell Harper, "The Development, 1913-1921," and William Hart, "Theory and Practice of Abstract Art, 1932-1948," in *Lawren Harris Retrospective Exhibition, 1963* (Ottawa: National Gallery of Canada, 1963), pp. 11-22, 27-40. Such connections are first examined by Dennis Reid, "Lawren Harris," *artscanada* 25 (December 1968), pp. 9-16. In addition, see Ann Davis, "An Apprehended Vision: The Philosophy of the Group of Seven," Ph.D. thesis, York University, 1973, particularly pp. 261-321; and Roger J. Mesley, "Lawren Harris' Mysticism: A Critical View," *artmagazine* 10 (November/December 1978), pp. 12-18, the latter the most literal reading to date of Harris's use of symbolism derived from Theosophy. Roald Nasgaard, *The Mystic North: Symbolist Landscape Painting in Northern Europe and North America 1890-1940* (Toronto: University of Toronto Press, 1984), particularly pp. 158-202, "Canada: The Group of Seven, Tom Thomson, and Emily Carr," presents the broader context of Harris's use of symbolism.

6. Toronto: Art Gallery of Ontario, 1978, pp. 132-44.

7. See Bruce F. Campbell, *Ancient Wisdom Revived: A History of the Theosophical Movement* (Berkeley, Los Angeles, London: University of California Press, 1980).

COLOUR PLATE NO. 1 (No. 24)

Composition **c. 1938**
Oil on canvas, 91.5 x 76.6 cm
Art Gallery of Ontario (84/863)

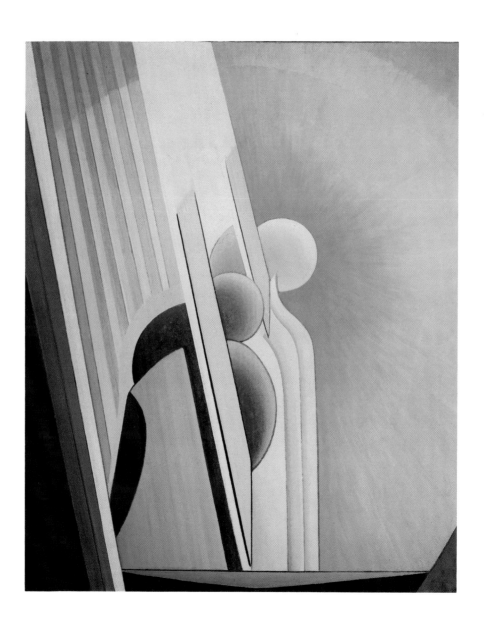

personal synthesis of the traditions of the occult with which he was familiar."[8]

At base an extended explanation of the guiding principles of the Group of Seven, "Revelation of Art in Canada" insists upon the need to cast off foreign influence while seeking and asserting the Canadian spirit. This spirit is inherent in the land itself, and because the Group's members' painting reflects it, Canadian youth have accepted their art

as naturally as they do the charged air, the clarity and spaciousness of our north country. For it has in it a call from the clear, replenishing, virgin north that must resound in the greater freer depths of the soul or there can be no response. Indeed, at its best it participates in a rhythm of light, a swift ecstasy, a blessed severity, that leaves behind the heavy drag of alien possessions and thus attains moments of release from transitory earthly bonds.[9]

For Harris, as for many of the members of the Toronto Theosophical Society, the special promise of Canada resided in its spiritual potential, resulting simply from its geographical position and its prescribed role in the evolution of the human spirit.

We in Canada are in different circumstances than the people of the United States. Our population is sparse, the psychic atmosphere comparatively clean, whereas the States fill up and the masses crowd a heavy psychic blanket over nearly all the land. We are in the fringe of the great North and its living whiteness, its loneliness and replenishment, its resignations and release, its call and its answer — its cleansing rhythms. It seems that the top of the continent is a source of spiritual flow that will ever shed clarity into the growing race of America, and we

Canadians being closest to this source seem destined to produce an art somewhat different from our Southern fellows — an art more spacious, of a greater living quiet, perhaps of a more certain conviction of eternal values. We were not placed between the Southern teeming of men and the ample replenishing North for nothing.[10]

This is essentially a romantic view, that the artist's role is to capture the deep character of a place, as though he were some sort of exquisite litmus, and that his art will be distinctive and meaningful to the degree that he has accurately described that character. In the texts above, Harris has added another dimension, of course, an international — if not cosmic — dimension to the interpretation of the landscape of the Canadian North. He found certain wilderness experiences to be intensely moving, elevating, in fact, to the point that he would sense his consciousness merging with the spirit of the place. He knew that this was not itself an art experience, but during the twenties, and particularly following the first of his annual summer visits to the Rocky Mountains in 1924, he continued to be motivated by the belief that his art could partake of the capacity of such places to evoke highly spiritual conditions — a capacity, many Theosophists believed, that was a consequence again of the role these particular places had played in earlier stages of spiritual development, and would play in the future.

Adamson describes in some detail how in response to his growing concern for spiritual development Harris's art evolved beyond this romantic position during the latter half of the twenties.[11] By the end of the decade, Harris himself had recognized a significant evolution. In the beginning

...the Canadian artist was drawn north,

and there at first devoted himself to Nature's outward aspect until a thorough acquaintance with her forms, her growth and idiosyncrasies, and the almost endless diversity of individual presences in lakes, rivers, valleys, forests, rocklands and habitations, led him to feel the spirit that informs all these.... He inevitably developed a sense of design, of selection, rhythm and relationship in individual conformity to her aspect, moods and spirit. Then followed a period of decorative treatment of her great wealth of material into design and colour patterns conveying the moods of seasons, weather and places. Then followed an intensification of mood that simplified into deeper meaning and was more rigorously selective and sought to have no element in the work which did not contribute to a unified intense expression. The next step was a utilization of elements of the North in depth, in three dimensions, giving a fuller meaning, a more real sense of the presence of the informing spirit.[12]

Harris knew, then, that he was no longer simply reflecting the spiritual nature of the land, nor an intense nature experience, but that in his greater concern for plastic qualities (what he calls depicting "in depth, in three dimensions"), and for generalized modelling that emphasizes essential forms, he was moving towards an expression of his own spiritual capacity.

Let me here suggest that a work in two dimensions may contain an intimation of the third dimension and that a work in three dimensions may contain an intimation of the fourth dimension. To-day the artist moves toward purer creative expression, wherein he changes the outward aspect of Nature, alters colours,

loneliness can be an asset

14

and, by changing and re-shaping forms, intensifies the austerity and beauty of formal relationships, and so creates a somewhat new world from the aspect of the world we commonly see; and thus he comes appreciably nearer a pure work of art and the expression of new spiritual values. The evolution from the love of the outward aspect of Nature and a more or less realistic rendering of her to the sense of the indwelling spirit and a more austere spiritual expression has been a steady, slow and natural growth through much work, much inner eliciting experience.[13]

The tendency of the creative evolution Harris has described would seem to be towards an image that is more and more real in itself, increasingly dependent upon the artist's inner life rather than nature. Once reference to nature has been abandoned to this inner vision, we have abstraction.

Harris was fully aware of abstract art by the mid-twenties, and actually rose to its defence publicly in May 1927, on the occasion of the showing at the Art Gallery of Toronto of the International Exhibition of Modern Art, drawn from the collection of the New-York-based Société Anonyme. Harris was the one Canadian member of the Société, and it was only as a result of his efforts that this radical exhibition of international modern art was shown in Toronto.[14]

In an essay for *The Canadian Forum*, "Modern Art and Aesthetic Reactions: An Appreciation," he describes the show, singling out particularly difficult aspects for explanation.

Most of the pictures were abstract. These could be divided as coming from two sources. One half of them from naturalistic sources wherein the more abstract and lasting qualities of design, movement, rhythm, equilibrium, spatial relationship, light, and order were extricated from the fleeting aspects of a scene or scenes to suggest its informing, persisting life. The other half, and in the main the most convincing pictures, were directly created from an inner seeing and conveyed a sense of order in a purged, pervading vitality that was positively spiritual.[15]

He certainly seems to have been impressed by this work, and to have been drawn particularly to that which derived from a searching inner life. Yet he was not prepared to take such a step in his own painting. He had exhibited a huge canvas, *Mountain Forms*, a generalized image of aspiring mountain grandeur, in the 1926 Group of Seven exhibition, to mixed reactions.[16] Then, in the next Group exhibition, early in 1928, he showed among fourteen canvases and a group of sketches two pictures that suggest a new direction: *Design for a Chapel*, and *A Fantasy*.[17] We know nothing of these works today, but if they were tentative steps towards creating images independently of a landscape experience, they were not pursued any further at that time.

At the end of the summer of 1928 Harris displayed *Lake and Mountains* (No. 1) at the Canadian National Exhibition, a picture certainly rooted still in his vision of sublime Canadian landscape. Although both a pencil drawing and an oil study survive, *Lake and Mountains* is not a painting of a particular place, but rather a synthesis of the qualities of a mountain experience, much like the earlier *Mountain Forms*. That such a mountain experience was essentially spiritual is evident. The thrusting, aspiring forms of the peaks, rendered in tones of blue, are overarched by rising white clouds and joined to a dark foreground beach by a brilliant path of light, spreading invitingly across the water from between dark headlands at the mountains' bases. Blue, yellow (which is blended with blue or white in parts of the picture), and white all carry specific symbolic meanings for

8. Adamson, *op.cit.*, p. 137. For the importance of the Theosophical Society within Toronto intellectual circles of the time see Michel Lacombe, "Theosophy and the Canadian Idealist Tradition: A Preliminary Exploration," *Journal of Canadian Studies* 17 (Summer 1982), pp. 100–118. For biographical information concerning Harris's early years see "Personal Reminiscences by Peggie Harris Knox" in Joan Murray and Robert Fulford, *The Beginning of Vision: The Drawings of Lawren S. Harris* (Toronto and Vancouver: Douglas and McIntyre, 1982), pp. 222–30 of the deluxe edition.

9. Lawren Harris, "Revelation of Art in Canada," *The Canadian Theosophist* 7 (July 15, 1926), p. 87.

10. *Ibid.*

11. *op.cit.*

12. Lawren Harris, "Creative Art and Canada," *Yearbook of the Arts in Canada, 1928–1929* (Toronto: The Macmillan Company of Canada Limited, 1929), p. 185. This article was reprinted from the *McGill News* (Montreal), December 1928.

13. *Ibid.*

14. See Ruth L. Bohan, *The Société Anonyme's Brooklyn Exhibition: Katherine Dreier and Modernism in America* (Ann Arbor, Michigan: UMI Research Press, 1982), particularly pp. 63–65, 109–12. See also Sandra Shaul, "Katherine Dreier, The Société Anonyme and the Canadian Connection," in *The Modern Image: Cubism and the Realist Tradition* (Edmonton: The Edmonton Art Gallery, 1982), pp. 9–11; and L.R. Pfaff, "Lawren Harris and the International Exhibition of Modern Art: Rectifications to the Toronto Catalogue (1927), and Some Critical Comments," *RACAR* 11 (1984), pp. 79–96.

15. As reprinted in *RACAR* 11 (1984), p. 94.

16. Art Gallery of Toronto, May 8–31, 1926, *The Exhibition of the Group of Seven*, no. 12. Adamson, *op.cit.*, pp. 172–73, repr. p. 173.

17. Art Gallery of Toronto, February 1928, *Canadian Paintings by the Group of Seven*, nos. 14 and 15.

COLOUR PLATE NO. 2 (No. 33)

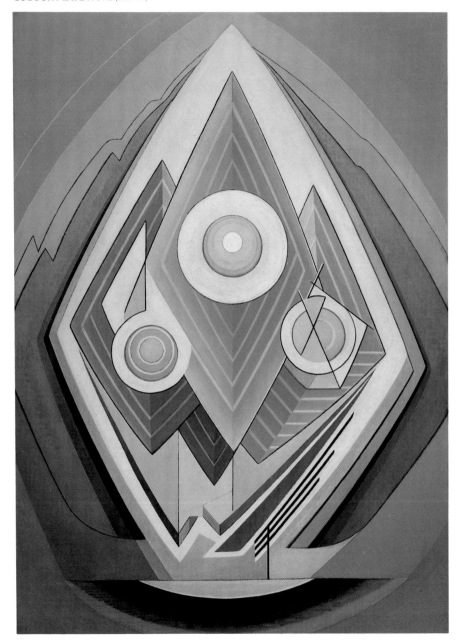

Painting No. 4 c. 1939
Oil on canvas, 129.5 x 93.0 cm
Art Gallery of Ontario (84/864)

Theosophists, meanings which are explained in great detail in a book entitled *Thought Forms*, which Harris must have known.[18]

On the other hand, Adamson has pointed out that Harris's use of some of these evocative hues is inconsistent with standard Theosophical application, and better reflects the interpretation expounded by Vasily Kandinsky in his *Concerning the Spiritual in Art*, another book with which Harris was familiar.[19] For Kandinsky, yellow represented material reality ("the typically earthly colour"), instead of the high intelligence it signalled to other Theosophists, although blue ("the typically heavenly colour"), he agreed, meant spirituality and religious feeling. The two colours together for him "have an active effect corresponding to man's participation in continuous and perhaps eternal cosmic motion…." White, in the form of light representing the pure truth of Theosophy to Mme. Blavatsky, for Kandinsky represented "a world from which all colours as material attributes have disappeared…. White, therefore, acts upon our psyche as a great, absolute silence…. It is not a dead silence, but one pregnant with possibilities."[20]

Harris's use of colour symbolism to underline or enhance the spiritual content of his landscapes is perhaps most obvious and successful in the sketches he brought back from the Arctic at the end of September 1930. This journey, in which he travelled for two months with A.Y. Jackson about the Eastern Arctic in a government supply boat on its annual rounds, must have been greeted with the keenest anticipation, for, as we know from his "Revelation of Art in Canada," the Arctic was the source of a continuous spiritual flow that was destined to benefit the entire continent. On the evidence of the surpassingly beautiful sketches he painted there, he was not disappointed. They are almost all limited to hues of blue, yellow, and, of course,

white, and some, such as *Fog and Ice, Smith Sound* (No. 3), could evoke in their forms alone that sense of "participation in continuous and perhaps eternal cosmic motion" that a Kandinsky could see in their colour schemes.

Although each sketch is doubtless topographically accurate (at least within the bounds usually tolerated by the Group of Seven), we can see that some, such as *Arctic Sketch XIII* (No. 2), come very close to that class of abstract painting Harris described in 1927 as deriving from naturalistic sources, "wherein the more abstract and lasting qualities of design, …light, and order were extricated from the fleeting aspects of a scene or scenes to suggest its informing, persisting life." It was the other kind, however, "directly created from an inner seeing," that he had found to be the more convincing pictures, indeed, to be "positively spiritual."

Why was he holding back? Perhaps, on the strength of the Arctic sketches, he felt that he could combine naturalistic and abstract characteristics, and the intense nature experience certainly still seemed to be an important part of the creative process to Harris, perhaps even essential. And there was little support for, and a great deal of resistance to, abstract art in Toronto, as everywhere in Canada. This was certainly true in the case of Bertram Brooker, the first artist in Canada to present a one-man exhibition of abstract paintings.[21]

Brooker was a friend of Harris's and if not a Theosophist, was certainly conversant with the movement's principles and goals. His ground-breaking exhibition was held at the Arts & Letters Club in January 1927, where it had been brought before the Exhibition Committee by Arthur Lismer. (Harris would sponsor and write an introduction to an exhibition of Brooker's drawings at the Art Gallery of Toronto in March 1929.) Another Group of Seven member, J.E.H. MacDonald, was so outspoken in his verbal criticism of

Brooker's exhibition, however, that he later wrote a letter of apology. He disliked "anything of the occult or secret doctrine" in art, he maintained, and consequently, although he thought Brooker's things "admirable," it was "mostly as *design* and *color*."[22]

We don't know exactly what Brooker exhibited that January, just two months before the Société Anonyme show at the Art Gallery of Toronto, but in March he showed two more of his abstractions in the Ontario Society of Artists' annual exhibition, including *Endless Dawn*, which depicts a generalized, reclining human figure merging with the pristine, snowy, and mountainous landscape upon which it gazes.[23] He continued to show such work as occasion arose, and even included two in the February 1928 Group of Seven exhibition as a guest contributor. One

18. Annie Besant and C.W. Leadbeater, *Thought Forms* (Adyar, Madras: The Theosophical Publishing House, 1967). First published in 1901, the 1925 reprint is reviewed in *The Canadian Theosophist* 7 (June 15, 1926), p. 77. The anonymous reviewer found that "It is difficult to suppose that the shapes and images of either psychic or artistic imagination shall always be standard…though the colours may more nearly represent the reality."

19. Adamson, *op.cit.*, pp. 190, 193. William Hart, *op.cit.*, pp. 27–40, convincingly demonstrates Harris's familiarity with Kandinsky's ideas. Kandinsky also knew *Thought Forms*. See Sixten Ringbom, *The Sounding Cosmos: A Study in the Spiritualism of Kandinsky and the Genesis of Abstract Painting* (Abo, Finland: Abo Akademi, 1970).

20. *Concerning the Spiritual in Art*, as quoted in Adamson, *op.cit.*, p. 193.

21. See Dennis Reid, *Bertram Brooker* (Ottawa: National Gallery of Canada, 1979), second printing, with augmented illustration; and Joyce Zemans, "The Art and *Weltanschauung* of Bertram Brooker," *artscanada* 30 (February–March 1973), pp. 65–68.

22. J.E.H. MacDonald to Bertram Brooker, January 28, 1927, with Victor Brooker, Toronto.

23. Repr. in Reid, *op.cit.*, pl. 3, p. 23.

of these, *Sounds Assembling*, is a spectacular *tour de force*, a futuristic abstract image that seems at once both a microscopic view of basic cellular structure, and a vast diagram of the complex unifying structure of the infinite universe.[24] Many of his abstractions bear similar titles that relate to music, and most as well seem to express the Theosophical concept of the unity of all being. Brooker was given a retrospective exhibition of his early abstractions in the Hart House Gallery at the University of Toronto in March 1931, but by then he had abandoned such an approach in favour of a highly realistic mode.

Although Brooker doubtless believed that he had affirmative reasons for this shift, it is likely that the general lack of support for abstract art contributed to his decision. One critic reviewing the 1927 OSA exhibition described Brooker's contributions as "symbolic, mystical pictures which are difficult to appreciate."[25] As we have seen with MacDonald, even viewers otherwise sympathetic to esoteric thought found its expression in abstract painting hopelessly obscure. Fred Housser, a Theosophist himself, in his 1926 study, *A Canadian Art Movement: The Story of the Group of Seven*, praised the members of the Group for not allowing "themselves to become putterers in a blind alley of professional abstraction into which the layman cannot enter."[26] The art critic for *The Canadian Forum* stated flatly: "Abstraction is not a natural form of art expression in Canada."[27]

Even Lawren Harris, in a long letter to Emily Carr following a trip to Europe in the spring of 1930 (during which he called on the radical artist Marcel Duchamp in Paris, while looking for Katherine Dreier), expressed a cautious view towards abstract art:

I have seen almost no abstract things that have that deep resonance that stirs and answers and satisfies the soul.... But that does not say that some painter may not produce them tomorrow or the next day.

And particularly when it came to Canada, he had his doubts about abstraction:

...with a new adventure largely before us, (not behind us) it doesn't seem natural to me. We have not yet learned nor made use of one billionth of what nature has for us — as a people — and we need it. Profundity to me, is the interplay in unity of the resonance of mother earth and the spirit of eternity. Which though it sounds incongruous, means nature and the abstract qualities fused in one work.[28]

This was written just before his trip to the Arctic with A.Y. Jackson, of course, where he produced sketches that come close to the fusion of nature and abstract qualities he described to Carr. That everything was still an open issue is evident in another part of the letter. The most important thing, he told Carr, is to

saturate ourselves in our place, the trees, skies, earth and rock, and let our art grow out of these. If it becomes abstract, wholly or in part or not at all is not the paramount thing. It is the life that goes into the thing that counts.

Sandra Shaul has argued that Harris could not take the seemingly natural step into abstraction that his European predecessors had taken "because he had tried to identify very abstract ideals with very literal images. Harris's need to have his colleagues and himself create something uniquely Canadian through a particular landscape made such total abstract philosophy impossible."[29] We have seen that Harris's art was indeed dependent upon the landscape experience, and

following his return from the Arctic in the late summer of 1930 he turned again to painting large landscapes on canvas from his field sketches. Although he showed only sketches in an exhibition of his and Jackson's Arctic work that opened at the National Gallery of Canada at the end of November 1930, he had six canvases ready for inclusion when the show opened in Toronto at the beginning of May 1931. All were of specific, named sites. There is finally concrete evidence, however, that at the same time, or at least (what is more likely) following Brooker's abstract show at Hart House in March, Harris finally turned to substantial experiments in abstract painting.

Before looking to these experiments, a minor abstract work of 1931 should be mentioned (see Fig. 1). One of a number of silk-screened designs for Christmas cards he contributed to a programme organized that year by William E. Coutts, it is remarkably reminiscent of the "symbolic portraits" and other hieratically arranged geometric abstractions painted 1913–16 by the American artist Marsden Hartley.[30]

Of much greater importance for the work eventually to follow were two large canvases that have not survived. One, *Figure with Rays of Light (Arctic Group III)*, is known from a photograph likely taken in the late thirties or early forties (Fig. 2). As symmetrical and as hieratic in composition as the Coutts card, it has, however, nothing to do with the work of Marsden Hartley. It derives from the recent abstractions of Bertram Brooker. The stylized figure, the general landscape arrangement, both reflect conventions found in Brooker's pictures of 1927. One of these in particular, *The Way*, which was included in an exhibition of April 1927, shows a similar cloud-like foreground with a blinding view through to a luminous 'beyond.'[31]

Related more directly to Harris's own recent landscape paintings is a canvas of the

same size known now only through a drawing, part of a 'visual inventory' of his paintings that he commissioned a few years later from a young artist then living in the Studio Building (see Fig. 3). Entitled *Abstract Painting*, it has been 'cancelled' with a single stroke of the pen, to record its conscious destruction. We can see that it was in part not dissimilar to *Lake and Mountains*, in that a pathway of light emanated from behind a dark headland shape on the right across the picture to the left corner. There, a crowd of forms bathed in the glow. These were rounded, organic, although there was the suggestion of an intersecting rectangular plane, and another precise form looped across the upper left corner. Both of these works (*Figure with Rays of Light* is recorded in a drawing on the same page of the inventory) seem to embody Harris's stated desire to represent "nature and the abstract qualities fused in one work."

According to Brooker and other of Harris's friends, such experiments, as all his painting, had ground to a halt by the summer of 1931. In his letters to Emily Carr he does occasionally mention working on Arctic canvases beyond that date, but it is clear that no new painting is being accomplished, that abstraction has offered no new challenges:

> Haven't painted for ages it seems and feel as if my painting days are over.... Occasionally I get a flicker of an idea then it fades or sufficient enthusiasm is lacking, and there we are. Nothing to do about it. I am at a crossroads really and have as yet no vision to know what to do; what road to take. But my O my, I am anxious to be on my way and that is trying when one doesn't know the way. [32]

Although anxiety was not a familiar emotion for Harris, his principles and practices would have assured that it did not

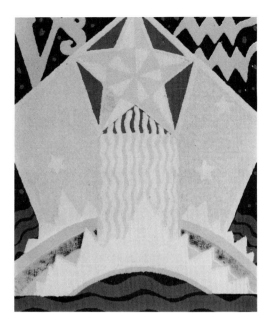

FIG. 1
Lawren S. Harris
Design for a Christmas Card 1931
Serigraph, 9.3 x 7.9 cm
Public Archives of Canada, Ottawa (CI05492)

assume such proportions as to seriously disturb the equilibrium he sought, and seemed always to maintain, in his feelings. A unique *Self-Portrait* of late 1931 or early 1932 (No. 4), painted for a small exhibition of members' self-portraits at the Arts & Letters Club,[33] while demonstrating that Harris still could, and upon occasion did, paint, and despite its emphasis upon his piercing eyes and magnificent mane of snowy hair, seems to confirm that he was at this juncture in his life a wary, troubled man. He does not face the viewer squarely, as do most of his earlier portrait subjects. He catches us out of the corner of his eyes, as though suddenly

disturbed in thought, wrenched from his preoccupation.

Could this lengthening period of creative sterility have hinged entirely upon an aesthetic crisis, an uncertainty about abstraction? The block he was suffering could have as easily grown from other causes. Was it in part the Depression, which must have had some impact on the Harris family fortune? That does not seem to be the case. He and his wife had travelled to Europe in May 1930, in part to examine modern house designs in Stuttgart, in preparation for the construction of their own home on Ava Crescent in exclusive Forest Hill. Although they had moved into a new house on Oriole Parkway less than three years earlier, he had decided to commission a strikingly modern mansion to be designed following his ideas by the Russian-born

24. Collection of the Winnipeg Art Gallery, repr. in colour in Reid, *op.cit.*, pl. 9, p. 28, and cover.

25. "O.S.A. Exhibition," *The Canadian Bookman* 9 (March 1927), p. 78.

26. (Toronto: The Macmillan Company of Canada Limited, 1926), p. 152.

27. *The Canadian Forum* 10 (May 1930), p. 288.

28. Harris to Carr, June 1930, Carr papers.

29. "Lawren Harris And the Dilemma of Nationalism vs Abstraction," in *The Modern Image: Cubism and the Realist Tradition* (Edmonton: The Edmonton Art Gallery, 1982), p. 16.

30. See Barbara Haskell, *Marsden Hartley* (New York: Whitney Museum of American Art in association with New York University Press, 1980), pp. 31-54.

31. Toronto, Simpson Galleries, April 9-23, 1927, *No-Jury Exhibition by Toronto Artists*, no. 11. Repr. in Reid, *op.cit.*, pl. 7, p. 27.

32. Harris to Carr, undated, 1933, Carr papers.

33. L.R. Pfaff, "Portraits by Lawren Harris: Salem Bland and Others," *RACAR* 5 (1978), pp. 21-22.

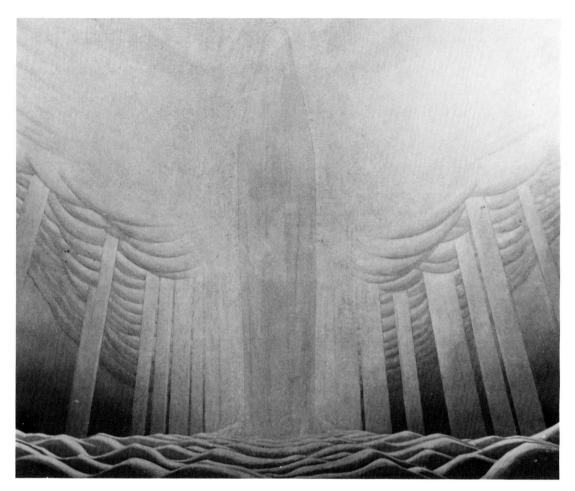

FIG. 2
Lawren S. Harris
Figure with Rays of Light (Arctic Group III)
c. 1931
Oil on canvas, 122.0 x 152.5 cm
Present whereabouts unknown

Alexandra Biriukova. The Harrises moved in early in 1931.[34]

In accordance with Theosophical principles, Harris himself saw his troubling situation simply as a natural consequence of the process of constant change.

All process that involves anything worthwhile has in it death and resurrection. All love, real love, in process is full of deaths and resurrections, —death of some phase, some littleness and a coming to life of a greater phase. Art is the same. I read too, and I know it is time, that a man in the forties —undergoes a sort of spiritual change which involves depression, perhaps for several years, then comes a new sort of rhythm, a new psychic rhythm and a more balanced life. The mystics call it the little death.

Really, old phases must die in us before the new can fill our being.... The

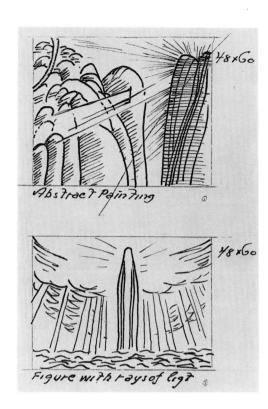

FIG. 3
Hans Jensen
Page from a Pictorial Inventory of Lawren Harris Paintings c. 1935
Pen and ink on paper, 28.0 x 21.5 cm
Private collection, Vancouver

results in art will be its last manifestation, not the first. In a sense it's a complete letting go in a deeper quiet than one has ever known before. The whole inner nature cleansed. It isn't resignation. Let everything go within, all the old ideas, old entanglements, old doubts, old questionings —when they go, as they go, the heart melts —and only when the heart melts can the spirit rise, the pristine new life.[35]

A phase in his spiritual growth; once it had been understood and mastered, then all other aspects of his life and work would begin to grow anew.

In a study of these crucial years, Douglas Worts has pointed out that in response to his mid-life crisis, Harris turned increasingly to spiritual concerns.[36] He had written for *The Canadian Theosophist* only once since his "Revelation of Art in Canada" of 1926, a piece published in December 1931, "Science and the Soul." Then in June 1933 he attended an international Theosophical convention at Niagara Falls, where he presented a paper, "Theosophy and Art," which was published in *The Canadian Theosophist* in two instalments the following July and August. Although essentially reiterating the ideas he had presented in his 1926 article, he expressed with a new fervour certain fundamental tenets of Theosophy. Among these was the central concept that "the essence of religions throughout the ages, is in essence the same, and the message with the various idioms, is identical, and its source one and not many."[37] And he affirmed the importance of the artist within the movement, for "the arts for us are of the highest practical importance in that they mirror for us, in some degree, the essential order, the dynamic harmony, the ultimate beauty, that we are all in search of whether consciously or not."[38]

I have used the term "movement" in this context with care, for Harris had not hitherto been particularly active in proselytizing publicly on behalf of Theosophy. He was now. In addition to further writing (a piece on "War and Europe" for a series organized by Fred Housser, "Theosophy and the Modern World," appeared in *The Canadian Theosophist* in November) he organized a series of radio broadcasts for the Toronto Theosophical Society on the theme of "The One Immutable Law, Re-Incarnation and Karma." Harris him-

self delivered the broadcast for the evening of November 5, 1933, "Justice in Human Life"; and that for December 3, an untitled discourse on basic Theosophical principles, which, he concluded, "covers every step of the progress of the soul toward conscious immortality, and explains all growth, all progress, by the logic of universal and eternal law"; and that of December 31, "Thought and Responsibility."[39] In addition, that fall he conducted classes for young people at the Society. The following March he undertook more classes.

While affirming his belief in the principles of Theosophy by immersing himself in the affairs of the Society, Harris did not eschew old associations. In fact, beginning early in 1933 and throughout that whole busy year, he was deeply involved as well in the foundation of the Canadian Group of Painters, successors to the Group of Seven. The new group was announced late in February 1933, with Harris as President and Fred Housser as Secretary. (Both had been involved the year before in arranging a Group-of-Seven-centred *Exhibition of Paintings by Contemporary Canadian Artists* at the Roerich Museum in New York. Nicolas Roerich was a mystic painter and

34. See "A Canadian Artist's Modern Home," *Canadian Homes and Gardens* 8 (April 1931), p. 40; and Donald Jones, "Divorce Drove Artist from Toronto Home," *Toronto Star*, July 5, 1980.

35. Harris to Carr, November 4, 1932, Carr papers.

36. Douglas Worts, "Lawren S. Harris: Transition to Abstraction, 1934–1945," final paper, Master of Museum Studies Programme, University of Toronto, 1982, pp. 37–43.

37. Lawren Harris, "Theosophy and Art," *The Canadian Theosophist* 14 (July 15, 1933), p. 130.

38. *Ibid.*

39. Broadcast over radio station CKNC, transcripts are with the Toronto Theosophical Society. See Worts, *op.cit.*, p. 40.

stage designer who was greatly influenced by Theosophical themes.) A.Y. Jackson served as Vice-President. Plans were soon made to stage the first exhibition of the CGP at the Art Gallery of Toronto in November, but when an invitation arrived to exhibit at the Heinz Art Salon in Atlantic City, New Jersey, in the summer, that opportunity was grasped.[40] Harris showed strong pictures of the twenties, and another selection of the same in Toronto in November, subsequently shown at the Art Association of Montreal. Critical reaction to these shows was mixed, but plans were soon underway for another exhibition in 1934.

It was not to be. Those close to Harris, sensing a growing tension, began to anticipate a climax in the spring of 1934. Emily Carr confided her feelings to her journal in May:

> No letter from the East yet. I wonder if its happened the inevitable mysterious something L has hinted about. I do not want to conjecture for I may be wrong and think injustices.[41]

The letter came in June. Fred Housser was separating from his wife, Bess. Lawren, leaping to her support, was separating from his wife Trixie. On July 6, Lawren and Bess left by car for Reno, Nevada, where divorces were granted, and where on August 29 they married.

All of this caused a terrible scandal in Toronto. Harris had arranged to store his larger pictures at the Art Gallery of Toronto and his oil sketches in a closet at the Studio Building before leaving, which suggests that he did not expect to return soon. They travelled about in the United States during the balance of the summer, ending up in New York in mid-October. At some point they visited Quebec City. Then in the middle of November they stopped at Dartmouth College in Hanover, New Hampshire, to visit Lawren's uncle, who

FIG. 4
Lawren and Bess Harris in Hanover, New Hampshire, c. 1935.

was a professor there, the same uncle with whom he had stayed as a young art student in Berlin thirty years earlier.

We know something of their feelings and plans at this time, because Bess, who was also a Theosophist and a painter, wrote regularly to an old Toronto friend, Doris Huestis Mills (later Speirs), who has saved the letters. The first of these dates from the day after their arrival in Hanover.

> The venomous hate aroused in the world when one endeavors to move from the Spirit's dictates is quite a different thing to pass through than to consider objectively. Animal magnetism is known with all its brutal and destructive force directed into one's own very life and vision. It seems to create a great vortex and it will with fiendish delight do away with you there if it can. Both of us have experienced it, we know it and have met it.
> —and it now at any rate has no power to confuse us nor weaken us. While that was seething it was impossible to do any creative work, although one saw so much that fairly invited paints and brushes.
> —Perhaps to say that we are both starting to work now will tell you more than anything else.
> We...expect to stay here for some months.[42]

They soon settled into the Whittaker Apartments on North Park Street, and early in December drove into the White Mountains for a week's sketching. The trip stirred them both deeply.

Oh Doris it is a beauty spot in winter, —the whole place drenched in it —the hill tops almost Himalayan in character! —We worked —all drawings. —every day from 10:30 a.m. to dark —so we have a winter's work ahead of us.[43]

Lawren was delighted to discover that Vermont and New Hampshire "are decidedly Northern," unlike nearby New York, Connecticut, and Massachusetts. Writing to Fred Housser and Yvonne McKague in May, he explained that Hanover "is in the Boreal zone. I don't know how it got there, but it's colder and more northern in feeling than all of Southern Ontario."[44] (Fred Housser had left Bess for Yvonne McKague, also a painter and Theosophist. That they all continued on friendly terms was in Toronto the most shocking aspect of the scandal. As Theosophists, of course, they could only have approached their problems in positive, supportive ways.)

New Hampshire, then, was somewhat familiar, but more importantly, it was northern, and in parts mountainous, and so favoured by Harris both as a matter of taste and in his beliefs. The White Mountains in particular, which Bess described as "almost Himalayan in character," and thus particularly spiritual (Theosophists believe the Himalayas to be the principal historical fountainhead of spiritual knowledge), must have excited him. So the work poured out. It was all drawings at first; a large number of New Hampshire drawings survive.[45] Many of these date from after the winter, but some are of snow scenes, and there is at least one small painting that also must have been painted in Hanover at this time, based on the drawings of December 1934. *Mount Washington* (No. 5), then, would be one of the first paintings he had completed in more than two years, and he gave it to his aunt, Ethel Stewart.

The subject of *Mount Washington* is the tallest peak in the American Northeast, part of an ancient, worn range in which the individual mountains are broadly based. Harris has painted it largely in white, blue, and brown, with a strong but sensitive black line outlining its stately silhouette. It is painted on the rough side of a piece of masonite, the texture of which softens the image and suggests atmosphere. The sort of study of the investing spirit or character of a special place that had preoccupied Harris throughout most of the twenties, it does not approach the degree of abstraction we have noted in some of his Arctic sketches.

A drawing of a snow-laden evergreen bough that was likely done that first winter does have in its upper left corner a separate, small study of an abstract shape (see No. 6). Its precise, spiky form seems the antithesis of the organic shapes of the principal drawing, although in purely formal terms it reveals a similar, studied concern to depict volumetric mass in space.

A canvas, *Winter Comes from the Arctic to the Temperate Zone* (No. 7), must also date from this first winter in Hanover. Here, Harris's interest in snowy boughs is given an explicit symbolic meaning, as we see that behind a foreground pyramid of creamy, snow-covered trees lies a deep blue Arctic island, and behind that an ethereal blue, soaring mountain form of the sharp-peaked Rocky Mountain variety. The hushed stillness of New Hampshire's snow-laden landscape thus partakes of the spirituality of the regenerative Arctic, and ultimately of those great mountains — Himalayas or Rockies — that represent to Theosophists the traditional source of spiritual knowledge. Harris is here seeking to achieve that profundity which, as he explained to Emily Carr almost four years earlier, "is the interplay in unity of the resonance of mother earth and the spirit of eternity," an interplay, he believed, that could be expressed most effectively with "nature and the abstract qualities fused in one work."

Winter Comes from the Arctic . . . is tied entirely to a specific landscape experience, and as such does not really go beyond the few experiments he had undertaken in Toronto earlier in the decade. Harris still believed this to be a necessary limitation to abstraction, it would seem, although his attitude would soon change, largely as a consequence of New York's proximity. Long familiar with that metropolitan centre, Harris found that its easy driving distance from Hanover encouraged frequent visits.

The Harrises had been in New York in mid-October 1934, and returned again to join Toronto painting friends Peter and Bobs Cogill Haworth for the week between Christmas and New Year's Day. As Bess explained to Doris Mills, "of course we saw so much, walked such miles in galleries and listened to so much music." One of the highlights was the Fifth Anniversary Exhibition at the Museum

40. See Charles C. Hill, *Canadian Painting in the Thirties* (Ottawa: The National Gallery of Canada, 1975), pp. 23–24.

41. "Journals" VI (May 22, 1934), Carr papers.

42. Bess Harris to Doris Mills, November 14, 1934, with Doris Huestis Mills Speirs, Pickering, Ontario; henceforth 'Speirs papers.' Doris Mills was also a painter. See Paul Bennett, *Doris Huestis Mills Speirs* (Oshawa: The Robert McLaughlin Gallery, 1971).

43. Bess Harris to Doris Mills, December 1934, Speirs papers.

44. Harris to Yvonne McKague and Fred Housser, May 14, 1935, Public Archives of Canada, Ottawa.

45. See Joan Murray and Robert Fulford, *op.cit.*, pp. 152–81.

of Modern Art.[46] In addition, on this trip or others during the following year they could have visited A.E. Gallatin's Gallery of Living Art (cubism and French abstraction) in the downtown library of New York University, and a number of commercial galleries then in the process of introducing European surrealist painting to New York. These included the Pierre Matisse Gallery, Valentine's, and most importantly during those years at mid-decade, Julian Levy's, whose book, *Surrealism*, was the first significant American study of the movement when it appeared in 1936.

There were also the numerous specialty bookstores, one of which doubtless was the source of Harris's copies of *AXIS: A Quarterly Review of Contemporary 'Abstract' Painting and Sculpture*, published in London between January 1935 and the winter of 1937. He had a complete run in his library at his death. We should also remember that Alfred Stieglitz, whose gallery at 291 Fifth Avenue Harris had visited as a young man, was still active at An American Place, where he continued to feature the work of those American pioneers of abstracting symbolist landscape painting, John Marin, Marsden Hartley, Arthur G. Dove, and Georgia O'Keeffe.

The work of Dove and O'Keeffe in particular — usually based on an intense nature experience, often symmetrical, and otherwise hieratic in nature — would have encouraged Harris in the direction he was pursuing with *Winter Comes...*, but the increasing incidence of surrealist art in New York would also have opened up new possibilities. Surrealism did not necessarily represent a diversion from the esoteric concepts by which Harris lived. Levy, in his book on surrealism mentioned above, in explaining the surrealists' fascination with the dream state, quotes from the *Tibetan Path of Knowledge*, published in London in 1935: "under all conditions during the day hold to the concept that all things are of the substance of

dreams and that thou must realize their true nature (ie. Maya or unreality)."[47] Many Theosophists understand such a concept, that the spiritual goal is the only reality; material substance is its debased, transitory shadow.

We don't know which are the paintings in which Harris first abandoned all naturalistic representation, nor when they were made. It is likely during 1935 that he began to experiment with images that, in the manner of Arthur Dove, seem to express the conjunction of surging streams of pure energy (see No. 8), while clearly recalling the distinct, flowing forms of Bertram Brooker's paintings of the late twenties (see Fig. 5). Painted on the sort of boards he used for landscape sketching, the forms of these pictures suggest landscape shapes, but there is no landscape space, and in some cases there is no apparent correct orientation. No. 8, for instance, reveals landscape elements whether positioned horizontally or vertically.

Other early abstract sketches are more evidently linked to the nature of mountains, while still describing force lines of pure energy (see No. 10). These brilliant arcs of light also suggest strongly the imagery of "thought forms," as promulgated by Besant and Leadbeater in their previously mentioned book of the same name, while the dark, threatening forms in the foreground (one of which seems to be melting at its tip) and the ambiguous, shifting space of the picture suggest as strongly the dream-like imagery of the surrealists.

Harris had been able to arrange with Dartmouth College that he function as an unofficial (without formal teaching responsibilities or pay) artist-in-residence, which gave him the use of a studio. In June 1935, he and Bess applied for permanent residence visas. They had decided to remain in this environment that was clearly such a stimulus to painting. In addition, they had been able to

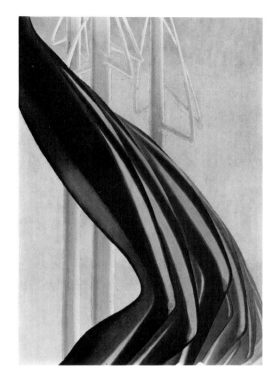

FIG. 5
Bertram Brooker
Green Movement c. 1927
Oil on board, 60.9 x 43.2 cm
Art Gallery of Ontario, Toronto, purchased with assistance from Wintario, 1978 (78/14)

achieve a degree of inner peace that was fortifying, and that promised further growth. "This being born again is no easy matter," Bess wrote to Doris early in October 1935, by which time they had been in Hanover just under one year.

We pick up broken pieces of ourselves and fit them together to make a new pattern — and stand off to take a look to see if it has more dimension than the old one.

The fact that there is that in us which can stand back and watch, — goes to show that the broken "I" is not so all important as we were wont to think it. — That which watches must be beyond opinions, beliefs and change — so we come to see that the opinions and ideas the old "I" had as fond possessions, were may-hap walls that imprisoned us and proved a barrier to others — ...But if one gets sufficiently objective about life it is all very thrilling, — this thing we are trying to do....[48]

That their life in Hanover seems to have been such a fresh new beginning suggests that the Harrises cut all connections with their past. This is far from the case. Bess kept in touch with Doris, of course, who visited them in November 1935.[49] Other friends from Toronto visited upon occasion, and Harris corresponded with painting colleagues. He and Bess visited Ottawa near the end of February 1936 to view the Group of Seven retrospective that had been arranged by the National Gallery of Canada, and later made every effort to encourage the director, Eric Brown, to ask the Museum of Modern Art in New York to consider taking the show.[50] They also met the Chairman of the Board of Trustees of the Gallery, a newspaper publisher, Harry Southam, with whom they became friends. It should be noted that many of these people — Eric Brown; his assistant, Harry McCurry; Harry Southam; and Doris Speirs — were Christian Scientists, and as such, more sensitive than many were to the spiritual quest that was at the centre of the Harrises' lives.

By the spring of 1936 Harris was committed entirely to abstract painting. You will recall that following his return from Europe in June 1930, he had informed Emily Carr that seldom had he seen an abstraction that had "that deep resonance that stirs and answers and satisfies the soul." In a letter to Carr in May 1936 he encouraged her to try it herself.

Feeling can be as deep, as human, or spiritual or resonant in an abstraction as in representational work, but because one has less to rely on by way of association, it requires a greater precision.... I have done quite a number of things and with each one learn a little more or increase that particular way of perceiving.... As for me, there is for the present no other way. I had, as you know, come to a complete full stop, the end, both in painting and in life. The new opportunity means new life and a new way of life and a new outlook and new adventure.[51]

His involvement with abstraction had become an integral part of the spiritual quest, indeed, a new way of life.

There is no evidence that Harris exhibited any of his abstractions during these years, and he did not date them, so it is virtually impossible to establish a chronological order in the work. There are canvases that are based on some of his early abstract sketches. One of these, *Resolution* (No. 9), follows its sketch closely (see No. 8), the only significant changes being that it is now taken to be a vertical picture, which gives dominance to the sharp pyramidal form in the centre, and that the angular spike that almost connects the undulating form at the bottom of the sketch to the pyramid that penetrates from the side, in the canvas stops well short, increasing the sense of tension.

Charles Hill has remarked that, although such canvases are clearly based upon stylized landscape elements (another is *Mountain Experience*, No. 11, which deviates considerably from its sketch, No. 10, and contains many elements that suggest a later reworking), they should not be read simply as "geometricized landscapes."[52] *Resolution* in fact is inscribed on its stretcher, "Resolution, interlocking forms — symbol of steadfastness, courage," which could describe the perceived character of a mountain, but suggests as well that the picture in question reveals these qualities directly. In his letter to Carr of May 1936, encouraging her to try her hand, Harris explains how abstractions from nature must "be even more *real* than the representational. Abstract the essence, the essential from nature, give it new form and intensity."

The evidence of the paintings that have survived from the 1936–37 period is that as well as landscape experiences Harris was exploring compositional concepts of an entirely ideal or non-objective sort. *Poise*, for instance, a study on masonite that was given to Doris Mills in October 1936 (No. 16), and its canvas (No. 17), which follows the study so faithfully that it must have been completed before Doris took away the model, makes no particular reference to landscape forms, although the structures described are presented in a shallow space that is, of course, a representation of that real space that landscape occupies. There are numerous similar works, drawings as well as oil studies and

46. Bess Harris to Doris Mills, January 6, 1935, Speirs papers.

47. As quoted in Dore Ashton, *The New York School: A Cultural Reckoning* (New York: The Viking Press, 1973), p. 95.

48. Bess Harris to Doris Mills, October 5, 1935, Speirs papers.

49. Doris Huestis Speirs, "Introduction," in W. Gordon Mills, *Timber Line & Other Poems* (Toronto: Natural Heritage/Natural History Inc., 1985), p. x.

50. Harris to Brown, March 1, 1936, and a copy of Brown to Harris, March 5, 1936, Central Registry, National Gallery of Canada, Ottawa; henceforth 'NGC files.'

51. Harris to Carr, May 3, 1936, Carr papers.

52. Hill, *op.cit.*, p. 76.

larger canvases, that similarly explore ways of describing structures in space. Some, like *The Bridge* (No. 12), show a particular concern for the roles of hue and tone in establishing space; others are more evidently taken up with defining limits of perspective (see Nos. 13–15).

Harris seems also during 1936–37 to have been developing a personal vocabulary of evocative forms, precise, machine-like, yet at the same time appearing as though they might have resulted from natural processes like erosion or crystallization. The interaction of such forms within ambiguous spatial constructions is at times very complex (see No. 18), although more often than not a coherent spatial ambience is maintained to evoke some sort of fantastic dream landscape (see Nos. 20 and 21). That these pictures are meant to describe an apocalyptic event is suggested by the title of *Riven Earth II*, a title, however, that was likely given years after it was painted. Its imagery includes a dark, sphere-like shape sheared clean through by a thin plane, an arcane floating form, ablaze with light, that resembles a piece from an elaborate, three-dimensional jigsaw puzzle, and in the upper right corner long icicles. A key to such imagery could likely be found in Theosophical concepts, but we should always keep in mind advice Harris gave to Emily Carr in an undated letter of about 1933:

> The whole Theosophical paraphernalia is so immense and intricate and various that all we can do is to take what at the time suits us just as we do in subjects to paint or write about. It is or should be creative — that is, from the mass of information, lore and ideas we fashion over our philosophy and way of life — and remain above all genuinely individual. Here again each of us is to judge for himself.[53]

So these are likely to be idiosyncratic expressions rather than particular configurations of systematically applied symbols of specific significance. And the imagery could have reflected more than one meaning for Harris. Given his predilection for mountains we are probably right to take every peaked form as a reference to one. Yet at the same time, knowing how thoroughly integrated his life and art were at this time, the following quotation from Kandinsky's *Concerning the Spiritual in Art* suggests strongly that some of these shapes represented for Harris the essence of his own creativity, bent on self-discovery and spiritual growth while exalting the path he had chosen: "Everyone who immerses himself in the hidden internal treasures of his art is an enviable co-worker on the spiritual pyramid which will reach to heaven."[54]

It was, finally, this very nonspecificity of abstraction that appealed to Harris — its distance from the literal, as he explained to Carr in the spring of 1937:

> I became more and more convinced that non-representational painting contains the possibility of expressing everything. It takes the expression away from the specific, the incidental, and can lift it into another place, where the experience is enhanced....[55]

Others disagreed, of course, and back in Canada the general opinion was that, rather than encompassing lofty, timeless concepts, abstraction was hermetic and lacking in meaningful human content.[56] Nonetheless, Harris finally decided to exhibit his new work, and sent four abstractions to the third exhibition of the CGP, which opened at the Art Gallery of Toronto in November 1937, and was shown subsequently in Montreal (January 1938), and Ottawa (February). These were

titled simply *Composition 2*, (now *Resolution*, No. 9), *Composition 4* (*Poise*, No. 17), *Composition 8* (*Riven Earth I*, No. 22), and *Composition 10* (No. 23). It would appear that Harris meant this to be a small survey of his work of the previous two years, from *Composition 2*, which likely dates from late 1935 or early 1936, through two works of 1936, and *Composition 10*, probably of the early summer or early fall of 1937. As a group they represent a movement or development, from somewhat loosely handled, expressive, organic forms related to landscape elements through to an entirely non objective, spatially ambiguous, and precisely painted object expressive of movement but suggesting no particular symbolic association. Elaborate, yet profoundly mysterious, *Composition 10* seems a long cry from the fusion of "nature and the abstract qualities" that had dominated his thoughts about abstraction for more than half a decade.

The Harrises loved motoring. They sometimes drove to New York, and frequently used their car to explore in New Hampshire. In October 1935 they travelled to Maine, and probably returned in subsequent years. Sometime in February 1938 they left on a journey that would take them across the continent on a route not unlike the one they had traced following their departure from Toronto almost four years earlier. Their southernmost destination was not Nevada, however, but New Mexico. The capital, Santa Fe, and nearby Taos, had for years been the sites of thriving artists' colonies.[57] A number of artists connected with Stieglitz's An American Place frequented the region, particularly Georgia O'Keeffe, who painted at Taos every summer from 1929, and then near the town of Abiquiu, between Taos and Santa Fe, from 1934. Harris certainly would have been familiar with the austere, spiritually charged desert landscapes and still-life subjects she produced there, even

though his interests were by 1938 centred entirely on non objective painting.

He and Bess arrived in Santa Fe in the middle of March. It is a small, beautiful city, rich with evidence of its Spanish heritage, and high enough above the desert plain to enjoy a relatively temperate climate. The Harrises must have been surprised at the number of artists they found working there, and with the relaxed, informal manner of the place. Raymond Jonson, who became their close friend, later recalled the way they met:

One day…we saw a stunning looking couple walking past our home and studio in Santa Fe. I went out and introduced myself to them and they to us…. I was delighted with our meeting for I knew of Lawren Harris as I had seen an exhibition of his work at the Roerich Museum in New York in late 1931 or early 1932….[58]

This was not a one-man show, but the *Exhibition of Paintings by Contemporary Canadian Artists* that had been held in March 1932. Harris had shown six of his landscapes, including *Lake and Mountains* (No. 1).

Raymond Jonson, who was born in Iowa, and worked in Chicago as a young artist, had moved to Santa Fe in 1924. Early an admirer of the work of Nicolas Roerich, and influenced deeply by Kandinsky's *Concerning the Spiritual in Art*, which he first read in 1921, Jonson was no less committed than Harris to the pursuit of spiritual goals. Although not a Theosophist, he sought to elucidate the underlying life force through his art, a force that he likened to the "astral glow" described by Rudolf Steiner, who broke away from Theosophy early in the century to found his own humanist-spiritualist movement, Anthroposophy. Six years younger than Harris, Jonson had moved through an evolution in

his work remarkably similar to that of the Canadian artist.[59]

Doubtless because they had so much in common, the two soon became fast friends, and Jonson introduced him to a small circle of painters who shared their interests in Kandinsky and esoteric concepts. Harris could not have arrived at a better moment, for they were beginning to discuss the formation of a group. He and Bess soon decided to move to Santa Fe, and were able to make arrangements to rent a wonderful adobe house, one of three in a large walled compound, Plaza Chamisal, on Acequia Madre, one of the oldest streets in the city. The owner even allowed a studio addition to be built.

The Harrises remained in Santa Fe until sometime near the end of May, by which time they had begun to make payments towards the purchase of one of Jonson's paintings, *Cosmic Theme No. 4* (Fig. 6), a picture they admired "immensely, unboundedly."[60] Before they set off to continue the journey they had begun over three months earlier, they also decided to build a collection of the work of the new group. Just how quickly, and unequivocally, they had been caught up in this new life in Santa Fe is apparent in a letter they wrote early in June from near Pike's Peak, Colorado:

Our most affectionate greetings and our love to you both and just general all around and up down pleasure and gratitude for the channels we were moved along in Santa Fe, our new but seemingly long-known friends and the new art movement — so far we have come upon no better designation than transcendental painters — but we'll be mouching over it and if we do we'll write.[61]

They travelled north and west along the Rockies at least as far as Yellowstone Park,

then turned east, arriving at Prouts Neck, Maine, about the middle of July. Developments meanwhile progressed back in Santa Fe. In addition to the Transcendental Painting Group, as it had been decided to call it, before he left Harris had suggested the establishment of a Transcendental Painting Foundation to facilitate the business side of their activities, and generally to support the aims of the Group. Jonson seems to have deduced from this that Harris wished to maintain a certain distance from the Group, for he would be the natural president of such a foundation. A letter from Maine in August set the record straight:

The Group as a band of active Transcendental painters interests me first and foremost — before anything else and a

53. Carr papers.

54. As translated in the authorized, first American edition (New York: George Wittenborn, Inc., 1947), p. 40.

55. Harris to Carr, April 15, 1937, Carr papers.

56. Hill, *op.cit.*, p. 76.

57. See Van Deren Coke, *Taos and Santa Fe: The Artist's Environment, 1882-1942* (Albuquerque: University of New Mexico Press, 1963); and Arrell Morgan Gibson, *The Santa Fe and Taos Colonies: Age of the Muses, 1900-1942* (Norman: University of Oklahoma Press, 1983).

58. Raymond Jonson, Albuquerque, New Mexico, to Peter Larisey, Ottawa, November 14, 1973, with Peter Larisey, Toronto.

59. See Ed Garman, *The Art of Raymond Jonson, Painter* (Albuquerque: University of New Mexico Press, 1976); and Elizabeth Anne McCauley, *Raymond Jonson: The Early Years* (Albuquerque: Art Museum, University of New Mexico, 1980).

60. Harris to Raymond Jonson, April 28, 1938, Jonson Gallery, University of New Mexico, Albuquerque; henceforth 'Jonson papers.'

61. Harris to Jonson, June 1938, Jonson papers.

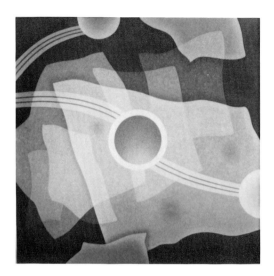

FIG. 6
Raymond Jonson
Cosmic Theme No. 4 c. 1937
Oil on canvas, 101.5 x 104.0 cm
University of British Columbia, Vancouver, gift of
Lawren S. Harris, 1960

good long way before anything else....

The Foundation is not basic, funda-
mental, primary. It can only become a
success when the painters themselves
produce works to justify it. And how many
such works are there? —a good many of
yours and damn little else as yet....

As for me, I would rather be the
humblest painter in the Transcendental
Painting Group than ten thousand times
president of any Foundation however
excellent....

So, I only accept the office of the
president of the foundation pro tem.[62]

The first public mention of the TPG was on
August 21, when almost the full front page of
the Saturday magazine section of *The New*

Mexico Daily Examiner was given over to the
Group. Under a general headline of "The
Transcendental Movement Opens a New
Period in the American Arts" are two articles:
"The Birth of the Transcendental Movement
and Its Manifestations in Music and the
Modern Dance," by Dane Rudhyar, and "The
Transcendental Painting Group: Its Origin,
Foundation, Ideals and Works," by Alfred
Morang. Morang, who had arrived in Santa Fe
only the year before, was already a leading
figure in the artistic community. An accom-
plished violinist, writer, and landscape painter,
he taught at the local Arsuna School of Fine
Arts (as did Raymond Jonson), and wrote a
regular arts column for the *Santa Fe New
Mexican*.[63] Neither he nor Dane Rudhyar, a
musician and composer who did some
painting, were members of the Group. Both,
however, were on the board of the American
Foundation for Transcendental Painting (of
which Harris was, indeed, President), Rudhyar
as a Vice-President, Morang as Publicity
Director.[64]

The charter members of the TPG, which
was founded June 10, 1938, according to
Morang, were Raymond Jonson, Emil Bisttram,
Bill Lumpkins, Robert Gribbroek, Stuart Walker,
Agnes Pelton, H. Towner Pierce, and Florence
M. Miller.[65] In June, Jonson was not sure that
Harris wanted to be a member. By the time a
pamphlet outlining the aims of the TPG had
been published in January 1939, Harris was
included in the list.

Chairman of the Group was Raymond
Jonson, who also served as Secretary of the
Foundation. Bill Lumpkins, a Santa Fe archi-
tect, watercolour painter, and keen student of
Theosophy, who was born in Arizona and had
studied architecture and sculpture at Albu-
querque, New Mexico, was Secretary-Treasurer
of the Group, and Treasurer of the Founda-
tion.[66] The most prominent member after
Jonson was Emil Bisttram of Taos. Bisttram,

who was born in Hungary, had studied
painting in New York before settling in Taos in
1931, where he established the Taos School of
Fine Arts the following year. Bisttram too had
a deep interest in Theosophy, and was also an
advocate of dynamic symmetry, of which more
later.[67]

Stuart Walker, a longtime close friend of
Lumpkins, likely shared his interest in Theoso-
phy, and from the appearance of Agnes
Pelton's symbolic, symmetrical paintings,
"the projections of fully integrated experi-
ences of an inner reality," it is likely that she
did too.[68] Of the others — Gribbroek, Miller,
and Pierce — we don't know, although again,
their work suggests a strong interest in
spiritual content and a knowledge of Kandin-
sky, and, or, Roerich (who had visited Santa Fe
upon occasion in the twenties).

In its official statement, however, the TPG,
while noting the shared interest in spiritual
matters that had brought them together,
carefully avoided any hint of dogmatism,
describing itself simply as a group

composed of artists who are concerned
with the development and presentation of
various types of non-representational
painting; painting that finds its source in
the creative imagination and does not
depend upon the objective approach.

The word Transcendental has been
chosen as a name for the group because
it best expresses its aim, which is to carry
painting beyond the appearance of the
physical world, through new concepts of
space, color, light and design, to imagina-
tive realms that are idealistic and spiritual.
The work does not concern itself with politi-
cal, economic or other social problems.

Methods may vary. Some approach
their plastic problems by a scientific
balancing of the elements involved; others
rely upon the initial emotion produced by

the creative urge itself; still others are impelled by a metaphysical motivation.... The main activity of the Group will be toward arranging exhibitions of work. The goal is to make known the nature of transcendental painting which, developed in its various phases, will serve to widen the horizon of art.[69]

As a group, then, the TPG was concerned with painting, not with proselytizing for a particular spiritual goal. There was in fact some wariness of what Morang called the "slightly dangerous thickets of mysticism." The TPG, he pointed out, "faces a period when Fascism and mystical culture are apt to blend into a destructive unit, when religious fanaticism is changing from a coat of so-called Christian doctrine to the doubtfully valuable dress derived from static Orientalism."[70]

Meanwhile, the Harrises had left Maine for Canada at some point near the end of August 1938. Harry Southam, Chairman of the Board of Trustees of the National Gallery of Canada, had commissioned Lilias Torrance Newton of Montreal to paint Harris's portrait, and so one or two sittings had to be arranged in that city.[71] He and Bess travelled as well to Toronto where he would have visited his sons, Howard and Lawren Jr., who was then teaching art at Northern Vocational School. Near the end of September they were in St. Catharines, near Niagara Falls, to visit his daughter Peggie. He wrote Eric Brown at the National Gallery from there, requesting that the four abstract paintings that had been included in the 1937 CGP exhibition, and subsequently stored at the Gallery, be sent to his new home at 1 Plaza Chamisal, in Santa Fe, "our address until June 1st 1939."[72] They themselves finally settled in there some time in October.

Both Lawren and Bess found the new environment stimulating and entirely conducive to work. Bess, in fact, soon undertook formal studies to assist her in moving into abstraction. This was to equip her better to help Lawren, as well as for broader idealistic reasons. It is all explained in a long letter to Doris at the end of the year:

I am studying Dynamic Symmetry you will be surprised to hear. Taking a course with two other (younger) married women, with an artist who lives 75 miles away! ... I must move into the abstract if I am to continue painting both for inner and outer reasons. — I need to be in the house and available, — even to be in the studio. — It is needful. It is also a joy that I can be really useful to Lawren in his own creative work, — and that the usefulness increases. — I am blessed with more painting perception than I am blessed with ability to do, — so it is good to use it. Whenever Lawren finds himself in a questioning place he comes for me and we go and talk it over — perhaps just the looking and talking together, — starts the creative flow once more. — Anyway there it is, — I don't feel free to go outdoors painting even should I want to. The inner demand and interest too grows and fastens more and more on the non-representational as expression of the inner life. — The more one looks the more meaningful the non-objective forms and spaces become.... It seems that in this day of social upheaval the dearest and brightest star of the spirit that has identical meaning for *all* peoples is the language of art.[73]

Bess was studying dynamic symmetry with Emil Bisttram in Taos. The invention of Canadian-born Jay Hambidge, dynamic symmetry is a theory of ideal composition based upon an understanding of the mathematical relationship of the proportions of the golden section to the logarithmic spiral. Following the turn of the century, Hambidge found support for his theory in comparing countless measurements of ancient Greek vases, and also in the high incidence of the logarithmic spiral in growing forms (for instance, the arrangement of seeds in the head of a sunflower). By the twenties he enjoyed a wide following among artists, many of whom, like Bisttram, used his precise, elaborate diagrams as frameworks for their compositions in the belief that they were reflecting a universal principle of perfect structure.[74] We will see later that, doubtless partly in response

62. Harris to Jonson, August 19, 1938, Jonson papers.

63. Gibson, *op.cit.*, p. 71.

64. Alfred Morang, *Transcendental Painting* (Santa Fe, New Mexico: American Foundation for Transcendental Painting, Inc., 1940), n.p.

65. Alfred Morang, "The Transcendental Painting Group: Its Origin, Foundation, Ideals and Works," *The New Mexico Daily Examiner*, August 21, 1938.

66. James Monte, Anne Glusker, *The Transcendental Painting Group, New Mexico 1938-1941* (Albuquerque: The Albuquerque Museum, 1982), n.p.

67. Gibson, *op.cit.*, n.p.

68. Monte and Glusker, *op.cit.*, n.p.

69. *Transcendental Painting Group*, a pamphlet published by the Group in January 1939.

70. Morang, *loc.cit.*

71. The portrait is now in the collection of the National Gallery of Canada. See Dorothy Farr, *Lilias Torrance Newton 1896-1980* (Kingston: Agnes Etherington Art Centre, 1981), p. 28, repr. p. 19.

72. Harris to Brown, September 23, 1938, NGC files.

73. Bess Harris to Doris Mills, December 28, 1938, Speirs papers.

74. See Elizabeth Mitchell Walter, "Jay Hambidge and the Development of the Theory of Dynamic Symmetry, 1902-1920," Ph.D. thesis, University of Georgia, 1978.

to Bess's enthusiasm for the procedure, but also because of his admiration for Bisttram's paintings, Lawren too would grapple with the intricacies of dynamic symmetry.

He seems to have exhibited Hanover paintings in the earliest TPG shows, however. The first of these was a small selection for the Golden Gate International Exposition in San Francisco in 1939. Alfred Morang 'reviewed' the work in mid-January before it was sent off. Harris's single contribution, *Composition*, he felt "varies between ice-like planes and forms that seem related to organic shapes that have been re-assembled after some disturbance of atomic energy and are endeavoring to force themselves into a new yet animated entity."[75]

This surprisingly literal reading could be a description of *Composition 8* (No. 22), which would have arrived from Ottawa by then, or the closely related *Riven Earth II* (No. 21), which doubtless too was initially titled by Harris simply as a numbered "Composition." Incidentally, it should be noted that he was represented in the Canadian section of the fair — which he had organized himself — by *Lake and Mountains* (No. 1), and another landscape of the twenties, *Country North of Lake Superior*.

The Harrises were back in New York for a visit again in mid-January 1939. Lawren met his mother there to discuss her leaving Toronto for a climate better suited to her health. (She settled in Pasadena, California, later in the year.) They called on Arthur Lismer, at the time a visiting professor at Columbia Teachers College, "had a tender and rarely lovely contact with Alfred Stieglitz," and enjoyed Raymond Massey in the new film, *Abe Lincoln in Illinois*, which they found "beautiful and deeply stirring."[76] Lawren was under instructions to scout out the new facilities of the Museum of Modern Art as a possible venue for the first New York showing of the TPG. It was not yet open, and seemed

not likely to be in time for the New York World's Fair later in the year. After two weeks, he was anxious to get home to his painting.

The Harrises were content to remain mostly working in Santa Fe for the rest of the year. They renewed the lease on their house in June, satisfied that the TPG would continue to provide a stimulating focus for their lives. It had again been noticed nationally in March, in the New-York-based *Art Digest*, and at about the same time a small controversy surfaced in Santa Fe over the selection of local artists for the Golden Gate Exposition in San Francisco.

Harris, it was alleged, had influenced the curator of that exhibition to choose from the Santa Fe region non-objective painters, and particularly members of the TPG, over others who were as accomplished if more traditional in their approach to painting. It must have reminded him of the early Group of Seven days back in Toronto as he patiently responded to the charges in a letter to the press. Yes, he certainly knew the man responsible for the North American portion of the exhibition, Roland McKinney. Harris had arranged the Canadian contribution to the Pan-American Exposition display that McKinney had organized for the Baltimore Art Gallery in 1931, and so when McKinney was given the job of mounting a similar exhibition for San Francisco, he turned to Harris again for a Canadian section. This was shortly after Harris had first seen and been impressed with the new work in Santa Fe, and he simply suggested to McKinney that he consider it.[77]

About a month later the TPG staged its first exhibition as a group, a small show in mid-April at the University of New Mexico in Albuquerque. The only mention of Harris resulted from what seems to have been a press conference in which one of two journalists amusingly misrecorded a statement. Peggy Lee, writing in the *New Mexico Lobo*, notes that "Lawren Harris says that his own

works are the intense dramatic expression of inner life." The anonymous reporter for the *Albuquerque Tribunal* has Jonson saying, "Lawren Harris' work is the expression of an intensely dramatic inner life."[78]

A month later what was likely the same exhibition was shown at the Arsuna School of Fine Arts in Santa Fe. This time Morang reviewed it, and among his generally positive, supportive remarks noted that Harris's work "has a three dimensional quality that makes his Transcendental painting akin to certain constructions. His color has subdued force and subtlety but it is his masterly creative design that places him in the front ranks of leading non-representational artists."[79] Morang commented in a similar vein at the end of the summer on Harris's contribution to a large regional survey show, "a canvas filled with intense nonrepresentational significance. The painter has succeeded in the difficult task of making abstraction into what may be termed objective mental forms."[80] The canvas was *Composition 10* (No. 23), a late Hanover painting he had already shown in Canada two years earlier, and by which he had been represented in the American section of the New York World's Fair exhibition during the summer of 1939. Incidentally, as in San Francisco at roughly the same time, he was represented in the Canadian section of the New York fair by two Group of Seven landscapes sent down from their storage place in the Art Gallery of Toronto.

Then, probably in the fall of 1939, Harris held a one-man show in the galleries of the Arsuna School of Fine Arts. Rather than review it, Morang wrote a biographical profile of Harris for *The Santa Fe New Mexican*, revealing only that the exhibition contained "examples of his work that range from a snowy landscape to his latest non-representational canvases."[81] The snowy landscape was likely *Winter Comes...* (No. 7).

There is not even a hint of the nature of his "latest" paintings.

It is only in October 1939 that there is at last substantial evidence of new Santa Fe work. That month Harris sent two pictures to Toronto for the CGP exhibition, *Painting I* and *Painting II*. The following April they were both included in a group of paintings that the TPG was sending to New York. The Museum of Modern Art *did* manage to open its new building in 1939, but that year another museum was opened as well. Situated in a renovated townhouse on Fifty-fourth Street, the Museum of Non-Objective Painting was the brainchild of the Baroness Hilla Rebay and her patron and lover, the enormously wealthy Solomon Guggenheim. Devoted to collecting art of a certain spiritual dimension, and particularly that of Kandinsky, the Guggenheim Museum, as it came to be called, was also committed to the encouragement of new art in a similar vein. It must have seemed tailor-made to the TPG.

The TPG was never featured in an exhibition at the Museum of Non-Objective Painting, however. Instead, works of members were included in two exhibitions, *Twelve American Non-Objective Painters* (May 14–June 27, 1940), and *Six American Non-Objective Painters* (August 6–September 30, 1940). Harris's *Painting II* was in the former, and his *Painting I* in the latter.

Only one other picture was noted by name during Harris's years in Santa Fe — *Memorial to an Airman*, which was included in a large survey show, *The Coronada Exhibition*, at the Museum of New Mexico in Santa Fe from June 1 to September 30, 1940. Known today as *Abstract Vertical*, *Memorial to an Airman* is now in the collection of the Art Gallery of Hamilton.[82] (It still bears the *Coronada Exhibition* sticker on its back.) *Painting II* is also known today, although in a radically altered form. It is in this exhibition (No. 36),

and will be discussed later. *Painting I* is known, as well, as *White Triangle* in the collection of the National Gallery of Canada.[83]

Morang, in writing of the TPG paintings that were sent to the Guggenheim for display, typified Harris's as showing "this remarkable artist's conception of gray tonalities coupled with the deep grasp of the emotional impact inherent in pure form used with no dependence upon nature."[84] In virtually all of his few remarks concerning Harris's work in Santa Fe, Morang stresses the complete autonomy of his forms, and certainly that is one thing that distinguishes most of the Santa Fe abstractions from those done in Hanover; the utter break with any reference to a nature experience.

Certainly this tendency began in Hanover, as *Composition 10* testifies (No. 23). It describes a complex, arcane shape, partly organic and partly mechanical, spinning silently on a thin axle. Jonson in a letter to Harris referred to it as the "Celestial Weathervane."[85] On the other hand, *Composition* (No. 24), which could be either a late Hanover or an early Santa Fe picture, when displayed vertically (as here) suggests two stylized figures, but when hung horizontally (as screw marks on the frame and stretcher show it has been) it becomes a strange, unsettled landscape viewed through a window, not unlike *Riven Earth II* (No. 21). This effect is due largely to the beautifully painted ground of blue with its radiant aura of white and yellow, which reads as a sky (see Pl. No. 1). By late 1939 and the *Painting* series, two of which Morang had described in terms of Harris's "conception of gray tonalities," we see much less concern for hue, and consequently, little opportunity to make associations with natural phenomenon on the basis of colour. This development too would appear to have been gradual, and but one of a number of routes Harris seems to have been working. *Geometrical Abstraction* (No. 25), for instance, is

closely related in form to both *Composition 10* and the Art Gallery of Ontario's *Composition* in form, but is virtually monochromatic.

Even more than during the Hanover period, Harris seems then to have been developing on a number of fronts at once. A good reason for this was his association with at least eight painters with similar interests — the members of the TPG — and some of his Santa Fe paintings reflect this association directly. As in Hanover, he often worked first on relatively small pieces of masonite before attempting a larger canvas, and a number of these experiments seem not to have gone beyond that initial stage.

75. Alfred Morang, "Transcendental Painting Group Sends Exhibition to San Francisco to be Shown During World's Fair," *The Santa Fe New Mexican*, January 17, 1939.

76. Bess Harris to Doris Mills, February 19, 1939, Speirs papers.

77. Lawren Harris, "Letters to the Editor," *The Santa Fe New Mexican*, March 16, 1939.

78. Albuquerque, April 22, 1939; April 19, 1939.

79. Alfred Morang, "First Local Exhibition by the Transcendental Painting Group," *The Santa Fe New Mexican*, May 19, 1939.

80. Alfred Morang, "100 Artists Show Vitality of Southwest Art in Fiesta Show," *The Santa Fe New Mexican*, September 1, 1939.

81. "Lawren Harris: Tireless Experimenter," undated clipping (1939), Jonson papers.

82. See Paul Duval, *Four Decades: The Canadian Group of Painters and their contemporaries — 1930-1970* (Toronto and Vancouver: Clarke, Irwin & Company Limited, 1972), repr. in colour p. 26.

83. See Hill, *op.cit.*, pp. 77, 178, repr. p. 87.

84. "Transcendental Painting Group Invited to Send Examples to Guggenheim," *The Santa Fe New Mexican*, April 11, 1940.

85. Jonson, Santa Fe, to Harris, New York City, January 27, 1939, copy with Jonson papers.

Some of these he might have felt were too similar to the models that had stimulated them. Nos. 26 and 27, which employ the vocabulary of dynamically equated geometric shapes developed by Kandinsky during his Bauhaus years of the twenties and early thirties, are in fact close variations of contemporary Bisttram paintings, reflecting that artist's interest not only in Kandinsky but in sources as unusual as traditional Navajo sand painting.[86] Other small paintings on masonite of these years reveal that in spite of Harris's determined commitment to non-objective painting, he was still turning upon occasion to a stylized landscape context. In one of these his characteristic quasi-geometric, quasi-organic shapes stride across a landscape whose features resemble the famous Sangre de Cristo mountain range, within whose foothills Santa Fe is situated (see No. 28). Harris did work this image up to canvas, at least twice. Although one of these, which he later cancelled in order to use the back for another painting (see No. 50), shows traces still of landscape elements, the surviving version shows none that have not been entirely stylized as geometric shapes (see No. 29).

Harris's use of geometry to reveal a sense of the underlying structure of things is one of the principal characteristics of his work in Santa Fe in the late thirties. Many drawings have survived that attest to this interest, as many, it seems, as from that great surge of drawing in Hanover that facilitated his first successful move into abstraction. It was not simply planar geometry that drew him to these explorations, but complex, three-dimensional forms developed from some of the spatial investigations of the Hanover period (see No. 30). And, as in Hanover, Bess shared this commitment to drawing. In a letter to her friend Doris she reveals the basis for the renewed enthusiasm.

FIG. 7
Near Santa Fe, New Mexico, c. 1939.

My dip into dynamic symmetry is proving of great interest. —I am *not* going into the mathematical intricacies of it. I accept that as outside my present capacity and need! —What I am finding is that this course based on dynamic symmetry is, —for me, —proving much more than that. —it is a gorgeous kindling of the inner life in terms of graphic composition. —I am doing innumerable little pencil drawings —haven't touched paint since last spring —but when I do I'm sure I shall find a great difference. —It has awakened an inner seeing, or a form of expression for my own way of seeing!! —[87]

That the application of principles of dynamic symmetry was guiding Lawren as well is clear from at least one series of three drawings, which reveals the stages in composition from the establishment of a carefully measured grid or trellis through to the finishing of the autonomous, free-standing forms that are the goal (see No. 31). Bess described the process as she applied it, and it could as effectively relate to these drawings of Lawren's.

It is a simple approach to dynamic symmetry — the recognition of certain "dynamic" areas, the use of a trellis or line skeleton for each area. —the choice of elements to be used, —the idea to be expressed —and then the placing of those elements on the trellis in a manner to express the *idea* —Not very clear? —Like theories of music I expect one has to *work* with them before they become living....[88]

Looking now at the canvas Harris developed from these drawings, *Abstraction (Involvement 2)* (No. 32), we can see in the proportions and relationships of its forms,

and in its graceful, arcing lines (fragments of logarithmic curves), clear evidence of his use of dynamic symmetry.[89] Yet, if we did not know the drawings, we would still sense a certain organic logic to the painting in the way that the forms seem to revolve around the strong central axis in elegant rhythms, suggesting a fantastic plant growing from the earthly apparatus in the painting's lower range. For Harris, this limitlessly expanding image springing from well-prepared ground would have caught something of the potential of the human spirit to partake of the complex order of the cosmos.

Painting No. 4 (No. 33, Pl. No. 2) also likely dates from 1939. Although as hieratically symmetrical as *Involvement 2*, its principal form, rather than expanding, folds inward. Its resemblance to a concentrated crystal about to burst the brownish-grey limits of the earthly vessel that contains it nonetheless relates it closely to that theme of spiritual aspiration Harris found to be so well served by the application of the principles of dynamic symmetry.

This is a good point at which to underline the fact that it was due to Emil Bisttram that Harris became involved with dynamic symmetry. Indeed, many characteristics of these entirely non-objective, geometric paintings of his last years in Santa Fe seem to have been derived from Bisttram, whose work from the mid-thirties to the end of the decade often displays a similar hieratic symmetry, and the same internally related proportions and arcing lines. There is in fact a series of Bisttram pictures featuring a large circle or bubble shape that Harris has emulated in certain of his paintings of the late thirties.[90] Also new to his work of this period is the use of transparent, overlapping planes, another common characteristic of Bisttram's pictures. Raymond Jonson also employed circles and transparent forms in his compositions, as we can see in the painting Harris owned, *Cosmic Theme No. 4*, of about 1937 (Fig. 6). Indeed, Harris evidently found the environment of Santa Fe, and particularly that sense of community he shared with all the members of the TPG, to be as stimulating, as conducive to experimentation and growth, as any he had ever known. To isolate the specific contributions of individual members of the TPG to his work during this period of accelerated change will, however, require more detailed investigation.

The Harrises had every reason to stay on in Santa Fe for years more. War had broken out in Europe in the summer of 1939, but it must have seemed harmlessly remote from the great desert expanses of the American Southwest. Lawren's daughter Peggie visited in March 1940, leaving early in April to call on her grandmother in Pasadena. The United States managed to stay aloof from the Second World War until December 1941, but sometime during the summer or early fall of 1940 Canadians in the States were rudely awakened to the fact that their country was into the second year of war when the transfer of Canadian funds abroad was prohibited. By mid-October the Harrises were back in Canada looking for a new home.

When Lawren's mother discovered that wartime measures necessitated her return to Canada, she decided to remain on the Pacific coast, and took a room in the Empress Hotel in Victoria, the capital of British Columbia. Situated on the southeast coast of Vancouver Island, it enjoys the most temperate weather in the country. The Harrises decided that they should again settle fairly close, and so chose Vancouver, on the mainland coast due north across the Strait of Georgia.

Lawren had continued to maintain some contact with Canada while in Santa Fe. He had organized the Canadian art display for the Golden Gate International Exposition in San Francisco in 1939, you will recall, had shown Group of Seven pictures at the Art Association of Montreal Spring Exhibition in March of that year, the same with the CGP at the New York World's Fair that summer, and again at the Canadian National Exhibition in Toronto in late August. His first Santa Fe abstractions were shown with the CPG at Toronto in late October. In March 1940 he was even chosen for one of a series of four-person shows of contemporary Canadian art staged by the Art Gallery of Toronto. He showed Arctic pictures (then still in storage at the Gallery) with Emily Carr, the Toronto painter Charles Comfort, and the Montrealer Fritz Brandtner, who included three abstractions (all entitled *Design*), among his fifteen works. The following month Harris was featured in Muriel Miller's ongoing series of profile articles, "Famous Canadian Artists."[91]

So, after visiting his mother in Victoria (and Emily Carr, too) in October, and checking out Vancouver, Harris was understandably anxious to visit Toronto again, which he hadn't seen since stopping there briefly to visit his sons in 1938. He and Bess took the train from Vancouver, and soon were established in the Windsor Arms Hotel. Near the end of their stay

86. See in particular Bisttram's *Outpouring* and *Upward*, both of c. 1940, repr. (the latter in colour) in James Monte and Anne Glusker, *op.cit.*, n.p.

87. Bess Harris to Doris Mills, February 19, 1939, Speirs papers.

88. *Ibid.*

89. For a close analysis of Harris's use of dynamic symmetry in this painting see Worts, *op.cit.*, p. 77.

90. See in particular Bisttram's *At-One-Ment*, repr. in Raymond F. and Lila K. Piper, *Cosmic Art* (New York: Hawthorn Books, Inc., 1975), p. 17.

91. "Lawren Harris: Landscapist and Figure Painter in Oils, and Street Scene Artist," *Onward* 50 (April 7, 1940), pp. 218-19.

COLOUR PLATE NO. 3 (No. 49)

Mountain Experience I c. 1946
Oil on canvas, 130.5 x 113.3 cm
The Art Emporium, Vancouver (D372)

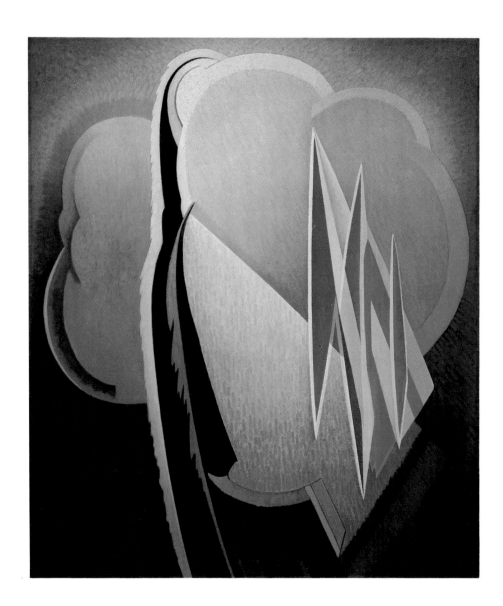

COLOUR PLATE NO. 4 (No. 56)

Untitled **c. 1952**
Oil on canvas, 114.0 x 146.8 cm
The Edmonton Art Gallery (82.2)

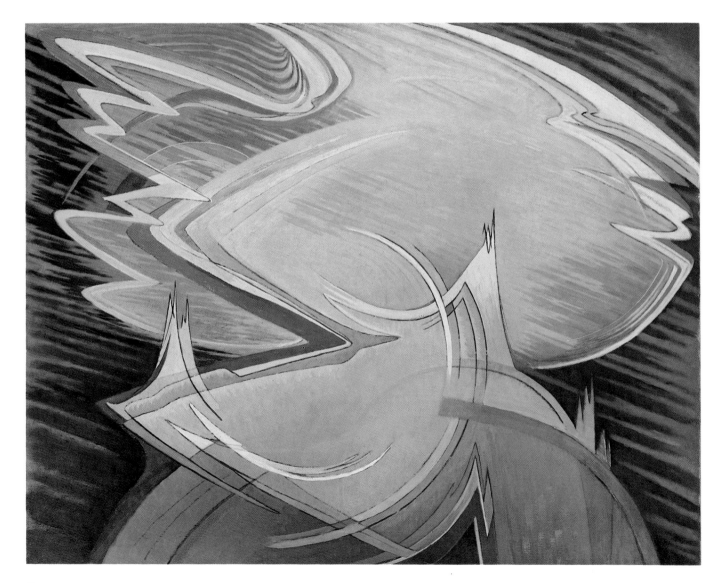

Lawren wrote to Raymond Jonson back in Santa Fe to explain the situation.

> The month here has been packed, jammed with visits, dinners, lunches, conferences, meetings and an endless program of renewing friendships.
> We leave here Sunday for Vancouver and will stop over a few days in Banff to rest and to view the mountains in what is now their winter.
> Then we go to Vancouver to settle for the winter and spring. We have a house there — haven't seen it — but know its plan and location and fancy it will suit us and that we can paint therein.[92]

The rented house was at 4749 Belmont Avenue, in the exclusive Point Grey section of the city, high above English Bay. With everything open-ended, however, no one knew what to expect of Harris's return. A.Y. Jackson dropped a note to the new Director of the National Gallery of Canada, Harry McCurry, after Harris had left Toronto for the West. "He should liven up the boys round there, or he may merely get them interested in reincarnation."[93]

In spite of the tentativeness of the arrangements, the Harrises soon settled in. By the end of January 1941, it had become clear that any belongings left behind in Santa Fe had to be returned immediately, and that they themselves would have to remain in Canada until at least the end of the war. Consequently, all the paintings that had been produced in the States over the previous five years were shipped to Vancouver. The definitiveness of this step doubtless further encouraged Harris to make the most of the new situation, as is evident in a letter to Jonson of early March.

> We have built a wooden shack of a studio a few jumps from the house. It has a grand light, is a good workshop and we are both busy therein. I am having a show here the end of April and am busy putting my stuff in shape.
> Mother loves Victoria...so that solves our problem. So long as she remains contented in Victoria we will remain here.[94]

Bess, for her part, was entirely won over by the early spring, as she explained to Doris.

> B.C. coast and Spring are hand in hand — the blossoming trees are exquisite and almost astound the eye — Its a heavenly place to live —....I was not really enthusiastic about coming — neither was Lawren. — now we are grateful that Life took us in hand and landed us in these beauteous parts —.[95]

It is perhaps a measure of the endurance of Harris's reputation from the Group of Seven years and those few months of his active involvement as first President of the CGP in the early thirties that he was accorded a one-man show at the Vancouver Art Gallery so soon after his settling in that city. Comprising twenty-seven canvases, it ran for about two weeks early in May, and was then displayed on the campus of the University of British Columbia. Doubtless in anticipation of queries, the Vancouver Art Gallery requested that he prepare a statement of intent, which was published in the gallery's *Bulletin*. Stressing that "abstract or non-objective painting" deals with ideas that "can only be expressed or embodied in visual language," he pointed out that it is nonetheless "a natural outgrowth from representational painting," and while thus enlarging "the field of the art of painting," it "does not and cannot replace any of the painting of the past."[96]

The moderate tone of Harris's claims for his new work encouraged a balanced critical reaction. It is evident that he spent time with the local art reviewers, attempting to explain his ideas, and one in particular even tried to suggest the meaning of his new work, work that

> is not art in the customary sense and should not be so regarded....
> Many people today are aware that the so-called natural world of which we are so cognizant is but a more dense and gross manifestation of that which moves at a much higher rate of vibration on higher planes, so it is right and natural that the artists of the race should be the bridge of interpretation between these two realms. The effort to do this is not readily comprehended by the materialistic mind and an understanding of these things must be earned by patient study and the complete abolition of prejudice and preconceived ideas.
> The pictures...convey various ideas of motion, peace, space, quiet, calm, fury, sanctity, haven, growth, etc.[97]

Another critic was not so enthusiastic.

> Is it worth it? This is art in its most limited form, dealing only with raw materials — shape form and color. It lacks the power of emotional purpose on the part of the artist. Mr. Harris is an exquisite colorist, a fine painter, but he expresses nothing more than a certain artistic good taste.[98]

Whether at Harris's insistence or not, the show was also noticed in Canada's first national art magazine, *Maritime Art*, which in June reprinted the statement that had appeared in the April issue of the Gallery *Bulletin*.[99] Early the following year there was in the same magazine a review with a full-page reproduction of one of the paintings. Pointing

out that "since the pictures have neither titles nor numbers, reference to them must of necessity be more general than specific," this reviewer nonetheless is able to give us a sense of the range of the work shown (which encompassed both Santa Fe and Hanover productions), while isolating some of Harris's specific accomplishments. The most important of these is the way in which

in placing his emphasis primarily on basic form, the artist has achieved the... effect of convincing the spectator that within the chosen color scheme there is a methodical train of thought and that underlying the basic forms themselves there is an idea that is logically consistent with their use as 'pure' symbols — symbols that are practically universal in their formal associations and are a fundamental part of our common heritage.[100]

As well he points out that

the field of these pictures is immense, and if they can be said to possess limits at all, those limits are there only by virtue of such restrictions as we might arbitrarily choose to impose....

But above and beyond all this there is another and far more tenuous quality in evidence. In ignoring that which is purely ephemeral, Mr. Harris has imparted to his work something of that singular quality of 'timelessness' of which we are always conscious when looking at a Greek bronze or an Etruscan vase. Whence this derives is not easy to determine, but in all probability 'perfect equilibrium' is its nearest identifiable origin. No other factor in painting can give us quite the same sense of connection between man, things, and the eternal as does this element of perfect proportion; it is the 'ne plus ultra' of abstract art.[101]

This sensitive, knowledgeable reading of his work must have pleased Harris immensely.

The painting that was reproduced to accompany the review is *Composition No. 1* (No. 34), a canvas that has long held the reputation of being the first painting he made in Vancouver. If it indeed was completed in time to have been included in the May showing, then it was painted in the new studio shack behind the rented house on Belmont the spring of 1941. Almost square in format, it was his largest abstraction to that date, reflecting, no doubt, the ambition he held out for his new beginning in Canada. Rather than heralding new directions, however, it represents, with its cool, austerely geometric, hieratic form emerging from a complex, generative foreground, and with its transparent planes and tight, coloured circles, the culmination of those concerns we have identified with his late Santa Fe paintings. (The sketch, on masonite, was almost certainly painted in Sante Fe.)

Immediately following his exhibition, in June 1941, Harris was elected to the Council of the Vancouver Art Gallery, a position that brought him into contact with virtually everyone in the city with any interest in art. Among them all, there was at least one, or that is a couple, who shared his interests in both the spiritual life and abstract art. This was the Scottish-born painter and teacher, Jock Macdonald, and his wife Barbara.[102] A resident of Vancouver for fifteen years and member of the Gallery Council for nine, Jock Macdonald, who supported himself by teaching at the Vancouver Technical High School, had been experimenting seriously with abstractions since the summer of 1935. His first one-man exhibition at the Vancouver Art Gallery, which opened on May 6, 1941 (it overlapped Harris's), included a number of these, which he called "modalities."[103]

Macdonald's modalities — most of which

date from 1937 through 1939 — are semi-abstract, often hieratically composed images that he himself described a year or two later as

idioms of nature — not completely geometrical, but containing a nature form in extension. It means the same as saying the 4th dimension is an extension of the third dimension; it contains an essence of the 3rd, but has a different space and a different time, and through its added value of motion, it is an entirely new dimension.[104]

As Joyce Zemans has pointed out, Macdonald in the above letter reveals a familiarity

92. Harris to Jonson, Santa Fe, November 28, 1940, Jonson papers.

93. A.Y. Jackson, Toronto, to H.O. McCurry, Ottawa, December 6, 1940, NGC files.

94. Harris to Jonson, Santa Fe, March 6, 1941, Jonson papers.

95. Bess Harris to Doris Speirs, March 16, 1941, Speirs papers.

96. 8 (April 1941), n.p.

97. Mildred Valley Thornton, "Display of Abstract Art by Lawren Harris at Gallery," *Vancouver Sun*, May 1, 1941.

98. Browni Wingate, "Speaking of Pictures," *Vancouver News Herald*, May 3, 1941.

99. *Maritime Art* 1 (June 1941), p. 24.

100. Sydney Smith, "The Recent Abstract Work of Lawren Harris," *Maritime Art* 2 (February–March 1942), pp. 79-80.

101. *Ibid.*, p. 80.

102. See Joyce Zemans, *Jock Macdonald: The Inner Landscape/A Retrospective Exhibition* (Toronto: Art Gallery of Ontario, 1981).

103. *Ibid.*, p. 98.

104. Macdonald to H.O. McCurry, Ottawa, May 10, 1943, NGC files.

COLOUR PLATE NO. 5 (No. 61) ***Abstraction (Ritual Dance in Spring)*** **c. 1955**
Oil on canvas, 131.5 x 124.8 cm
LSH Holdings Ltd.

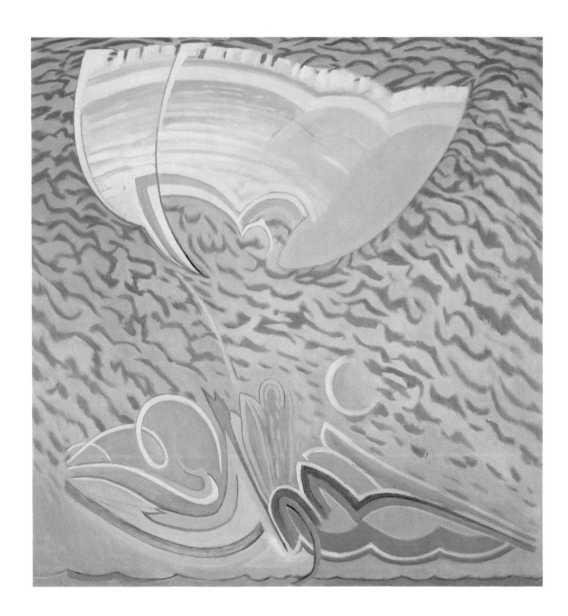

with the theories of Ouspensky,[105] yet another point in common with Lawren Harris.

Harris and Macdonald were soon fast friends, and the two couples spent a number of weeks together at Lake O'Hara Lodge near Hector, British Columbia, that summer of 1941.[106] It was Harris's first sketching trip in the Rockies since his annual visits in the late twenties, and he was thrilled to discover that Macdonald loved them as much as he. In fact, alongside his work with the modalities he had continued to paint landscapes. Of course, Harris himself found that this experience of the mountains revived the whole issue of representational painting versus abstraction. But as he explained to Raymond Jonson in a long letter at the end of the summer, his commitment still lay entirely with the resolution he had achieved in Santa Fe.

> We were six weeks in the mountains and had a grand time. We did very little work but a great deal of climbing and even more clambering around, imbibing the elevation of the spirit the mountains afford in the hope that it will convert itself into plastic ideas for painting.... There is an austere starkness about them that braces me no end. But there is an almost complete divorce between the naturalistic — representation — and non-objective painting. The one won't go into t'other, yet on seeing marvelous mountains and having exciting experiences among and on them I am convinced that there are equivalents in non-objective painting which are more expressive, moving and elevating than any possible representations of them in paint....[107]

Nonetheless, as we can see in a drawing he did at Lake O'Hara Lodge (see No. 35), his old concern with the integration of representa-tional elements with abstract forms was again on his mind.

Another mountaineering friend, Ira Schwartz, who is not a painter, recalled joining Harris that first summer at Mt. Robson Lodge, north of Lake O'Hara, from whence they hiked in to Mt. Ann-Alice.[108] It is unclear whether Harris often took such trips of shorter duration just for the climbing, but certainly he and Bess returned to the mountains for a few weeks of hiking and sketching during July and August every year until at least the end of the decade.

Almost immediately following their trip to Lake O'Hara that first summer, Macdonald held an exhibition of some of the landscapes he had completed in the mountains. His second one-man show at the Vancouver Art Gallery, it opened September 8. Both he and Harris demonstrated their continuing commit-ment to abstraction a couple of months later, however, when both contributed work to an exhibition of abstract painting Harris organ-ized for the Gallery.[109] Intending to incite new activity as well as encourage those already working in the mode, he showed paintings by Bisttram, Jonson, and Stuart Walker from New Mexico, with the work of three Canadians, in addition to Macdonald's and his own. These three were the youthful Arthur Erickson of Vancouver, a student at the University of British Columbia who would turn to architec-ture following the war; Jessie Faunt, also of Vancouver, an art teacher at Point Grey High School; and Gordon Webber, a Toronto student of Arthur Lismer's who had just settled in Montreal in order to work with Lismer at the Art Association, following studies with Moholy-Nagy and Gyorgy Kepes in Chicago. Somewhat of an eclectic show, it served the purpose of keeping the issue of abstract art before the public.

The Harrises found much to please them in Vancouver, and in his involvement with the Gallery Lawren had that which always pleased him the most: a cause. Deciding to stay, then, very late in 1941 or early in 1942 (before February) he purchased a large clapboard house at 4760 Belmont, high on a hill across the road from 4749. (Moving from Victoria, his mother then rented 4749. She would die later in the year.) By the summer, this impressive, soaring white home had become the focus of a small group of friends who met regularly for musical evenings (see Fig. 8). Harris owned a good 'high fidelity' phonograph record player and a large collection of records, and before long these social evenings had developed into a regular salon with planned programmes for listening. Such rigorous seriousness was not everybody's idea of a good time, but by the middle years of the war the Harris circle as defined by these evenings had grown to include, among others, the Macdonalds, Bertram Binning, who was an instructor at the Vancouver School of Art, Ira Dilworth, regional director of the CBC in Vancouver, and John Korner, a Czechoslovakian-born and Prague-trained painter with whom Harris became friends when both served on the Gallery's Exhibition Committee. (Harris was Chairman from June 1942 until December 1956.) Among the younger artists there were at first Arthur Erickson, and Joe Plaskett, a recent graduate of the University of British Columbia then teaching at North Shore College while attending evening classes at the Vancouver

105. *Op.cit.*, p. 82.

106. *Ibid.*, p. 101.

107. Harris to Jonson, August 31, 1941, Jonson papers.

108. Transcript of a taped interview, *CBC Spectrum: Lawren Harris*, sound roll 13, pp. 15-16.

109. See Vancouver Art Gallery *Bulletin* 9 (November 1941).

School of Art. At the end of the war Gordon Smith, a painter who had studied with L.L. FitzGerald in Winnipeg, was introduced into the circle.

The big house at 4760 Belmont soon became a magnet for visiting celebrities as well, and some of the musical evening habitués were often invited to dine with well-known painters, writers, or musicians from the East or abroad. The rather formal musical evenings ended abruptly shortly following the war when someone — someone who had been a guest, it was widely believed — broke into the house and stole all the records. The Harrises continued to entertain, but their social circle tightened slightly. It presented a unique social context in Vancouver, and a useful forum for Harris's thoughts and opinions. The young painter Jack Shadbolt, an instructor at the Vancouver School of Art with Binning but not a member of the Harris circle, has described it as in part responsible for introducing to Vancouver "the notion of an arts 'establishment.'"[110]

Secure in the belief that he was advancing free expression within Vancouver's artistic community, and thereby establishing the necessary climate for the acceptance of abstraction, Harris understood that to be truly effective the cause had to assume national dimensions, as had been the case with the Group of Seven and the CGP in Toronto during the twenties and early thirties. In May 1942 he joined a small delegation of British Columbian artists who attended in Toronto the First Annual Meeting of the Federation of Canadian Artists, a national group that had been established as a result of a Conference of Canadian Artists held in Kingston, Ontario, in June 1941. Harris was elected Regional Convenor for British Columbia, and shortly following his return home organized a general meeting at the Vancouver Art Gallery in order to explain the aims of the FCA.

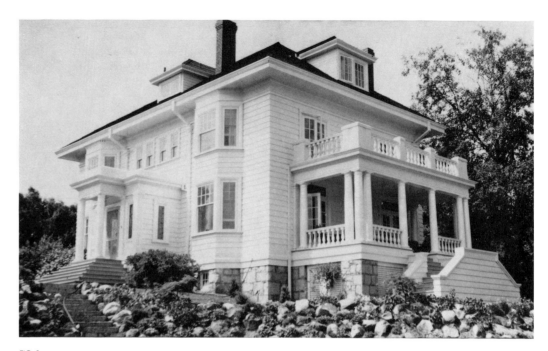

FIG. 8
4760 Belmont Avenue, Vancouver, c. 1943.

In a prepared statement, subsequently published in the Gallery *Bulletin*, that echoes Group of Seven pronouncements of twenty years earlier, Harris raised a general call for the recognition of the necessity of a national cultural consciousness. "Lacking creative activity in the arts," he proclaimed, "a people will be lost in mere material striving. For the arts constitute a go-between, an interplay and inter-communication between the world of our everyday concerns and the world of the imagination, of the mind and spirit in man."[111] On the brink of a "new era," it was clear "that now, during the war, is the time to organize and plan in terms of the country as a whole and its needs...." That way the FCA "will be a strong, going concern and a living factor in the new and growing cultural life which, according to our vision, we envisage and project for Canada when the war ends."[112]

Although an idealist, and concerned above all else with spiritual development, Harris was at the same time a practical man, determined to get things done. He had built the Studio Building in Toronto before the First World War as a home for the small group of nationalist painters that was gathering about him then (the First Annual Meeting of the FCA was held there almost thirty years later), but now he felt that there was a greater need for public galleries and other more broadly based centres, and this soon became the focus of a concerted campaign. Beginning in October 1942 he published a series of articles

in the Vancouver Art Gallery *Bulletin* under the general title, "The Function of an Art Gallery." That first article in October addresses definitions — distinguishing between an "Art Gallery" and a "Museum," for instance — and presents expectations. "An Art Gallery should be a dynamic institution," he claims. "It should serve its community as a center of creative activity in the arts."[113]

Subsequent articles — the last appeared in April 1943 — analyse the situation in England and Europe, "Art Galleries in New York City," galleries elsewhere in the United States, "Canada's Art Galleries — The National Gallery," (which, he argues in concert with Charles Scott, Principal of the Vancouver School of Art, should decentralize and "become more a people's gallery all across Canada")[114] and other "Art Galleries in Canada." The suggestions regarding the National Gallery he drew directly to the attention of his Ottawa friend, Harry Southam, then still Chairman of the Board of Trustees of the Gallery: "It is possible that had I remained in Toronto, that is in a thriving and more or less self-contained art center, I would have remained ignorant of the needs of the country as a whole. But our years of travel...has convinced me that a new policy for the National Gallery is essential...."[115]

As he had in the service of Theosophy in Toronto in the early thirties, Harris now turned to radio to further his call for a renewed look at national artistic needs in Canada. In a series of six talks on the general theme of "Art and Life," beginning March 31, 1943, at 7:45 P.M. over the CBC radio network, he explored such topics as "Science and Art," "Art and Democracy," and "Canada and the Arts." Then in an article for *Maritime Art*, "The Federation, the National Gallery, and a New Society," he outlined how the FCA represented an attempt to address the concerns of artists in a democratic way across the whole country, and

how the National Gallery too had to expand its services to reach all Canadians equally if it was to prepare for the "new world society" that would inevitably follow the successful conclusion of the war. In this spirit, he announced, "the B.C. region has set up a special committee which is considering in some detail the relations of the National Gallery to the country as a whole, to different regions, communities and centres."[116] By October, this committee had concluded that what was required was a "modest" building in Ottawa, and "ten or more branches of the National Gallery in strategic centres across the country...."[117]

The Director of the National Gallery, H.O. McCurry, could only react by welcoming the interest, and encouraging consultation, requesting particularly "an outline of your scheme for comment...."[118] Harris sent along "A Plan for the Extension of the National Gallery of Canada" in mid-December, and in his covering letter expanded on an idea in it to have public galleries in Canada rent the work of artists they wished to display.[119] By this time it must have been clear to all that Lawren Harris was, once again, the most energetic and imaginative spokesman in Canada for art and the interests of artists, and at the second general meeting of the FCA, held again in Toronto in March 1944, he was elected National President. His reimmersion in Canadian art politics had just begun.

Harris's involvement with the FCA during the mid-forties was in many ways similar to his role within the Group of Seven in Toronto in the twenties, and within the TPG in Santa Fe in the late thirties. It was fundamentally different, however, in that the presidency of the FCA was an elected position, and his constituency consisted of artists of various persuasions, none of whom necessarily shared his particular approach to painting. Harris's involvement with the Group of Seven — certainly during the years before their first exhibition together

as a group in 1920 — was intensely interactive. We have similarly seen that the work of some of his associates in the TPG was stimulating to him, and contributed directly to the rapid evolution of his art. He did not enjoy such intense relationships in Vancouver. His concerns as President of the FCA were with the general conditions for cultural activity in Canada.

That is not to say that there were no creative relationships with other painters. But these were predicated upon somewhat different bases than were most of those he had known before. His friendship with Jock Macdonald was closest to the earlier models in that it arose from a number of shared creative concerns, and particularly a mutual interest in abstraction as a means of investigating spirituality. Both, too, were still drawn to landscape, and as we will see, this attraction caused Harris to reconsider the calculated

110. Jack Shadbolt, "A Personal Recollection," *Vancouver: Art and Artists 1931–1983* (Vancouver: The Vancouver Art Gallery, 1983), p. 41.

111. "The Federation of Canadian Artists," Vancouver Art Gallery *Bulletin* 9 (June 1942), n.p.

112. *Ibid.*

113. "The Function of an Art Gallery," Vancouver Art Gallery *Bulletin* 10 (October 1942), n.p.

114. Vancouver Art Gallery *Bulletin* 10 (February 1943), n.p.

115. Harris to Southam, February 23, 1943, copy in NGC files.

116. 3 (April–May 1943), p. 127.

117. Harris to H.O. McCurry, Director, National Gallery of Canada, October 3, 1943, NGC files.

118. McCurry to Harris, October 8, 1943, copy in NGC files.

119. Harris to McCurry, December 14, 1943, NGC files.

Painting XIII (Abstraction) **1957-58**
Oil on canvas, 120.0 x 94.2 cm
LSH Holdings Ltd.

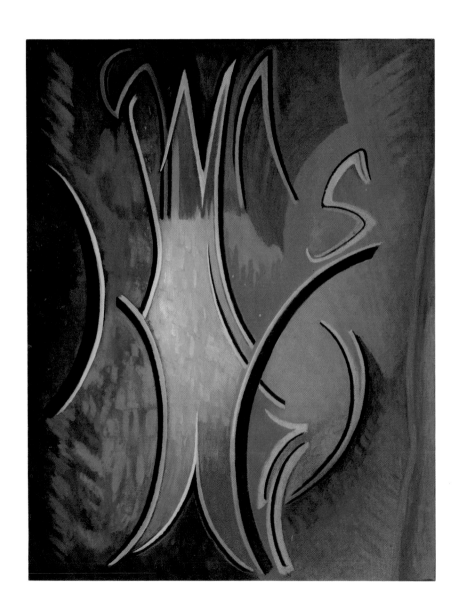

COLOUR PLATE NO. 7 (No. 77)

Abstraction **1961**
Oil on canvas, 164.0 x 93.5 cm
LSH Holdings Ltd.

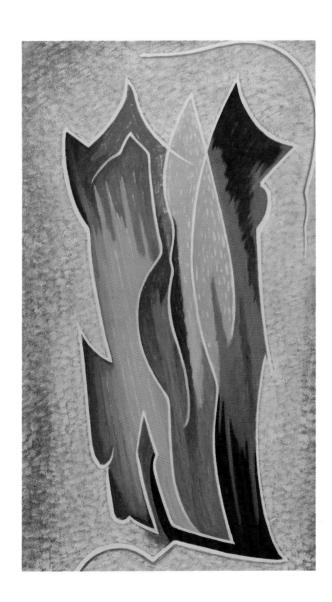

geometrics he had embraced in Santa Fe.

Although Macdonald had been actively pursuing abstraction for about the same period of time as Harris, that is from roughly 1935, he seemed to be *experimenting* in the early forties, with Harris's self-assured work representing a still-distant goal. Be that as it may, Macdonald's experiments following the visit to Vancouver of a British psychiatrist and surrealist painter, Grace Pailthorpe, who was given an exhibition at the Vancouver Art Gallery in April 1944, turned almost entirely to working within an 'automatic' mode of composition derived from the French surrealists. As Joyce Zemans has noted, by 1945 "he was almost totally absorbed in his automatics," as he called them.[120] There is no evidence that Harris was ever interested in similarly composing on the basis of free association, although some works of the period, as we will see, suggest strongly that he was, as in Hanover in the mid-thirties, thinking about surrealism. Once Macdonald was ready to exhibit his automatics, he was given a one-man show at the Vancouver Art Gallery devoted entirely to them. That was in September 1946, just before he and his wife left Vancouver so that he could take a teaching position at the Provincial Institute of Technology in Calgary. The following year he moved to Toronto, where a little over a decade later he would die.

Emily Carr also at one time shared Harris's interest in esoteric spiritualism, although she had long ago rejected his Theosophy, preferring instead the sense of a personal relationship to Godhead that she enjoyed in her more traditional Christianity. Although she and Harris had actually met on only three occasions before his moving to Vancouver, they had sustained a close friendship by letter prior to 1934, and had kept in touch for about three years beyond that. When the Harrises first visited Victoria in the fall of 1940, they called on Carr, who had that June suffered a stroke. (She had had a heart attack in January 1937.)

Carr did not get along with Bess, but the Harrises were able to overlook this, and Lawren kept in fairly close contact with the ailing painter who, during long bouts of convalescence, had turned to writing. Her first book, *Klee Wyck*, appeared in 1941, and won a Governor-General's Award. That same year, Harris and Ira Dilworth, who was Carr's literary confidante, helped her select forty-five of her best paintings to be held in trust for a bequest to the people of British Columbia. (Harris also wrote a short article on her work for the Toronto-based *Canadian Forum* later in the year.)[121] When she drew up her will in November 1942, Carr appointed Dilworth, Harris, and a Victoria friend, William Newcombe, with her lawyer, trustees of a formal Emily Carr Trust that would administer her paintings following her death. All proceeds from sales were to be used for scholarships or otherwise in the encouragement of art in British Columbia. It has been suggested that this was Harris's idea.[122] Carr suffered another stroke in 1944, and died in March 1945. Harris had become increasingly involved in her affairs, along with Ira Dilworth, but as we shall see later, their work only really began with her death.

One other friendship of these first years in Vancouver should be explored briefly. Again, this was not intensely interactive on a creative level, and again, it represented the re-establishment of a relationship that dated back to the Toronto years. Harris had not hitherto been as close to LeMoine FitzGerald as he had been to Carr, however. Although the Winnipeg artist was a friend of Bertram Brooker's, and had visited Toronto at least once during Harris's residence there, they had not met. Harris had purchased one of FitzGerald's drawings from an Arts & Letters Club show in 1928, though, and the two had subsequently corresponded. FitzGerald even became an 'official' member of the Group of Seven, but only in 1932, following the Group's last exhibition.

A decade later, Harris in Vancouver heard from a mutual friend that FitzGerald was planning to visit his daughter in the city that summer, and would be staying at her cottage on Bowen Island, close by in the mouth of Howe Sound. He wrote to FitzGerald, inviting him to stop for a visit, and at the end of the summer FitzGerald did call for dinner.[123] It was the first time they had actually met.[124] The Harrises were very impressed with the large, near-abstract drawings of landscape details he had completed that summer. They arranged to buy two, and later in the year Harris suggested a show of these drawings, which was held in the Vancouver Art Gallery the following February.[125]

FitzGerald returned to Bowen Island for sketching in the summer of 1943, and again in 1944, and visited with Harris both times. Harris had become very fond of him, and admired the work that had developed entirely from one spot on Bowen Island over the period of the three visits. The following year he wrote a short piece for *Canadian Art* magazine in which he praised these drawings and watercolours — one of which he illustrated — for their combination of "exceptional delicacy and precision."[126]

For his part, FitzGerald too had come to admire Harris deeply, and had grown sympathetic to his new work, as is evidenced in portions of a "REPORT on a little journey around the art world of Vancouver..." that he prepared for the Winnipeg Art Gallery following his return in 1944.

Among the artists there is a definite trend toward a modern outlook reaching a peak in the abstractions of Lawren Harris....

At the end of each summer's painting,

for the past three seasons, I have spent a few unusual hours with he and Mrs. Harris. A perfect ending to the long thoughtful hours of solving problems in paint in pleasant isolation.

To see a number of Harris paintings together and to talk about them with him, is to appreciate more fully what he is working for and to better understand them. They are serious productions from a serious mind. They are also the natural outcome of all his previous painting. His fine sense of design, beautiful restrained color and exquisite craftsmanship, contained in the older pictures, comes to greater fruition in these more recent abstractions.[127]

What can we reconstruct of Harris's "recent abstractions," the work of those first few years in Vancouver? There is *Composition No. 1* (No. 34), of course, that grand summation of the geometric configurations that had absorbed his interest during the latter part of his stay in Santa Fe. Otherwise, there is not at first much to go on. He participated in no society shows during 1941, other than a Royal-Canadian-Academy-organized benefit for the Canadian Red Cross Society at Eaton's in Toronto in February, to which he contributed three Group of Seven landscapes.

In February 1942, however, he showed two pictures with the CGP at the Art Gallery of Toronto, both entitled *Painting*, and in May another *Painting* with the British Columbia Society of Fine Arts at the Vancouver Art Gallery. We know nothing of these three abstractions. In March 1943 he showed a small group of unidentified abstractions in Saskatoon, which were moved to Regina in April. In May he displayed one abstraction (*Painting*, again) along with what was likely an earlier landscape, *Hills North of Lake Superior*, with the BCSFA. During July and August he

showed this same landscape again, by itself, in the annual B.C. Artists' Summer Show at the Gallery. Then in September–October he was represented by a work entitled *1943* in the Gallery's twelfth Annual B.C. Artists' Exhibition. Exhibited with the CGP in Toronto the following April as *War Painting*, it is known today simply as *Abstract* (No. 42). Entirely geometric, it is reminiscent of Santa Fe as well in its use of intersecting transparent planes. On the other hand it diverges from the later Santa Fe work in its darkly dramatic mood (suitable to its subject), and in its deep space and full modelling. Some of its forms remind us of the vocabulary Harris employed in his Hanover paintings, and if viewed on its side it is particularly evocative of the *Riven Earth* pictures of 1936. Recalling Harris's remarks to Raymond Jonson following his return to the Rocky Mountains the summer of 1941, however, we also can see in this *War Painting* of 1943 some evidence of his renewed interest in landscape, even if it is, as was often the case in Hanover, landscape that echoes the dream-space of the surrealists.

Another painting reveals that Harris was no longer entirely content with the clean, elegant geometry of his work of the late thirties. *Painting No. 2*, a Santa Fe picture that he exhibited widely, you will recall, he later virtually completely painted over, probably soon after settling in Vancouver (see No. 36). Traces of the graceful curves of dynamic symmetry still show beneath the overpainting. The characteristic bubble form of one series of late Santa Fe pictures remains, but it, like the now virtually uniform ground, serves only to highlight a strange floating form that resembles a stylized shellfish, or an exotic seed pod. An organic form, it is related to two unfinished sketches that are painted on the sort of soft fibreboard he had used in Toronto. One of these depicts a free-floating rock of indeterminate scale, the other a suspended

clam shell.[128] The actual study for the floating organic shape in *Painting No. 2* is on masonite, however, which he used primarily in Hanover and Santa Fe, and during the earliest years in Vancouver.

Harris was experimenting on a number of fronts. A radiant landscape, *Mt. Ann-Alice*, dates from the early forties, evidence that his musings concerning the efficacy of representation carried over into the studio (see No. 37). Its peak, a great slab of ice and rock the shape of a thrusting tongue, glows with spiritual potency. Its overall high-keyed tone and clearly delineated forms are similar to Jock Macdonald's landscapes of the same years.

Further evidence of Harris's rethinking of the thorough geometrics of his Santa Fe style

120. *Op.cit.*, p. 118.

121. "Emily Carr and Her Work," *The Canadian Forum* 21 (December 1941), pp. 277-78.

122. Edythe Hembroff-Schleicher, *Emily Carr: The Untold Story* (Saanichton, B.C., and Seattle: Hancock House Publishers, 1978), p. 39. See also pp. 145-67, "The Errant Emily Carr Trust."

123. Harris to FitzGerald, July 12, 1942, and 'Wednesday,' 1942, FitzGerald Study Centre, University of Manitoba, Winnipeg.

124. Helen Coy, *FitzGerald as Printmaker* (Winnipeg: The University of Manitoba Press, 1982), p. 110.

125. See Harris to FitzGerald, December 21, 1942, FitzGerald Study Centre, University of Manitoba, Winnipeg.

126. Lawren Harris, "FitzGerald's Recent Work," *Canadian Art* 3 (November 1945), p. 13.

127. Copy in the FitzGerald Study Centre, University of Manitoba, Winnipeg. The report is dated October 31, 1944.

128. The rock is Harris Family Collection, the clam shell is LSH Holdings Ltd., LSH 52.

can be seen in other works of the first half of the forties. In *From the Harbour to the Open Sea* (No. 38), he has retained the geometry, but has softened the edges of the forms while heightening the dramatic contrast of light and dark (much as in *War Painting*). Most notably, however, he has applied the paint in a loose, painterly way, modelling the forms through a tonal range that describes volume, again not unlike the volumetric modelling that is so important to the drama of *War Painting*. It should be noted as well that *From the Harbour to the Open Sea* is painted on the back of a cancelled Santa Fe picture, and that it was very likely reworked about 1950. But more of that later.

One other group of paintings confirms Harris's renewed interest in a landscape space charged with the moody ambiguities of surrealist dream imagery. *Untitled*, the masonite sketch and its canvas catalogued here, read immediately as landscape, with their earth-coloured, rock-shaped forms dominating the foreground, and ethereal blue 'sky' filling the upper portions (see Nos. 39 and 40). Shapes to the left are more geometric than organic, but those to the right evoke trees in a forest. Dominating the picture is a large, red-cored, infolding form in the centre, encased in dark outlines that extend above to enclose a cool green and grey shape that resembles characteristic forms of northwest coast Indian art. The 'eye' of this upper form is red in the canvas. A rope-like twist extends across the whole picture at this level, and above it hovers a disc-shaped form that is black below and radiant with reflected light above. Able to be read on one level as an individual expression of Theosophical aspirations for release from human passion and other earthly bonds, it seems as well to evoke the particular landscape of the northwest coast, thickly lush, harbouring gargantuan, almost monstrous forms, forms that echo

stylistic conventions of the native culture. Harris doubtless shared with Emily Carr the belief that native northwest coast cultures entail an understanding of the particular spiritual nature of their environment.

Another pair of pictures — masonite sketch and finished canvas — presents this same basic composition, but in a more stylized, abstracting way, much less evocative of particular landscape or ethnic imagery.[129] The composition — which is virtually identical in sketch and canvas — represents a visual bridge, however, from the pair we have just been examining to the large canvas that Harris gave to the National Gallery of Canada in 1960, *Abstract Painting No. 20* (No. 41). Although still largely organic in form, this major canvas of the forties has moved entirely away from landscape reference, a fact that is accentuated by its vertical thrust (in spite of the fact that the canvas is a perfect square).

In *Abstract Painting No. 20* the upper and lower components of the central form are equal in size and shape, one the virtual echo of the other in everything but colour. They are bound together by a light, transparent vertical band that loops elegantly around itself to one side, exactly like the central totemic shape around which *Involvement 2* of c. 1939 so elegantly revolves (No. 32). Underlying these new organic shapes then is a structural system that, while largely eschewing the geometric style, still affirms that sense of order, continuity, and interdependence, the essential oneness that was at the centre of Harris's Theosophical principles.

In spite of the deeply involving nature of these new turns in his painting, Harris threw himself into his role as National President of the Federation of Canadian Artists following his election in March 1944. A charismatic figure, he had always been a popular leader, and his return to the national stage was greeted with enthusiasm. The April-May issue

of the *Canadian Review of Music and Art*, with a bust of Harris by the Toronto sculptor Florence Wyle illustrated on its cover, and featuring a profile by Dr. John D. Robins, who said of Harris, "No man I know has a keener sense of civic responsibility," was virtually a celebration of the new presidency.[130]

Harris, in turn, took his new position with the utmost seriousness. The National Vice-President of the FCA, the painter Fred Taylor, lived in Montreal, and both the National Executive Secretary, Rik Kettle, and the Treasurer, K.D. Scott, lived in Toronto. In addition, among the principal goals of the FCA as the tide of war began to turn in favour of the Allies was the involvement of artists in all aspects of a national postwar "Reconstruction Programme," the establishment of community centres across Canada to be serviced by a newly decentralized National Gallery, National Film Board, and the CBC, and the creation of a forum for regular discussion among the various existing national cultural organizations. Harris immediately caught a train for the East, and in a whirlwind of May meetings in Toronto, Ottawa, and Montreal, promoted the steady advancement of discussion among FCA members, other cultural organizations, and the various appropriate agencies and departments of the federal government.

Duncan Campbell Scott enjoyed a brief visit with Harris in Ottawa in the middle of it all, which he described in a letter to a friend:

Lawren Harris was here yesterday, just for a day, came in about half after four, had a cup of tea, smoked two cigarettes, cleaned

129. LSH 12 (the sketch) and LSH 90 (the canvas) are both with LSH Holdings Ltd., Vancouver.

130. "Lawren Harris, National President Federation of Canadian Artists," *Canadian Review of Music and Art* 3 (April-May 1944), p. 18.

Untitled **c. 1968**
Oil on canvas, 111.0 x 163.0 cm
LSH Holdings Ltd.

his picture which needed it badly, had an animated talk, went into my bedroom at half after five, slept soundly for three-quarters of an hour and then was off to dinner to a meeting and the night train for Toronto. Here is a man I admire hugely.[131]

Just before this visit, Harris wrote from the Park Plaza in Toronto to Taylor in Montreal: "This has been the fastest pace Bess or I have been subjected to. We are holding up but another week of this might finish us."[132]

The Harrises indeed were on a train west within the week, but the pace hardly slackened. There were meetings to establish a Western Art Circuit for touring exhibitions, concern over developments with the new *Canadian Art* magazine, which was run in part by the FCA, but was largely under the control of the National Gallery, and Harris continued to write in support of these various projects. Early in the summer he published a piece on "The Federation of Canadian Artists" in the *Canadian Review of Music and Art*, in which he outlines the general principles and main goals of the FCA,[133] and another piece in *Canadian Art*, "Reconstruction Through the Arts," in which he argues that the arts are the most effective vehicle for creating Canadian unity.[134]

Following a two-week break in the mountains in early August, it was back into the fast stream. Personalities had to be contended with. Taylor, swamped with responsibilities as Vice-President, wanted to give up the chairmanship of the Montreal region, which he also held. He was finding it difficult to gain cooperation from the other artists, and Lismer in particular was being obstreperous. Harris passed on the opinion of A.Y. Jackson, who was then visiting, "That given Arthur's present make-up that he will darn near ruin

whatever he gets into — he evidently antagonizes everyone."[135] Then a month later, more thoughtfully, he suggested that Lismer was concerned that the FCA was seeking financial support from the Carnegie Corporation, his principal source of funding at the Art Association of Montreal. Lismer was proud of his "great personal achievements in progressive community work, child and adult art education," and feared "a loss of power, prestige and acclaim if the FCA gets the community centres plan across."[136]

In November Harris undertook a speaking tour of Calgary, Saskatoon, Regina, and Winnipeg, addressing interested audiences on the subject of "Art and Democracy," and generally promoting the idea of community art centres and the interests of the FCA. In a letter from Regina to a friend in Santa Fe he explained in some detail the proposed structure of the centres and how important he believed them to be.[137] Following the trip, he informed Taylor:

All places are now organized to back the community centres for the arts plan. Whether the Govt. implements the brief or not these cities will go ahead on their own and that is of vital importance.[138]

In December he contributed to yet another article on the subject.[139] The federal government ultimately decided not to support the project financially, but as Harris had predicted a number of communities in the Prairies were able to establish centres on their own.

In April 1945, he was in the East again for meetings in Toronto and Ottawa. These were primarily for FCA business, but were also to arrange a retrospective exhibition and memorial volume on Emily Carr, who had died early in March. As an executor of her estate he had spent much of the balance of that month preparing inventories, and also in soliciting

the advice of A.Y. Jackson and others regarding the nature of the retrospective. He had also written to McCurry suggesting the use of the Studio Building in Toronto for returning war artists.[140] He was a remarkable catalyst, and once he was in Toronto, Pearl McCarthy reported to her readers

that stirring of interest which invariably marks a visit by Lawren Harris. His strong broad mind always seems to inspire strong, broad thinking in the circles where he moves. . . . At present he is painting very little, giving almost all his energy to the Federation of Canadian Artists because, he says, he believes that art has peculiar power to unify the people of a democracy.[141]

Following his return west, in a series of letters to Harry McCurry he was able to iron out many of the problems relating to *Canadian Art* before disappearing into the mountains with Bess in August.

The war was by then officially over, which made the implementation of the art centres seem all the more urgent. He was personally involved in establishing a new civic centre in Vancouver, was promoting the addition of a Carr memorial gallery to the existing Vancouver Art Gallery, and, as he wrote to Taylor near the end of September, was deeply involved in the affairs surrounding the Emily Carr Trust and memorial collection.[142]

The Emily Carr retrospective finally opened at the Art Gallery of Toronto October 19, 1945, and was shown subsequently at the National Gallery in December, at the Art Association of Montreal January–February 1946, and at what Harris anticipated to be "a great memorial event" at the Vancouver Art Gallery in May. It was accompanied by a fine, substantial catalogue published by Oxford University Press. Harris contributed an essay,

"The Paintings and Drawings of Emily Carr." He encouraged McCurry at the National Gallery to place the show in the Museum of Modern Art in New York or the Tate Gallery in London, but with no success.

In recognition of his many services in the interests of Canadian art, Harris was awarded an honorary degree by the University of British Columbia, May 16, 1946. The next day he and Bess were off again to Toronto and Ottawa for a month of meetings. His two-year term as President was up, but he was asked to stay on, and agreed to do so for another six months. It was almost a year before he was finally able to step down, during the annual meetings in Toronto early in April 1947. He and Bess then went on to New York City for a few days, their first visit in more than eight years. They returned to New York the following spring, and other signs suggest that he was again thinking a great deal about his own painting. There were by then plans, in fact, for a retrospective exhibition at the Art Gallery of Toronto. It opened October 16, 1948, the first ever accorded a living Canadian artist.

What of Harris's art during this period of dedication to the general weal of artists? There are constant references in letters and elsewhere to his "doing no painting" between 1944 and 1948, yet he made a determined effort to keep his work in the public eye. During those four years he contributed to all but one of the exhibitions of the British Columbia Society of Fine Arts, most of the Vancouver Art Gallery's B.C. Annuals, all the exhibitions of the CGP, and even once, in 1947, to the annual spring show of the Art Association of Montreal.

Because of his reluctance to title his paintings, it is difficult to determine exactly what he did exhibit. As mentioned earlier, *War Painting* of 1943 (No. 42) was exhibited with the CGP in Toronto April–May 1944. With it were two others, *Mountain Form*, dated 1943, and

Rhythmic Organization. Rhythmic Organization was then shown again September–October in the B.C. Annual. The following spring he contributed two Bylot Island canvases to the annual exhibition of the BCSFA, paintings of the early thirties, or perhaps recent reworkings from Arctic sketches. He finally retrieved his Group of Seven sketches from the Studio Building in Toronto about this time. The CGP exhibition, shown in both Toronto and Montreal in 1945, contained three paintings, each entitled *Painting*.

He showed only in Vancouver in 1946, and only abstractions, it would seem. *Composition* was with the BCSFA in June, *Painting* in a special Jubilee exhibition in July, *Mountain Form VI* and *Abstract Painting of a Mountain Experience* in the 15th B.C. Annual, September–October. Curiously, he exhibited only in Montreal in 1947. The spring show included *Subjective Painting, Mountain Experience*, and with the CGP, held at the Art Association of Montreal later in the year, it was *Painting*, and a large landscape of the early forties, *Lake and Mountain*, now destroyed.

During these same years from 1944 to 1948 Harris held three one-man shows. One, at the Winnipeg School of Art in October 1944, was a modest event staged by the principal, his friend FitzGerald; three landscapes and two abstractions displayed with two Group of Seven period sketches owned by the School. More important was the *Exhibition of Abstract Paintings by Lawren Harris* at the Little Centre, Victoria, in November 1946. Of the twenty works exhibited all were titled *Abstract Painting* except for five. These were *Mount Thule, Bylot Island*, a canvas presumably of the early thirties he had exhibited with the BCSFA in the spring of 1945; *From the Arctic to the Temperate Zone*, an early Hanover canvas; *Mountain Form VI*; and *Abstract Painting of a Mountain Experience I* and *II*. But before we pursue this, we should look quickly at another show.

In February 1945 the Vancouver Art Gallery held an exhibition they called simply *Lawren Harris Sketches*. It was a selection of the oil sketches he had left in Toronto in 1934, recently retrieved by he and Bess, likely early in 1944.[143] There survive a small number of

131. Arthur S. Bourinot, editor. *Some Letters of Duncan Campbell Scott, Archibald Lampman & Others* (Ottawa: Published by the Editor, 1959), p. 37.

132. May 10, 1944, Federation of Canadian Artists' papers, Archives of Queen's University, Kingston, Ontario; henceforth 'FCA papers.'

133. 3 (June–July 1944), pp. 16-17, 31.

134. 1 (June–July 1944), pp. 185-86, 224.

135. Harris to Taylor, September 9, 1944, FCA papers.

136. Harris to Taylor, October 8, 1944, FCA papers.

137. Harris, Regina, Saskatchewan, to Charles E. Minton, Santa Fe, November 26, 1944, Jonson papers. His American friend would have been very interested, for as one commentator has pointed out, the goals of the FCA were in large part modelled on the earlier programmes of the Federal Art Project in the United States. See Julia Gorman, "Lawren Harris and Paul-Emile Borduas: Abstract Art, the Audience and Public Art Galleries in Canada, 1920-1950," final paper, Master of Museum Studies Programme, University of Toronto, 1982, pp. 59-61, and chapter III, "Vancouver and the Federation of Canadian Artists; 1940-45."

138. Harris to Taylor, December 7, 1944, FCA papers.

139. "Community Art Centres: A Growing Movement," *Canadian Art* 2 (December–January 1945), pp. 62-63.

140. Harris to McCurry, March 25, 1945, NGC files.

141. Pearl McCarthy, "Canadians Avoid Psychotic Art," *Globe and Mail*, April 14, 1945.

142. September 23, 1945, FCA papers.

143. He offered some for sale to the National Gallery at the time of the exhibition. See Harris to McCurry, February 18, 1945, NGC files.

abstract sketches painted on the same sort of soft, lightly coloured composition board he had used in Toronto. (As mentioned earlier, virtually all his sketches from Hanover and those from Santa Fe are on masonite.) These could have been unused boards brought to Vancouver along with the early sketches, or unfinished or otherwise unsatisfactory sketches that he had scraped off.

One of these abstract sketches of the mid-forties shows no traces of an earlier painting, although its experimental nature is suggested by the fact that it has a cancelled contemporary sketch on the back (see No. 44). A related drawing also suggests the use of dynamic symmetry to work out the composition (see No. 43), a suggestion supported, it would appear, by the elegantly arcing lines and complex interrelated forms of the canvas, *Sun and Earth* (No. 45). It should be pointed out as well that *Sun and Earth*, while employing much of the vocabulary of the late Santa Fe pictures, reveals a direct visual relationship to landscape, and a more painterly quality in the brushwork than we have seen in any painting other than *From the Harbour...* (No. 38).

One other painting reveals even more clearly the relationship of these sketches of the mid-forties to those of the twenties. It is, in fact, an unfinished sketch of the north shore of Lake Superior (see No. 46). The sky is complete (and apparently all original). The foreground of rock and water is just blocked in. The more recent additions appear to be a large pale blue shape in the centre that could be an underpainting for the lake, and two fragmented planes at the left side, one brilliant red, the other a sliver of yellow. Here too there is a related drawing that shows us that Harris was not simply messing around with these old boards, but was thoughtfully considering yet again the relationship, indeed the possible fusion, of nature and the abstract

FIG. 9
November 1945.

(see No. 47). Probing, experimental, scrappy, these sketches are exactly what we might expect of him during his unsettled years as the President of the FCA.

Back, now, to those paintings he actually exhibited during the period 1944 to 1948. There are four titled works that could have been contemporary. These are *Mountain Form* of 1943, *Rhythmic Organization*, exhibited first early in 1944, *Mountain Form VI*, and *Abstract Painting of a Mountain Experience I*, and *II*, all three exhibited in 1946. Certainly, the experience of mountains dominates. It

would be difficult to overestimate the impact his return to the Rockies had on Harris's thinking during the forties. The escape into the mountains every summer seems to have been crucial for Lawren to climb and Bess to paint. He occasionally did some drawing, of course, and she climbed with him at least once, during a stay at Mount Temple Chalet near Lake Louise. Her description of the experience they shared underlines yet again the spiritual nature of the mountains for them.

For the next three hours it was one

continuous wonder. — The like of which I don't know that I could even attempt to describe. — There was beauty superlatively. The land below vanished — lost in a glorious up-soaring movement of white — of sun-lit cloud, — now and again a peak all snow dimly was seen, — one lost the common sense of earth and sky. — It was a new space — all movement and light — I could only think I was *looking* at *music*.[144]

Mt. Ann-Alice could be *Mountain Form*, as it is listed in an inventory of 1963 as "Mountain Experience, 1943" (see No. 37). *Composition 10*, a late Hanover painting, was reproduced in 1948 as "Mountain Form No. 6" (see No. 23). Could *Rhythmic Organization* be the painting we know today as *Sun and Earth* (No. 45)? *Abstract Painting of a Mountain Experience I* is known today simply as *Mountain Experience I* (No. 49, Pl. No. 3), a large canvas that combines the characteristic peak of Mt. Ann-Alice with a painterly aura and superimposed abstract forms reminiscent of the "thought forms" of Annie Besant and C.W. Leadbeater. Although we have noted Harris's use of symbolic colour in a fashion consistent with the theories of the Theosophists Besant and Leadbeater as early as his landscapes of the twenties, this is the first instance of his use of the *forms* in conjunction with landscape elements, other than in the Hanover canvas, *Mountain Experience* (No. 11), which, as mentioned earlier, seems to have been reworked, perhaps as late as the mid-forties. Another canvas that combines such Theosophical imagery with landscape forms dates from the same time, and is a good candidate to be *Abstract Painting of a Mountain Experience II*.[145] A Harris unlike any other, it is a narrative record of the ascent of a mountain, with stages compartmentalized by symbolic forms doubling as interior frames. Curious

rather than effective, it marks the limit of one avenue of exploration of the combination of abstract forms with natural.

It hardly represented an impasse to Harris, however, as he prepared his work for the retrospective exhibition of 1948. It was, to repeat, the first full-scale, catalogued retrospective given to a living Canadian by the Art Gallery of Toronto, or the National Gallery, where it was shown in December. A selection was then circulated to London, Ontario; Vancouver (where a smaller catalogue was also issued), Victoria, Calgary, Edmonton, Saskatoon, and Winnipeg, where it closed in November 1949. It was a striking tribute, and Harris doubtless took extra satisfaction from the knowledge that the venues for much of the tour existed in large measure due to his efforts a few years earlier to help establish community art centres.

Generally speaking, the retrospective was well received, and particularly by those who took a broad view of Harris's contribution to Canadian art over the almost forty years covered by the exhibition. Those who specifically addressed the issue of his abstractions — which comprised only 18 percent of the exhibition, although he had devoted over 30 percent of his career to them by 1948 — were in most cases unprepared to judge them. Among the most prominent reviews, Paul Duval's in Toronto's *Saturday Night* explained in some detail why the abstract work had to be taken seriously, but was nonetheless content to report simply that it "annoys some, stimulates others."[146]

Canadian Art published two reviews, back to back. Andrew Bell, in the first, was enthusiastic about the exhibition, but turned only two short paragraphs to his thoughts concerning the abstractions. He had literally almost nothing to say.[147] The one impressive exception to this critical pussyfooting was Northrop Frye, whose review followed Bell's

immediately.[148] The whole show impressed him, with some particular reservations, but the abstractions he found to be the best part, and he devoted almost half his essay to their analysis. With his first sentences on the subject, and his last, he registered strong, positive feelings and clear judgement.

When we enter the 'abstract' room we are conscious first of all of a great release of power. The painter has come home: his forms have been emancipated, and the exuberance of their swirling and plunging lines takes one's breath away....

But they are pictures and not cryptograms, and have no single explanation or key, just as music can suggest any number of emotions or ideas without being programme music. With interpretation or without it, Lawren Harris's best abstractions are a unique and major contribution to Canadian painting.[149]

In the years following the retrospective it was views like those of Duval and Bell that predominated, however, rather than those of Frye. Even so sensitive an observer as Donald

144. Bess Harris to Doris Speirs, August 15, 1944, Speirs papers.

145. Repr. in Dennis Reid, "Lawren Harris," *artscanada* 25 (December 1968), p. 14, as "Abstract No. 19, 1945-8." It is currently on the Vancouver art market.

146. Paul Duval, "Lawren Harris' Switch to Abstract Art Annoys Some, Stimulates Others," *Saturday Night* 54 (October 9, 1948), pp. 2-3.

147. Andrew Bell, "Lawren Harris — A Retrospective Exhibition of His Painting 1910-1948," *Canadian Art* 6 (Christmas 1948), pp. 51-53.

148. Northrop Frye, "The Pursuit of Form," *Canadian Art* 6 (Christmas 1948), pp. 54-57.

149. *Ibid.*, pp. 54-55, 57.

Buchanan (who became an editor of *Canadian Art* in 1944) was out of sympathy with Harris's work. He had to include him in his important 1950 study, *The Growth of Canadian Painting*, but he appears to have believed that "The Search for the Absolute" upon which the artist was set was essentially misguided. "To some of his followers..." Harris's abstractions, Buchanan wrote, "have a mystical appeal, but, generally speaking, to many friendly observers they appear to be, as one critic recently described them, 'The art of a Puritan who, by the rigorous imposition of theory, strives to create some kind of metaphysical ecstasy in paint.'"[150]

It was but one sign of a subtle shift in the way Harris was perceived at the end of his first decade back in Canada, both locally in Vancouver and nationally. He turned sixty-five in 1950, of course, and the artists with whom he was most closely associated in the public eye no longer seemed to represent the cutting edge of Canadian artistic development. He was seen to be encouraging young painters in Vancouver, as when he selected the work of Peter Aspell, Lionel Thomas, Gordon Smith, Don Jarvis, and Joe Plaskett for the World Youth Festival in Prague the summer of 1947,[151] but even when these painters were thought to be part of the Harris 'circle' it was not clear that this implied a shared aesthetic. Aspell, for instance, was a figurative painter, and although Plaskett had been greatly influenced by Harris's work in the early forties, he had abandoned abstraction by 1951. Even among those in Vancouver pursuing abstraction, which by 1950 included Jack Shadbolt, and Harris's friend B.C. Binning, as well as younger painters, the public saw only divergence in approach and intent.

Harris was still closely identified with Emily Carr through his association with the work of the Emily Carr Trust (which he managed virtually single-handed), selling paintings and distributing the proceeds in the form of scholarships to young painters. He was also soliciting support for the expansion of the Vancouver Art Gallery (opened in September 1951), intended to house the paintings Carr had left to the people of British Columbia.

Among other old friends, L.L. FitzGerald spent the whole school years of 1947–48 and 1948–49 on the west coast, the latter year living in Vancouver. He saw quite a bit of Harris, and when he returned to Winnipeg and retirement from the principalship of the art school, turned to abstraction himself. Through correspondence and the occasional visit A.Y. Jackson remained close to Harris, who advised him on financial matters and encouraged him to write his autobiography. (It appeared finally in 1958.) Beginning in 1951 Arthur Lismer and his wife vacationed annually on Vancouver Island, and so he too re-established more or less regular contact with Harris.

For his own part, Harris had become concerned to situate the Group of Seven in the history of Canadian art. He delivered a paper, "The Group of Seven in Canadian History," at the annual meeting of the Canadian Historical Association in Vancouver in June 1948,[152] prepared a radio broadcast on the same subject for the CBC in June 1950, and story as a lengthy introduction to the catalogue of a Group of Seven exhibition he organized in 1954 with the curator of the Vancouver Art Gallery, Jerrold Morris.[153]

On the other hand, he continued to write and otherwise promote the idea of abstract art, as we shall see. And his continuing concern for the role of art galleries in Canadian life was also manifest. "A Debate on Public Art Gallery Policy" with E.R. Hunter, published in *Canadian Art* the summer of 1950, probably had something to do with his later that year being the first practising artist to be appointed to the Board of Trustees of the National Gallery of Canada, a position he would fill until 1961. This necessitated twice-yearly trips to Ottawa, and usually in the fall Bess would accompany him when the journey was extended to include visits with family in Toronto and a few days in New York. His contribution to Canadian art was honoured again by degrees from the University of Toronto in 1951, and the University of Manitoba in 1953.

By 1953, the beginnings of concern for declining health — Bess's more than Lawren's — led the Harrises to abandon their annual vacation of climbing in the Rockies for a late-winter motor trip to the American Southwest, their first visit to the desert in thirteen years. They stayed near Tucson, Arizona, in February–March, returned a year later, and spent March 1955 at Yuma, where Arizona, California, and Mexico meet. (Bess's ailment had by then been diagnosed as a gall bladder condition, which was finally corrected by surgery.) None of these numerous small changes in Lawren's practices and patterns, however, could prepare us for — let alone explain — the dramatic turn his painting took following the retrospective.

The earliest evidence of this change appears in a picture owned for a few years by Harris's friend, the newspaper publisher and longtime Chairman of the Board of the National Gallery of Canada, Harry Southam. (Southam was Chairman 1929-48, and 1952-53. He died in 1954.) Exhibited first as *Painting* with the CGP in Montreal in January 1949, and the following month in Ottawa, it is a warmly coloured picture made up largely of glowing organic forms that twist at the centre in a golden dance of constant change (see No. 50).

Viewed with its right-hand side up, we can see vestiges of a thrusting mountain peak, and viewed horizontally in its usual fashion

there are remnants, in hot hues of red and orange, of the sort of foreground landscape elements we have seen periodically since the mid-thirties. But the dominant element is a canvas-filling elliptical form of soft green fading to the pure light of the central evolving shapes it contains. It is a gently rhythmic, encompassing form that, while abstract, seems entirely natural. Largely independent of landscape reference, and free entirely of the precise geometry of Santa Fe, this *Painting*, with its glowing suffusion of intense colour, presents a resolution of that dichotomy between abstraction and nature experience in elucidating the spiritual path with which Harris had been wrestling for most of the decade, and, indeed, for years before that. It is painted on the back of a late Santa Fe canvas.

You will recall that *From the Harbour to the Open Sea* (No. 38) is also on the back of a Santa Fe painting. The decision to cannibalize an earlier work in this way could hardly have arisen from a need for economy, as Harris never lacked the wherewithal to keep himself well stocked with painting supplies. There are, in fact, a number of pictures of the late forties through the mid-fifties that are painted on the back of Santa Fe canvases, further evidence that in this new work Harris was resolving issues that had in part been raised by his old.

What brought on this distinct turning? Was it simply the consequence of having reviewed his life's work for the retrospective? That, and being finally free of the demanding responsibilities of the presidency of the FCA were large factors. So too could have been the sale of the Studio Building in 1948, his last substantial link with Toronto, and more certainly, changes to the house in the late fall of 1949, when the living room was expanded to encompass a porch, creating a new studio with a panoramic picture window overlooking Spanish Banks and the Gulf of Georgia. Henceforth Harris painted in the living room,

delighted that he had achieved yet another degree of integration of the aspects of his life.

The most important reason for this change in his painting, however, appears to have been his first encounter with new creative directions in the United States. Friends of the Harrises recalled having dinner with them one evening shortly after they had returned from one of their trips east. "It was either Chicago or New York. It was the first time he had seen an exhibition of the American expressionists, and he was still wildly excited by the impact that they had made on him, particularly Rothko's work."[154] Harris was in Chicago at the end of September 1948, and in New York in the spring of both 1947 and 1948, as well as the fall in 1948, and in 1950, and 1952.

Was he moved by Mark Rothko's paintings as early as 1947 or 1948? If so, these would have been the 'surrealist' works, with their biomorphic forms (not unlike Harris's central shape in *Painting*) floating on deep fields of diaphanous colour,[155] or perhaps those works of 1947 and 1948 in which Rothko's pictures first came to be dominated by rough floating rectangles of intense and very particular colour. There is no concrete evidence, however, that he was aware of abstract expressionism this early, although he would not have used such a term at the time.

Certainly, the intense personal review of his work that seems to have occurred with the retrospective did bring him to reflect on the nature of abstraction, which resulted in "An Essay on Abstract Painting" that appeared in the *Journal of the Royal Architectural Institute of Canada* in January 1949, and was reprinted in *Canadian Art* shortly after.[156] In it, Harris defines "three main kinds of abstract painting" (up from the two he had posited when he first wrote in defence of abstraction for *The Canadian Forum* back in 1927). These are paintings "abstracted from nature," non-objective paintings with "no relation to any-

thing seen in nature," and a third kind which "is simply a fine organization of lines, colours, forms and spaces." By the time that an expanded form of the essay was published as a booklet in June 1954, he had added a fourth category, "abstract expressionism." He did not by this mean the sort of gestural painting that is today usually implied by the term. He describes it as being not really a style in painting, but "a new realm in which the imagination is released into an illimitable range of new subjects and new visions of old subjects...."[157] One of his own paintings, called *Nature Rhythm*, is reproduced as "an example of abstract expressionism in which the forces of nature work together in a continuous movement of harmonious formation."[158] *Nature Rhythm* is one of a series of

150. Donald W. Buchanan, *The Growth of Canadian Painting* (London and Toronto: Collins, 1950), p. 41.

151. See Scott Watson, "Art in the Fifties: Design, Leisure, and Painting in the Age of Anxiety," *Vancouver: Art and Artists 1931-1983* (Vancouver: Vancouver Art Gallery, 1983), p. 82.

152. *The Canadian Historical Association: Report of the Annual Meeting held at Victoria and Vancouver June 16-19, 1948* (Toronto, 1948), pp. 28-38.

153. "The Story of the Group of Seven," *Group of Seven* (Vancouver: Vancouver Art Gallery, 1954), pp. 9-12.

154. Transcript of a taped interview with Alistair and Betty Bell, *CBC Spectrum: Lawren Harris*, end of sound roll 7, roll 8, pp. 6-7.

155. See Robert Rosenblum, "Notes on Rothko's Surrealist Years," in *Mark Rothko* (New York: The Pace Gallery, 1981).

156. *JRAIC* 26 (January 1949), pp. 3-8; *Canadian Art* 6 (Spring 1949), pp. 103-107, 140.

157. Lawren Harris, *A Disquisition on Abstract Painting* (Toronto: Rous & Mann Press Limited, 1954), p. 11.

158. *Ibid.*, p. 10. *Nature Rhythm* is now in the collection of the National Gallery of Canada, Ottawa.

pictures that developed directly from Harry Southam's *Painting*.

On the other hand, Harris did produce the most gestural and expressive painting of his career in 1950. *In Memoriam to a Canadian Artist* (No. 52) is based on a late Santa Fe sketch that has been altered dramatically by the addition of a loosely painted orange, red, and yellow form that seems to have grown over the clean geometric shapes like some exotic fungus (see No. 51). An homage to Tom Thomson, the canvas displays no trace of this geometry, but instead a large, dark, looming, mountain-like shape that supports a similar accretion of brilliant hot colours, an accretion that in this context is clearly more closely related to Theosophy's "thought forms" than to New York gestural painting. It too is painted on the back of a Santa Fe canvas.

So is *Configuration in Space (Formative I)* (No. 53), which was exhibited with the BCSFA in the spring of 1950. It is one of a series of large pictures he produced over the next two or three years that all grew from the preceding *Painting*. Ranging from muted earth colours (see No. 54) through to sizzling hot hues in jaggedly dynamic forms (see No. 56, Pl. No. 4), they all explore rhythm, and what Harris in his description of the related *Nature Rhythm* called "the forces of nature" working "together in a continuous movement of harmonious formation." The series, an impressive and distinct body of work, can perhaps be seen to culminate in *Northern Image* (No. 57), in which these nature forces are again made explicit. Harris could not go for too long, it seems, without openly declaring those intense experiences of sublime nature in which his spirituality was so clearly grounded.

While concentrating on this new, more painterly direction in his painting, Harris continued to be involved in public issues concerning art. During the early fifties in particular he took his trusteeship of the

National Gallery of Canada very seriously. There are numerous letters in the files of the Gallery attesting to his deep involvement in matters of policy and programme, and although board meetings were held only twice a year, he actually travelled to Ottawa for consultations as many as four times over one eight-month period.[159]

By the time of the opening of the newly expanded Vancouver Art Gallery in September 1951, Harris was widely held to be the most important figure in that gallery's administration. He had been much in evidence while raising money for the expansion, and was closely involved with the supervision of the design and construction. Late in 1950, however, it was his continuing role as Chairman of the Exhibition Committee that brought him squarely before the public eye. A local critic took exception to an abstract painting that had been included in an exhibition at the Gallery, and Harris responded with both a defence of the painting and an attack on, or at least a serious questioning of, the basis of the critic's judgement. The issue eventually subsided, but surfaced again a year later. Drawing in the curator, Jerrold Morris, it remained, nonetheless, focused on Harris, who was typified as the leader of a clique that ran the Gallery in its own interests: for the promotion of abstract painting and the suppression of academic values. It was even reported that the Gallery had a policy against exhibiting nudes, although Morris quickly explained that that impression had arisen from his own casual response to a reporter's impertinent question.

Bess remarked to her friend Doris back east that it was all "quite like the old Group of Seven controversy — and has its useful as well as its foolish side."[160] The controversy in fact attracted a number of people who saw Harris as less than an entirely positive influence on the direction of the Gallery. They did not only represent conservative opinion, but included

a range of individuals who either felt excluded from the Harrises' social circle, or who suspected their spiritual concerns (which while they did not at this time actively proselytize, neither did they hide), or resented the direct, authoritative manner in which Harris made decisions on those matters about which he felt competent. That was virtually every aspect of running a public art gallery, including, as he demonstrated in an article in *Canadian Art* in the fall of 1954, knowing "What the Public Wants."[161]

It was still his own art that interested him the most, of course, and he stuck to it in spite of all these demands upon his time, painting every day: "Monday through Sunday as the Radio announcers say — he is at his easel from 10:30 to 1:30 — has lunch —does garden chores or walks —then has another hour in the afternoon —" recorded Bess. "And after dinner in the evening we have a discussion over what has taken place —the pros and cons of colour and composition —during the day."[162]

Harris exhibited his new paintings at every opportunity; with the CGP, the BCSFA, and in the B.C. Annuals. Curiously, he at the same time held a whole series of exhibitions across the country of Group of Seven work, including his first shows with commercial galleries. And this in spite of the fact that, as he explained to A.Y. Jackson: "I have never included any sale of paintings in my income tax return as the sales have never exceeded my costs — and I have to make sure that my sales do not amount to more than costs or I'll get into a mess. I have now requests for pictures which will have to be held — some of them — for three years…"[163] Only two years later, in May 1951, he held an exhibition of his early work at the Dominion Gallery in Montreal, which was shown at Eaton's in Toronto in October. A smaller show was held at the Art Gallery of Greater Victoria in April 1952, another at the

FIG. 10
On the front steps at 4760 Belmont Avenue, c. 1955.

Edmonton Art Gallery in March 1953, shown at Calgary in June, and yet another at Edmonton in October. Then from December 1953 through to the following April a selection of Group of Seven sketches toured the Western Art Circuit, and then the Maritime Art Circuit from December 1954 to the following April.

The recent abstractions received their due finally in May 1955 in a one-man show at the Vancouver Art Gallery. In the introduction to the checklist published on the occasion, B.C. Binning pointed out that all twenty-two canvases had been painted within the past five years. It was a remarkable achievement for an artist who had just turned seventy, he suggests.

At a time when most men are simply summing up their past work, Lawren Harris continues to broaden and deepen the dimensions of his expression. The rhythms of his painting swirl deeper into the richness of life and broaden into larger circles, encompassing its greater joy. These are the qualities of great art. For Canada this marks an important event — an occasion for celebration.

At least one Vancouver critic shared this view, describing the exhibition as "the most important and exhilarating showing of abstract pictures by a Canadian artist seen in Vancouver." It was as well, he pointed out, "a new manner of painting termed 'abstract expressionism,'" through which, "during the past decade or so," Harris "has developed greater freedom and stronger creative impulse...."[164]

The exhibition included *In Memoriam to a Canadian Artist* (No. 52), *Configuration in Space* (No. 53), *Northern Image* (No. 57), and *From the Harbour to the Open Sea* (No. 38). The administration of the Gallery had specifically requested that Harris name individual paintings, and so Harris called together a group of friends for a naming party. More recent works named in this fashion were *Lyric Theme* (No. 62), *Migratory Flight* (No. 59), seemingly the record of some dark passage of the spirit, and *Eclipse of the Spirit* (No. 58), yet further evidence of his abiding concern for Theosophical themes.

Harris hoped to be able to circulate the exhibition to some of the larger eastern galleries, but his proposal came too late to allow proper scheduling, and the project was dropped. Then two years later he was able to arrange for a similar show to go to the Winnipeg Art Gallery (September 1957), and then on to Windsor and London in Ontario early in the new year. Although no checklists were apparently issued, those paintings shown in Ontario bear labels from the host institutions. A number were very likely in the Vancouver show in 1955. Among these are *Abstraction (Ritual Dance in Spring)* (No. 61, Pl. No. 5), and a currently untitled work (No. 60), that could be *Phoenix* in that earlier show. Both of these are remarkable for their flamboyant, high-keyed colour and extravagantly expressive form.

Abstraction (No. 66) was also in that 1957-58 travelling show, although it was painted following the 1955 exhibition in Vancouver. A highly developed, evocative image, it clearly has evolved from *Eclipse of the Spirit*, which in turn grew from that group of large rhythm pictures of 1949-52. It relates as well to an untitled work I have dated to about 1956 (No. 63), although it could be earlier, as it is painted on the back of a Santa

159. See Bess Harris to Vera Jonson, Albuquerque, New Mexico, April 26, 1955, Jonson papers.

160. Bess Harris to Doris Speirs, January 12, 1952, Speirs papers.

161. Lawren Harris, "What the Public Wants," *Canadian Art* 12 (Autumn 1954), pp. 9-13.

162. Bess Harris to Doris Speirs, January 12, 1952, Speirs papers.

163. Harris to A.Y. Jackson, Toronto, February 27, 1949, with Naomi Jackson Groves, Ottawa; henceforth 'Jackson papers.'

164. Palette, "Lawren Harris Display at Gallery Until June 5," *Vancouver Province*, May 14, 1955.

Fe canvas. It and *Three Planes of Being* (No. 64), suggest strongly that Harris near the middle of the decade was looking at Tantric Buddhist images from Tibet, highly abstract meditative objects that reflect an unusual degree of spirituality.

The mid-fifties, then, was a period of intense looking, as well as painting. Harris drew visual ideas and a new sense of the range of the material qualities of paint from abstract expressionism (most notable in the dry, open texture of the highly coloured pictures), and reinforced his sense of the role of art in elucidating the spiritual path through his study of Eastern mandalas. In addition, following Bess's recuperation from a gall bladder operation late in 1955, Lawren planned a leisurely sea voyage to Italy, which they undertook the following March and April. It was Bess's first trip to Europe, and Lawren's first since 1930. They spent two weeks at Revello in the hills above Amalfi so that Lawren could climb, and visited as well Genoa, Naples, and Rome. As Bess explained to Doris later, "most of our journey was an Art Pilgrimage and we spent our days looking at Masterpieces and having a wonderful time."[165] This too provided fresh stimulus for Lawren, who had been "working steadily ever since we returned from Italy.... It seems to me there is a fresh creative wave up his beach."[166]

Harris finally resigned from the chairmanship of the Exhibition Committee at the Vancouver Art Gallery that year, doubtless to take advantage of this surge in his work. The following year was devoted almost exclusively to painting, for Harris increasingly a solitary activity, as he worked virtually without benefit of critical support. In fact, that year were published negative judgements more damning than those of Buchanan seven years earlier. At least Buchanan was unsympathetic to *all* of Harris's painting. Tony Emery, writing prominently in the London-based *The Studio*,

was the first to suggest that the abstractions represented a marked decline:

> Of recent years he has painted abstractions which retain the disciplines and rhythms of his earlier works while lacking their structural power; weak in form and unappealing in colour they have a cheerless, cerebral quality which accords ill with the kindly and genial personality of this outstanding Canadian painter.[167]

One of the few reviews of the 1957–58 tour judged them as harshly:

> ...the new work is an almost complete denial of the qualities which have made Harris, in this critic's view at any rate, the outstanding representational painter of his generation in Canada.... In them there is, instead of strength, weakness; the superb color sense degenerates into what one might term an almost vulgar playfulness, and the meticulous form of the earlier periods becomes fussy and rather trivial.[168]

In spite of such criticism, if not oblivious to it, Harris worked on, secure in the vision he had been pursuing for so many years.

As mentioned above, Harris devoted most of his time to painting during 1957, once again, as during the mid-thirties, refining his ideas on masonite (pieces that he called sketches, even though they were usually over 75 cm tall), before transferring them to larger canvases. Some of these are dated on the back, and so we know that he continued to develop the kind of complex, yet tightly harmonious nature rhythm compositions that had so entirely involved him in the period immediately following the 1948 retrospective. By 1957, however, the elegantly curving lines define virtually autonomous forms that fill the

centres of the pictures (see No. 66). Invariably displayed in a vertical position now, these images seem to spring from the bottom edge of the picture, perhaps twisting, certainly reaching in a flame-like dance of constant change (see No. 65).

One darker, richer image, first exhibited early in 1958, could go back to the early fifties in its sketch which, unlike all the others of 1957, is on the softer kind of board Harris had used in Toronto in the twenties, and to which he had returned in the mid-forties (see No. 67). The canvas, which follows the sketch closely, is more linear than other pictures of 1957, almost calligraphic in nature. The central form is tighter, more attenuated, evoking characteristics of a discrete figure (see No. 68). The intense, saturated colour is more opaque than in most others of 1957, although it is used to reinforce that same sense of form evolving, congealing, that is so characteristic of work of that year (see No. 68, Pl. No. 6).

Harris's production actually increased during the early months of 1958, it would seem, as there are a surprising number of paintings so dated on their backs. Almost all are on masonite, either the 75 cm sketch size or one slightly larger at just over 90 cm (exactly one yard, the measurement Harris would have used). The flame-like forms are now entirely contained at the centre of the image, and these new pictures are clearly meant to function as mandalas, radiant objects for contemplation (see No. 69). And they are radiant, as Harris continued to explore that new approach to colour we first noticed with his 'abstract expressionist' paintings of the post-retrospective period. The looser, more painterly handling characteristic of all the work of the fifties had introduced a somewhat more atmospheric space and, as we noted earlier, a more highly developed sense of colour as a material component of a

newly enlivened matte surface of dry, open texture. The sense of palpable light is almost hypnotic (see No. 70).

Another series of sketch-sized paintings dated 1958 continues the investigation of Tantric imagery Harris had first introduced a couple of years earlier. Loosely expressive calligraphy engages the whole surface of the picture while still presenting a fixed centre to focus meditation (see Nos. 71 and 72). In the yard-high format is an unusual image, one of another small series dependent for its effect largely upon the manner in which the white paint is applied on a dark blue ground: thinly in regular strokes with a stiff brush, resembling frost on a window (see No. 73). Yet another painting of this size is a highly stylized landscape dominated by clouds that also echo Tantric imagery (see No. 74).

This tremendous surge of inventive and technically accomplished work came to an abrupt halt when early in April 1958 Harris suffered a heart attack, and was operated on to correct an aneurism of the aorta. He responded well, and a month later was able to report to A.Y. Jackson:

> Yep, I had a very serious operation and came through it remarkably well.... I bust all records, walked out of the hospital on the 12th day after the operation, I have been home two weeks and though up all day and taking short walks I find it slow going toward a complete recovery.[169]

Three months later, he was still not able to work, although, as Bess reported to friends in New Mexico, he was thinking about "his paintings of the winter — quite a new and creative period."[170]

He was not down for long, however, and in fact had selected a group of paintings from British Columbia for the Canadian National Exhibition in Toronto that opened August 20,

a group that included five of his own abstractions. Then, September 9 he actually attended the opening at the Vancouver Art Gallery of what was described in the introduction he wrote to the catalogue as the first CGP exhibition to have been arranged for a location outside Toronto. He exhibited two pictures, *Painting* and *Mountain Spirit*.

Clearly determined to keep his work in the public eye, Harris arranged for an exhibition and sale of abstract paintings along with Group of Seven sketches at the Laing Galleries in Toronto in November. The following May, a similar show in the Emily Carr rooms at the Vancouver Art Gallery presented his early landscape sketches with an equal number of those 'sketches' on masonite of 1958. He and Bess meanwhile had sailed to England via the Panama Canal, travelled in Europe, and returned via New York, a convalescing trip that rivalled the one they had taken early in 1956 following Bess's operation. Then in July it was to Ottawa, to join a dinner party at Government House for the Queen.

Harris was not able to work much during this year-plus of convalescence, although his work was never far from his thoughts. In January 1960 he held another exhibition and sale at the Laing Galleries in Toronto, devoted entirely to the *Abstract Paintings 1957–1958*. He subsequently left a small group of paintings with the Roberts Gallery in the same city, a group that included three abstractions. And also that year the Dominion Gallery in Montreal purchased a number of the 1957-58 abstractions.

In spite of such evidence of concern for his recent abstract work, the first painting completed following the heart attack appears to have been a landscape, a "new Algoma painting" based on a sketch that was at least forty years old. Entitled *Spruce and Lake*, the Roberts Gallery wanted it,[171] but Harris instead showed it with the BCSFA at the end of May (with

a house painting of the late teens), and as his only entry in the next CGP exhibition, which opened in Montreal in November and then was shown in Regina in January 1961. Although in handling not entirely satisfactory, it is strong in mood.[172]

Harris presented another exhibition of abstract paintings at the Art Gallery of Greater Victoria in October 1961, but there was no suggestion at the time that any of the work was new. Then finally at the CGP exhibition in November — held again at the Vancouver Art Gallery — he showed a large canvas, *Painting*, which could have been recent. Not too recent, however, as he wrote to Jackson about this time, "my writing has been on the blink for two months so please forgive all mistakes."[173] He did, though, as Bess wrote to Doris, paint "a part of every day,"[174] but he was not strong enough to travel to Ottawa in February 1962 to

165. Bess Harris to Doris Speirs, Christmas 1956, Speirs papers.

166. *Ibid.*

167. Anthony Emery, "British Columbia's Progressive Art," *The Studio* 153 (June 1957), p. 169.

168. Angelo, "The Winnipeg Gallery," *Winnipeg Free Press*, September 23, 1957.

169. Harris to A.Y. Jackson, Manotick, Ontario, May 8, 1958, Jackson papers.

170. Bess to Vera Jonson, Albuquerque, August 10, 1958, Jonson papers.

171. L.J. Wildridge, Roberts Gallery Limited, Toronto, to Harris, April 28, 1960, copy with Roberts Gallery.

172. LSH 176, collection LSH Holdings Ltd., Vancouver, it is titled and dated verso, "Northern Lake, 1958-9."

173. Harris to A.Y. Jackson, Manotick, Ontario, late 1961, Jackson papers.

174. Bess to Doris Speirs, January 2, 1962, Speirs papers.

receive a Canada Council medal, which Bess collected for him.

Nonetheless, the first new abstractions appeared later that year, with the CGP in Toronto in November 1962, shown again at the National Gallery March–April 1963. These were not entirely new. One, the tallest picture he ever painted, and the largest overall since *Composition No. 1* of 1941 (his first canvas in Vancouver), was begun in 1958 but finished in 1962. It is a beautifully painted, exultant example of those flame-like images that had developed over the past decade (see No. 76). The other is not quite as big (see No. 78). It might have been painted entirely following the heart attack, but it is an enlargement of one of his masonite sketches of 1958, a Tantric-like calligraphic composition (see No. 72). One other picture also dates to this period (see No. 77, Pl. No. 7). Again big, it too is an enlargement of a 1958 sketch.

Just at this important juncture in his later career, Harris enjoyed the entirely unprecedented honour of a *second* major retrospective of his life's work. Initiated by the Vancouver Art Gallery, it was arranged with the National Gallery of Canada, where it opened June 7, 1963. Unable for reasons of health to make it to Ottawa for the opening, he did see it there later during the summer, and, of course, had a number of opportunities to view it in Vancouver, where it opened in October. The exhibition was accompanied by a handsome catalogue containing, for the first time in a publication devoted to a living Canadian artist, a number of essays by specialists, each addressing specific historical issues raised by Harris's work and life.

This time, thirty-five of the eighty pictures in the Ottawa showing were abstractions, which reflected almost exactly the proportion of his career devoted to their production. A few post-1958 works are listed in the catalogue, including Nos. 76 and 77 in this exhibition. At

FIG. 11
Lawren and Bess hiking near Vancouver, c. 1960.

least one work had never been exhibited before, *Atma Buddhi Manas* of 1962 (No. 79 and cover). A remarkable painting, it relates to the flame series, although here there are three distinct forms floating in a vibrant energy field that changes subtly in colour from blue on brown-red to blue on yellow to blue on white. These forms, representing the principles of Atma, Buddhi, and Manas, attest to the central place Theosophy still held in Harris's thinking. The lower, darker part of the field holds the Manas figure, which represents the highest state of mind, of intellectual knowing. The middle area is occupied by the Buddhi figure, representing the highest level of spirituality that can be achieved through meditation. The highest level of all, however, is Atma, which is entirely spiritual, essentially the condition of Godhead. For Theosophists, these three ways to achieving self-knowledge, these keys to an awareness of the harmony of higher planes of being together represent the Ego, the consciousness of self. It is interesting that Madame Blavatsky mentions them as a unit specifically in relation to the term 'Devackan,' which refers to the state in which the Ego exists "between two earth-lives," while awaiting reincarnation.[175] Following his heart operation, Harris of course was preparing for the next critical stage in his own spiritual journey.

One other work of 1962, entitled simply *Abstraction* (No. 81), was shown in the retrospective in Vancouver, but not catalogued. It relates closely to *The Spirit of Remote Hills* (No. 80), a painting begun in 1957, and first exhibited in November of that year, although altered considerably following 1958. It is enough, perhaps, to point out that these two pictures attest to the fact that in the final analysis the landscape experience remained for Harris as important as abstraction in elucidating the spiritual path.

Although critical reaction to the 1963

retrospective was of no real interest to Harris, we should at least note that the situation as regards his abstractions had changed virtually not at all since 1948. Paul Duval, while claiming that "no man has contributed more to Canadian art than Lawren Harris," still had nothing to say about them at all.[176] This was typical. But again, as with Northrop Frye in 1948, there was one deeply sympathetic critic. Robert Ayre had supported Harris's abstract work since the days of his involvement with the Federation of Canadian Artists, and he understood clearly that Harris's art could be read as the map of a spiritual journey.

It was inevitable that he should become disembodied, free himself of the drag of even the barren mountains and the ice and become airborne, caught up in the swift ecstasy, the rhythm of light. You can study his ascent, his flight into freedom, see him make an equation of the mountains — and of the sea: gull shapes over dark wave rhythms — and join earth and heaven in geometrical, astronomical diagrams — the thrilling abstract journey "From the Harbor to the Open Sea" and the dizzying perspectives of "Sun and Earth"; and then dissolve all structure and substance.

"Northern Image" is like the aurora swiftly unfolding in the sky. The light leaps up in "Ritual Dance of Spring." Three amorphous figures drift by in a current of light in "Atma Buddhi Manas." Mystical flowers bloom; essences dance, shift and change, like flames.... You need time with these paintings, time, in the words of the painter, to become 'Transparent, fully receptive to all radiance.'[177]

To be "transparent," to be "receptive to all radiance," is to be entirely open to the mandala. All the paintings of 1961 and 1962

are mandalas, and they function as, above all else, objects to assist in meditation.

There is another decisive turn in Harris's work sometime during 1962, however, that resulted in canvases — among the largest that he ever painted — that can only be described as visionary. They doubtless are what he was referring to in an interview of March 1962: "'My work has gone beyond abstractions,' he states. 'When I begin a work today I have no idea what the finished product will look like until I'm almost finished.'"[178] It could look like landscape, as in the most intensely spiritual mountain picture of his career, painted entirely in small feathered strokes of blue on white, with a pale cast of yellow, about 1963 (see No. 82). Or it could look like an unearthly landscape of vast proportion, painted in blue and gold and salmon, reflecting the most intense white light from the swelling surfaces of its rapidly expanding forms (see No. 83). Or it could look like a dense, heavy sun, buoyed high on a cosmic wave (see No. 84). The pure energy in these paintings is the more remarkable as Harris had largely withdrawn from public activity. "It is wiser for Lawren to continue his present peaceful and relaxed way of life," Bess informed A.Y. Jackson.[179] "He does not care

175. See H.P. Blavatsky, *The Key to Theosophy* (Pasadena, California: Theosophical University Press, 1972), p. 328. I am grateful to Robert Welsh for bringing this reference to my attention.

176. Paul Duval, "Canada Honors An Old Master," *The Telegram* (Toronto), August 24, 1963.

177. Robert Ayre, "Lawren Harris Retrospective," *Montreal Star*, August 10, 1963.

178. Bob Trimbee, "Rebel Painter Harris," *Montreal Gazette*, March 31, 1962.

179. Bess to A.Y. Jackson, Ottawa, Ontario, January 18, 1965, Jackson papers.

FIG. 12
At the age of eighty-four, 1969.

about meeting people now," Doris was told.[180]

Harris exhibited nothing between the 1963 retrospective and 1966. That year he showed three paintings with the CGP, at Hamilton, Ontario, in April, and then at Charlottetown, Prince Edward Island, in June. These were *Winter in the Northern Woods*, a huge decorative snow scene of about 1918 he still owned that is the widest picture he ever painted; *Mt. Lefroy*, now in the McMichael Canadian Collection, but then the largest mountain picture still in his possession; and *The Way*, a recent canvas, also large. It was a very deliberate choice of works, marking three great stages in his journey while proclaiming the consistency of his intent. It has not as yet been possible to identify *The Way*, as there is a group of pictures painted after 1965 that are all about the same size. It is tempting to argue that only that canvas that displays a great glowing image of an ascending triangle against a field clarifying through a lower range of raging reddish-violet to an upper level dominated by the most rarified, ethereal

blue could stand with those other heroic signboards of earlier stages in his career (see No. 85). We may never know. It was the last exhibition to which he would contribute.

Harris was hospitalized for a month again in the fall of 1966. He was strong enough to travel by train to Ottawa in June 1967 to view the *Three Hundred Years of Canadian Art* exhibition. This was just an excuse "to see the land once again," as Bess told A.Y. Jackson.[181] It was his last trip, and henceforth he was satisfied with a limited routine. "He is enjoying his quiet life" Bess wrote to Jackson again early in 1968, "—is not a bit restless or dissatisfied —walks a mile or more every day —rain or shine —has a drive into the country and paints on large canvases."[182]

These very last canvases, large indeed, are among the most remarkable accomplishments of his career (see Nos. 86, 87, 88, and Pl. No. 8). Radiant, expanding, of infinitely deep space, they are entirely unselfconscious. A dramatic departure, they are still the natural, seemingly inevitable culmination of a

life's work. At one moment both microcosm and macrocosm — images of perhaps the generation of a cell while at the same time of an exploding sun — they are transcendent visions into a tunnel of pure light; expanding, encompassing spirit.[183]

Bess died at the end of September 1969. Lawren followed her exactly four months later.

180. Bess to Doris Speirs, December 1, 1965, Speirs papers.

181. Bess to A.Y. Jackson, Ottawa, Ontario, June 22, 1967, Jackson papers.

182. Bess to A.Y. Jackson, Ottawa, Ontario, February 22, 1968, Jackson papers.

183. These "last canvases" also reflect specific Theosophical concepts. See in *The Key to Theosophy* the following definitions: "Long Face" (p. 343), an image of deity; "Macrocosm" (p. 344), the cosmos; and "Microcosm" (p. 351), the "little" universe, that is "man, made in the image of his creator."

Abbreviations

Albuquerque 1982

Albuquerque, New Mexico, The Albuquerque Museum, June 6-September 12, 1982, *The Transcendental Painting Group, New Mexico 1938-1941.*

BCAE

Annual British Columbia Artists' Exhibition catalogue, Vancouver Art Gallery.

BCSA

British Columbia Society of Artists, catalogue of the annual exhibition at the Vancouver Art Gallery.

CGP

Canadian Group of Painters, exhibition catalogue.

Harris 1948

Toronto, Art Gallery of Toronto, October 16-November 14, 1948, and national tour, *Lawren Harris Paintings 1910-1948.*

Harris 1955

Vancouver Art Gallery, May 10-June 15, 1955, *Lawren Harris, Recent Paintings.* Some of these were subsequently shown at the University of British Columbia, Vancouver.

Harris 1958

Windsor, Willistead Art Gallery, from March 19, 1958, subsequently shown at London, Ontario, The Elsie Perrin Williams Memorial Art Museum.

Harris 1963

Ottawa, National Gallery of Canada, June 7-September 8, 1963, Vancouver Art Gallery, October 4-27, 1963, *Lawren Harris Retrospective Exhibition, 1963.*

Harris 1976

Vancouver, The Art Emporium, November 2-13, 1976, *Lawren Harris.*

Harris 1983

New York, Martin Diamond Fine Arts, November 8-December 10, 1983, *Lawren Harris: Paintings of the Late Thirties.*

Harris-Colgrove 1969

Bess Harris and R.G.P. Colgrove, eds., *Lawren Harris* (Toronto: Macmillan of Canada, 1969).

Vancouver 1983

Vancouver Art Gallery, October 15-December 31, 1983, *Vancouver: Art and Artists 1931-1983.*

1

Lake and Mountains 1928

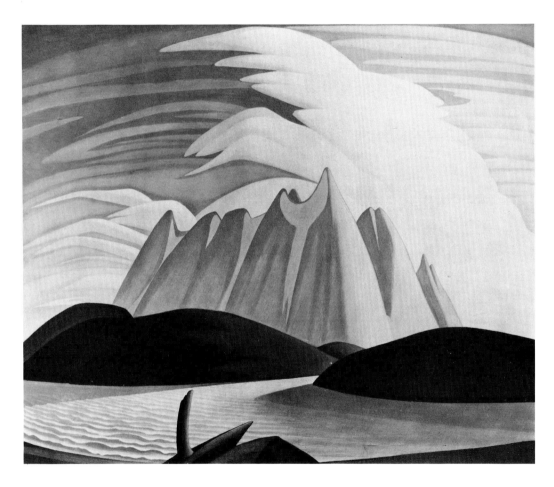

Oil on canvas, 130.8 x 160.7 cm
Art Gallery of Ontario, Toronto, gift from the Fund of the T.
Eaton Co. Ltd. for Canadian Works of Art, 1948 (48/8)

PROVENANCE
The artist.

LITERATURE
F.H. Brigden, "Exhibition of Fine and Graphic Arts
Canadian National Exhibition," *Royal Architectural*
Institute of Canada Journal V (October 1928), repr.
p.366, as "Mountain Forms." *Canadian Review of*
Music and Art I (October 1942), repr. p.10, as "Mountain
Forms." *Accessions 1948–49* (Toronto: Art Gallery of
Toronto, 1949), repr., n.p. Paul Duval, "Lawren Harris's
Switch to Abstract Art Annoys Some, Stimulates Others,"
Saturday Night 54 (October 9, 1948), repr. p.2. *Harris-*
Colgrove 1969, repr. in colour p.75. Helen Pepall
Bradfield, *Art Gallery of Ontario, The Canadian*
Collection (Toronto: McGraw Hill Company of Canada
Limited, 1970), p.161, repr. Sandra Shaul, *The Modern*
Image, Cubism and the Realist Tradition (Edmonton:
The Edmonton Art Gallery, 1982), repr. fig.5, p.15.

EXHIBITIONS
Toronto, Canadian National Exhibition, *Fine, Graphic &*
Applied Arts, August 24 – September 8, 1928, No.351,
repr., as "Mountain Forms." Ottawa, National Gallery of
Canada, January 15–February 28, 1931, *Annual Exhibi-*
tion of Canadian Art, No.103, as "Lake and Mountain."
New York, Roerich Museum, March 5–April 5, 1932,
Exhibition of Paintings by Contemporary Cana-
dian Artists, No.14. Ottawa, National Gallery of Canada,
February 20–April 15, 1936, *Retrospective Exhibition of*
Paintings by the Group of Seven, 1919–1933, No.76.
San Francisco, Department of Fine Arts, Division of
Contemporary Painting and Sculpture, 1939, *Golden*
Gate International Exposition, p.28, No.8. *Harris 1948*,
No.40, repr. pl.11. Vancouver Art Gallery, 1954, *Group of*
Seven, No.22, repr. Downsview, Ontario, Art Gallery of York
University, January 31–February 18, 1977, *Art Deco*
Tendencies in Canadian Painting, No.19, repr.
Toronto, Art Gallery of Ontario, January 14–February 26,
1978, *Lawren S. Harris, Urban Scenes and Wilder-*
ness Landscapes, 1906–1930, No.153, repr. in colour
p.176.

A preparatory drawing, *Lake and Mountains, Rocky*
Mountains, c. 1927, in a private collection, Vancouver, is
repr. in Joan Murray and Robert Fulford, *The Beginning*
of Vision: The Drawings of Lawren S. Harris (Toronto,
Vancouver: Douglas and McIntyre, with Mira Godard
Editions, Toronto, 1982), p.123. The oil sketch is in the
McMichael Canadian Collection, Kleinburg, Ontario
(1972.18.12), repr. in *The McMichael Canadian Collec-*
tion (Kleinburg, Ontario: McMichael Canadian Collection,
1970), n.p.; and in subsequent catalogues until 1983,
p.72.

2

Arctic Sketch XIII 1930

3

Fog and Ice, Smith Sound 1930

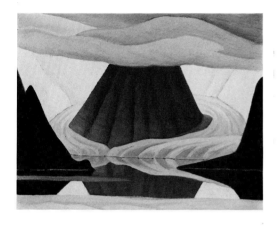

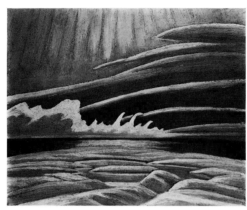

Oil on board, 30.5 x 38.1 cm
Agnes Etherington Art Centre, Queen's University, Kingston,
gift of Mrs. Etherington, c. 1944 (O–85)

PROVENANCE
The artist (Picture Loan Society, Toronto).

LITERATURE
Frances K. Smith, *Agnes Etherington Art Centre,
Queen's University at Kingston, Permanent Collec-
tion, 1968* (Kingston: Agnes Etherington Art Centre, 1968),
No.56, repr.

EXHIBITIONS
Toronto, Art Gallery of Ontario, January 14–February 26,
1978, *Lawren S. Harris, Urban Scenes and Wilderness
Landscapes, 1906–1930*, No.167, repr. p.194.

Oil on board, 30.5 x 38.1 cm
Private collection, Toronto

PROVENANCE
The artist. Mr. and Mrs. Charles S. Band, Toronto, c. 1931. By
descent to the present owner 1982.

EXHIBITIONS
Ottawa, National Gallery of Canada, November
26–December 8, 1930, and shown subsequently at the
Art Association of Montreal, January 31–February 15,
1931, *Arctic Sketches by A.Y. Jackson, R.C.A., and
Lawren Harris*, No.13. Art Gallery of Toronto, October
1947, *Selected Paintings from the Private Collec-
tions of C.S. Band, R.S. McLaughlin, and J.S.
McLean*, no No. Ottawa, National Gallery of Canada,
February 12–28, 1953, *Paintings and Drawings from
the Collection of Mr. and Mrs. C.S. Band*, No.15.
Buffalo, New York, Albright Art Gallery, October 1–
November 2, 1958, *The Collection of Mr. and Mrs.
Charles S. Band, Contemporary Canadian Paint-
ing and Drawing*, No.16, as "c. 1930." Art Gallery of
Toronto, February 15–March 24, 1963, and Montreal
Museum of Fine Arts, May 23–September 1, 1963, *The
Collection of Mr. and Mrs. Charles S. Band*, No.20.
Toronto, Art Gallery of Ontario, January 14–February 26,
1978, *Lawren S. Harris, Urban Scenes and Wilder-
ness Landscapes, 1906–1930*, No.164, repr. p.191.

The work is signed verso. The canvas, *Sun, Fog and Ice,
Smith Sound*, was exhibited at the Art Gallery of Toronto,
May 1931, *Arctic Sketches by Lawren Harris and A.Y.
Jackson, R.C.A.*, No.390. It was included in a Montreal
sale, Christie, Manson & Woods (Canada) Ltd., October
14, 1971, lot 72, repr. p.57, and in colour on the cover.

4

Self-Portrait c. 1932

5

Mount Washington c. 1934

6

Sheet of Studies c. 1934

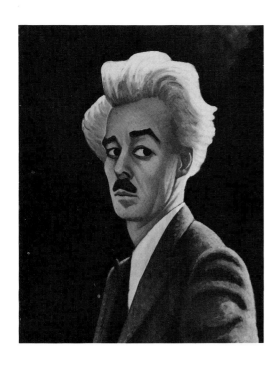

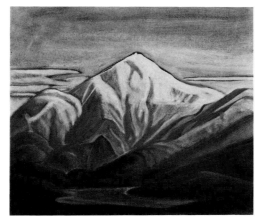

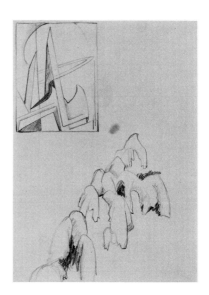

Oil on board, 81.3 x 63.5 cm
Private collection, Toronto

PROVENANCE
The artist. Mr. and Mrs. Charles S. Band, Toronto, c. 1935.
By descent to the present owner 1982.

LITERATURE
L.R. Pfaff, "Portraits by Lawren Harris: Salem Bland and
Others," *RACAR* V (1978), pp.21–22, repr. fig.3, p.24, as
"c. 1932."

Oil on masonite, 45.7 x 55.9 cm
Hood Museum of Art, Dartmouth College, Hanover, New
Hampshire, bequest of Mrs. Ethel K. Stewart through the
estate of Pennington Haile, 1983 (P.983.8)

PROVENANCE
The artist.

EXHIBITIONS
Hanover, Hood Museum of Art, Dartmouth College,
October–December 1983, *Recent Acquisitions:
Carracci to Warhol*, no cat.

Graphite on paper, 21.0 x 28.0 cm
Art Gallery of Greater Victoria, Victoria, British Columbia,
gift of Mrs. Peggie Knox, 1981 (81.222.10)

PROVENANCE
Estate of the artist.

7

Winter Comes from the Arctic to the
Temperate Zone (Semi-Abstract No.3)
c. 1935

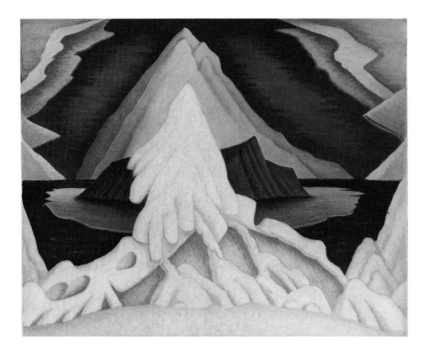

Oil on canvas, 74.0 x 91.0 cm
LSH 163
LSH Holdings Ltd., Vancouver.

PROVENANCE
Estate of the artist.

LITERATURE
Harris-Colgrove 1969, repr. in colour p.97, as "1935–37."

EXHIBITIONS
Victoria, Little Centre, October 29–November 17, 1946,
Exhibition of Abstract Paintings by Lawren Harris,
No.3, as "From the Arctic to the temperate zone." *Harris*
1963, No.54, as "1935."

8

Abstract Sketch **c. 1935**

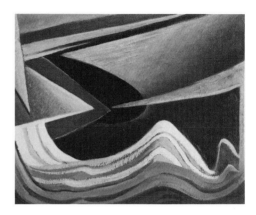

Oil on board, 30.7 x 38.0 cm
The McMichael Canadian Collection, Kleinburg, Ontario,
purchased 1971 (1971.8)

PROVENANCE
The artist. Gift to Jock and Barbara Macdonald, 1946.
Acquired from Barbara Macdonald.

LITERATURE
The McMichael Canadian Collection (Kleinburg:
The McMichael Canadian Collection, 1973), p.154, repr.:
and in subsequent catalogues to 1979, as "c. 1937";
always illustrated horizontally, sometimes one way up,
other times the other. Charles C. Hill, *Canadian*
Painting in the Thirties (Ottawa: The National Gallery
of Canada, 1975), p.178, as "c. 1937."
The work is titled verso, and inscribed: To Jock &
Barbara/with affectionate greetings/and best wishes for
a/beneficent life in every way/in their new environment./
Bess & Lawren. The canvas is in this exhibition, No.9.

9

Resolution (Composition 2) c. 1936

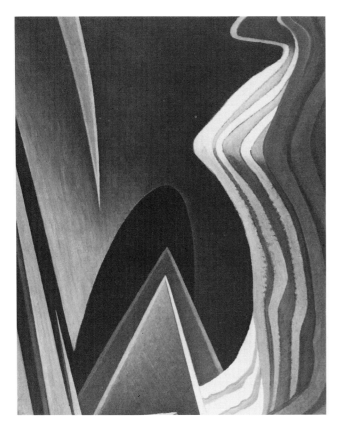

Oil on canvas, 91.4 x 71.1 cm
Mr. John C. Kerr, Vancouver

PROVENANCE
The artist. Mr. and Mrs. Leslie J. Kerr, Vancouver, c. 1955. By descent to the present owner.

EXHIBITIONS
CGP, Toronto, November 1937, Montreal, January 1938, No.29, as "Composition-2." *CGP*, Ottawa, February 9–28, 1938, No.23, as "Composition 2." *Harris 1963*, No.55, as "1937." Ottawa, National Gallery of Canada, 1975, and subsequent national tour, *Canadian Painting in the Thirties*, No.54, p.178, repr. p.86.

The work is inscribed verso on the stretcher: RESOLUTION/ INTERLOCKING FORMS — SYMBOL OF STEADFASTNESS, COURAGE. The oil sketch is in this exhibition, No.8.

10

Abstract Sketch c. 1935

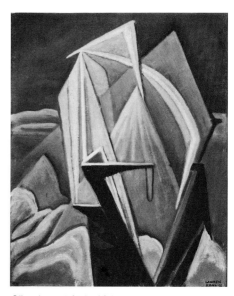

Oil on board, 37.8 x 30.8 cm
Signed lower right: LAWREN/HARRIS
Art Gallery of Ontario, Toronto, gift from the McLean Foundation, 1959 (58/23)

PROVENANCE
The artist (Laing Galleries, Toronto), 1958.

LITERATURE
Helan Pepall Bradfield, *Art Gallery of Ontario, The Canadian Collection* (Toronto: McGraw-Hill Company of Canada Limited, 1970), p.161.

EXHIBITIONS
Toronto, Laing Galleries, November 15–29, 1958, *Lawren Harris*, no cat. Toronto, Art Gallery of Toronto, February 13–March 14, 1965, *Art and Engineering*, No.9A, repr.

The work is signed and titled verso. The canvas is in this exhibition, No.11.

11

Mountain Experience c. 1936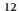

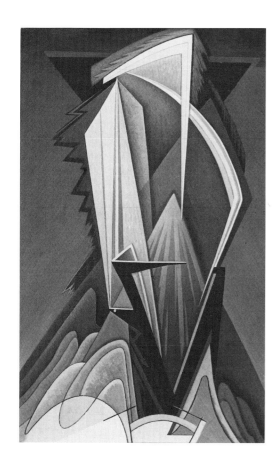

Oil on canvas, 142.6 x 88.2 cm
School of Art, University of Manitoba, Winnipeg

LITERATURE
"Art on the Campus," *The Alumni Journal, University of Manitoba* 23 (Summer 1963), repr. p.8.

EXHIBITIONS
Harris 1948, No.61, as "Abstract Painting."

The work is signed and titled verso. The sketch is in this exhibition, No.10. Another version, now cancelled, is the verso of LSH 140, LSH Holdings Ltd., Vancouver.

12

The Bridge 1937

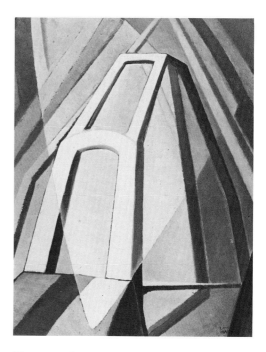

Oil on panel, 38.1 x 30.5 cm
Signed lower right: LAWREN/HARRIS
Mr. R.G.P. Colgrove, Sante Fe, New Mexico

PROVENANCE
The artist (Laing Galleries, Toronto), 1959.

LITERATURE
Harris-Colgrove 1969, repr. in colour p.5, as "1937." Paul Duval, *Four Decades: The Canadian Group of Painters and Their Contemporaries — 1930–1970* (Toronto: Clarke, Irwin & Company Limited, 1972), repr. p.26, as "1937."

The work is titled verso. A related panel was on the Vancouver art market, spring 1985.

13

Abstract Sketch c. 1936

14

Study of Space c. 1936

15

Untitled c. 1936

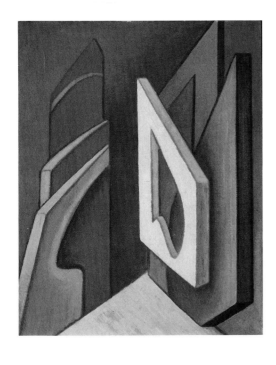

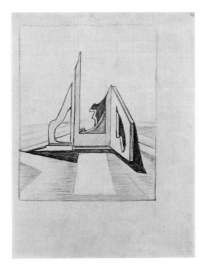

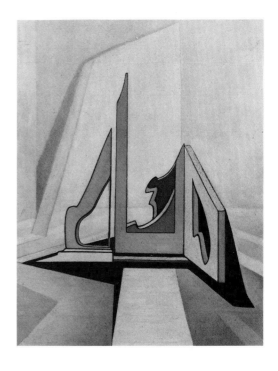

Oil on panel, 37.8 x 30.2 cm
The National Gallery of Canada, Ottawa, purchased
1973 (17,614)

PROVENANCE
The artist. Mr. Harry Adaskin, Vancouver.

EXHIBITIONS
Edmonton Art Gallery, December 11, 1981–January 24,
1982, *The Modern Image, Cubism and the Realist
Tradition*, No.21, repr. fig.6, p.15.

Graphite on paper, 27.8 x 21.7 cm
Collection of the Harris family

PROVENANCE
Estate of the artist.

Oil on masonite, 56.0 x 51.0 cm
LSH 66
LSH Holdings Ltd., Vancouver

PROVENANCE
Estate of the artist.

EXHIBITIONS
Harris 1983, no cat.

16

Poise 1936

17

Poise (Composition 4) 1936

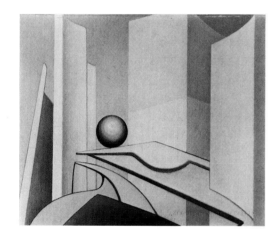

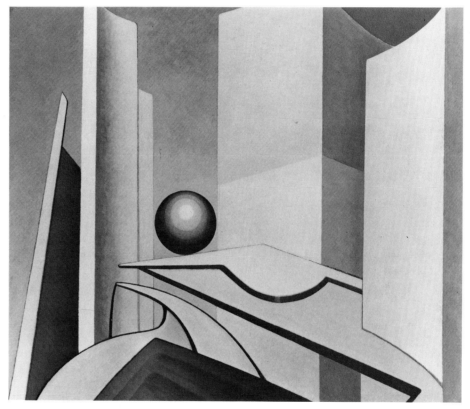

Oil on masonite, 45.8 x 56.0 cm
Mrs. Doris Huestis Mills Speirs, Pickering, Ontario

PROVENANCE
The artist, 1936. The work was for many years on loan to
Mrs. Edwin Meredith, Toronto.

LITERATURE
"Lawren Harris," *Mayfair* 22 (November 1948), repr. p.74,
as "Abstract, Painted 1937–47, From Collection of Mrs.
Edwin Meredith, Toronto."

The work is inscribed verso: TO DORIS/ON HER BIRTHDAY/
OCTOBER 1936./LAWREN HARRIS. The canvas is in this
exhibition, No.17. A preparatory drawing, *Abstract I.D.
544*, private collection, Vancouver, is repr. in Joan Murray
and Robert Fulford, *The Beginning of Vision: The
Drawings of Lawren S. Harris* (Toronto, Vancouver:
Douglas and McIntyre, with Mira Godard Editions,
Toronto, 1982), p.207.

Oil on canvas, 74.0 x 90.0 cm
Private collection, Ottawa

PROVENANCE
The artist (Laing Galleries, Toronto). Peter Bronfman,
Montreal. Waddington Galleries, Montreal. Artinvest,
Toronto. Acquired by the present owner c. 1981.

LITERATURE
J.S., "Lawren Harris Exhibit to Be Discussed," *Star-Phoenix*,
Saskatoon, Saskatchewan, October 18, 1949, repr.

EXHIBITIONS
CGP, Toronto, November 1937, Montreal, January 1938,
No.30, as "Composition-4." *CGP*, Ottawa, February
9–28, 1938, No.24, as "Composition 4." *Harris 1948*,
No.67, as "Abstract Painting."

The oil sketch is in this exhibition, No.16.

18

Abstraction No.3 c. 1937

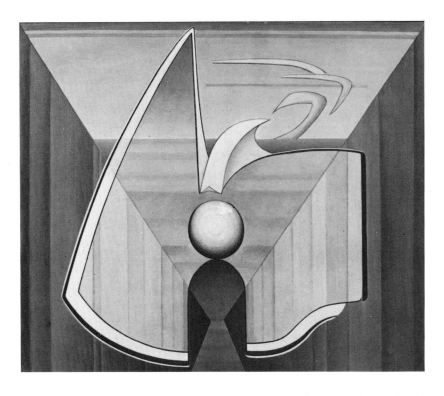

19

Pyramid c. 1937

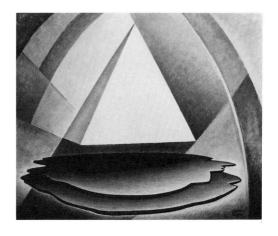

Oil on canvas, 74.0 x 92.0 cm
Collection of the Société Anonyme, Yale University Art Gallery, New Haven, Connecticut, gift of Katherine S. Dreier, December 1949 (1950.42)

PROVENANCE
The artist, November 1949.

LITERATURE
J.S., "Lawren Harris Exhibit to Be Discussed," *Star-Phoenix*, Saskatoon, Saskatchewan, October 18, 1949, repr. *Collection of the Société Anonyme: Museum of Modern Art 1920* (New Haven: Yale University Art Gallery,

1950), pp.127–28, repr. p.127. Robert L. Herbert, Eleanor S. Apter, Elise K. Kenney, eds., *The Société Anonyme and the Dreier Bequest at Yale University, A Catalogue Raisonné* (New Haven and London: Yale University Press, 1984), pp.321–22, repr. p.322, as "1934–37."

EXHIBITIONS
Harris 1948, No.69, as "Abstract Painting." New London, Connecticut, Lyman Allyn Museum, March 9–April 6, 1952, *Société Anonyme Collection*, no cat. *Harris 1963*, No.46.

Oil on masonite, 45.6 x 55.9 cm
Signed lower right: LAWREN/HARRIS
Art Gallery of Windsor, Windsor, Ontario, gift of Yvonne McKague Housser, Toronto, 1964 (64:11)

PROVENANCE
The artist, before 1945.

EXHIBITIONS
Art Gallery of Toronto, September 22–October 14, 1945, *Members' loan exhibition*, no cat.

The work is titled verso, and inscribed: TO YVONNE/WITH LOVE FROM/LAWREN.

20

Untitled c. 1937

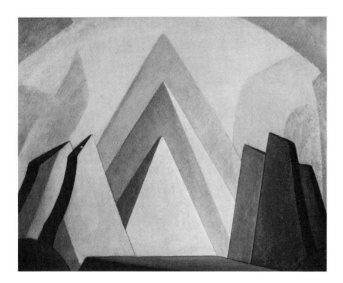

21

Riven Earth II 1936

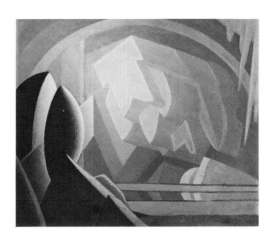

Oil on masonite, 55.9 x 66.0 cm
Signed lower right: LAWREN/HARRIS
Private collection, Toronto

PROVENANCE
The artist. Mr. and Mrs. Charles S. Band, Toronto, c. 1949.
By descent to the present owner 1982.

LITERATURE
Harris-Colgrove 1969, repr. in colour p.124, as
"Abstraction, 1936," although listed p.146 as "Riven Earth
II, 1936." Charles C. Hill, *Canadian Painting in the
Thirties* (Ottawa: The National Gallery of Canada, 1975),
p.177, as "c. 1936."

Oil on masonite, 50.7 x 63.5 cm
LSH 53
Georgia Riley de Havenon, New York, New York

PROVENANCE
Estate of the artist. LSH Holdings Ltd., Vancouver (Martin
Diamond Fine Arts, New York), 1983.

EXHIBITIONS
Albuquerque 1982, no No., as "c. 1938–1941." *Harris
1983*, no cat.

22

Riven Earth I (Composition 8) 1936

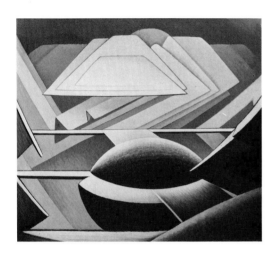

23

Composition 10 1937

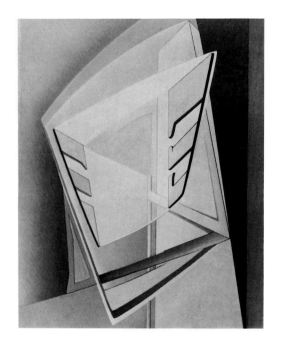

Oil on canvas, 77.5 x 91.4 cm
Miss Isabel McLaughlin, Toronto

PROVENANCE
The artist, c. 1949.

LITERATURE
H.A. Mulligan, "The Canadian Painters," *Canadian Comment* 6 (December 1937), pp.25–26, repr. Robert H. Hubbard, *The Development of Canadian Art* (Ottawa: The National Gallery of Canada, 1963), repr. pl. 172, p.101, as "Composition No.8, 1937." *Harris-Colgrove 1969*, repr. in colour p.108, as "Abstraction, 1936," although listed p.145 as "Riven Earth I, 1936."

EXHIBITIONS
CGP, Toronto, November 1937, Montreal, January 1938, No.31, as "Composition-8," repr. *CGP*, Ottawa, February 9–28, 1938, No.25, as "Composition 8." *Harris 1948*, No.68, as "Abstract Painting." *Harris 1963*, No.50, as "Abstraction." Ottawa, National Gallery of Canada, May 12–September 17, 1967, and at Toronto, Art Gallery of Ontario, October 20–November 26, 1967, *Three Hundred Years of Canadian Art*, No.249, repr. p.151, as "Composition No.8." Ottawa, National Gallery of Canada, 1975, and subsequent national tour, *Canadian Painting in the Thirties*, No.53, p.177, as "c. 1936," repr. p.86.

Oil on canvas, 101.6 x 81.3 cm
LSH 79
LSH Holdings Ltd., Vancouver

24

Composition c. 1938

(SEE COLOUR PLATE NO. 1)

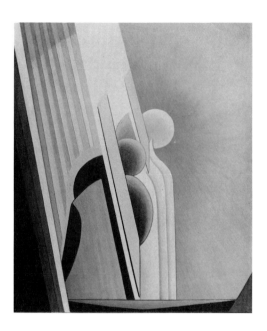

25

Geometrical Abstraction (Transatlantic)
c. 1939

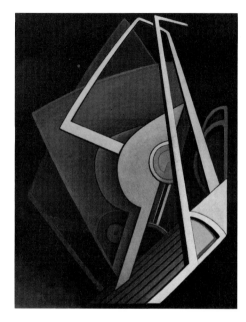

PROVENANCE
Estate of the artist.

LITERATURE
Paul Duval, "Lawren Harris's Switch to Abstract Art Annoys
Some, Stimulates Others," *Saturday Night* 54 (October
9, 1948), repr. p.2, as "Mountain Form No.6." Barbara
Gallati, "Lawren Harris," *Arts Magazine* 58 (January
1984), p. 50, as "Painting #79."

EXHIBITIONS
CGP, Toronto, November 1937, Montreal, January 1938,
Ottawa, February 9–28, 1938, No.32. New York World's
Fair, 1939, *American Art Today*, No.211, repr. p.92. Santa
Fe, August 1939, *Fiesta Show*, no No. ?15th *BCAE*,
September 21–October 13, 1946, No.52, as "Mountain
Form VI." ? Victoria, Little Centre, October 29–November
17, 1946, *Exhibition of Abstract Paintings by Lawren
Harris*, No.1, as "Mountain Form VI." *Harris 1948*, No.70,
as "Abstract Painting." *Harris 1958*, no cat. *Harris 1983*,
no cat., repr. in colour in the brochure, as "Painting #79,
c. 1938."

Oil on canvas, 91.5 x 76.6 cm
LSH 99
Art Gallery of Ontario, Toronto, purchased 1984 (84/863)

PROVENANCE
Estate of the artist. LSH Holdings Ltd., Vancouver.

The work is signed and titled verso on the stretcher.

Oil on canvas, 91.8 x 73.7 cm
Vancouver Art Gallery, gift of Dr. and Mrs. T. Ingledow,
Vancouver, 1970 (70.10)

LITERATURE
J.S., "Lawren Harris Exhibit to Be Discussed," *Star-Phoenix*,
Saskatoon, Saskatchewan, October 18, 1949, repr.

EXHIBITIONS
Harris 1948, No.71, as "Abstract Painting." *Vancouver
1983*, p.387, no No.

26

Abstract c. 1939

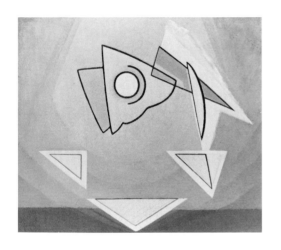

27

Untitled c. 1939

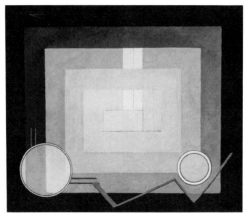

28

Untitled c. 1939

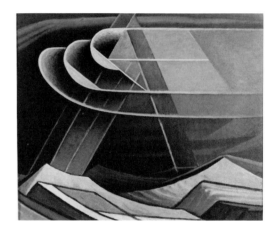

Oil on masonite, 56.0 x 60.5 cm
Signed lower left: LAWREN/HARRIS
LSH 71
Private collection, Victoria, British Columbia

PROVENANCE
Estate of the artist. LSH Holdings Ltd., Vancouver, 1980.

Oil on masonite, 51.0 x 60.0 cm
LSH 194
LSH Holdings Ltd., Vancouver

PROVENANCE
Estate of the artist.

EXHIBITIONS
Harris 1983, no cat.

In an inventory of paintings in the collection of Lawren
Harris, compiled in his home by Ian McNairn, May 31,
1963 (Central Registry, National Gallery of Canada,
Ottawa), this work is listed as No.34, dated 1943.

Oil on masonite, 50.5 x 61.2 cm
LSH 40
LSH Holdings Ltd., Vancouver

PROVENANCE
Estate of the artist.

EXHIBITIONS
Harris 1983, no cat.

The canvas, now cancelled, is the verso of No.50 in this
exhibition. No.29 is a related canvas.

29

Abstract No.7 c. 1939

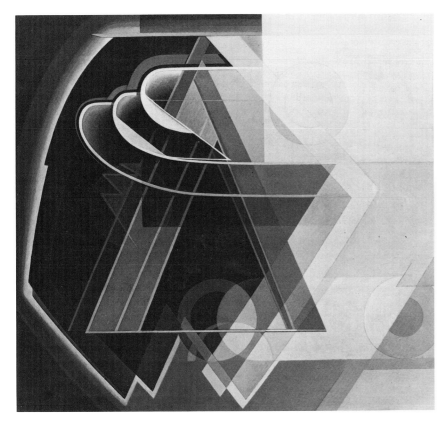

Oil on canvas, 110.5 x 123.2 cm
Vancouver Art Gallery, Founder's Fund, 1950 (50.5)

PROVENANCE
The artist.

LITERATURE
R.E. Watters, *British Columbia: A Centennial Anthology* (Toronto: McClelland and Stewart, 1958), pp.532–34, repr.

EXHIBITIONS
Harris 1948, No.74, as ``Abstract Painting.'' *Vancouver 1983*, p.387, no No., repr. p.25.

The work is inscribed on labels verso: Reserve for Miss Isabel McLaughlin/Also Reserved for Hart House. The sketch underlying No.51 in this exhibition is related.

30

Sheet of Studies c. 1938

Graphite on paper, 28.0 x 21.0 cm
Art Gallery of Greater Victoria, Victoria, British Columbia, gift of Mrs. Peggie Knox, 1981 (81.222.8)

PROVENANCE
Estate of the artist.

31

Three Studies, Involvement 2 c. 1939

a

b

c

Graphite on paper, each sheet 27.7 x 21.5 cm
Collection of the Harris family

PROVENANCE
Estate of the artist.

The titles were noted on a label verso by Bess Harris, c.
1968. The canvas is in this exhibition, No.32.

32

Abstraction (Involvement 2)　c. 1939

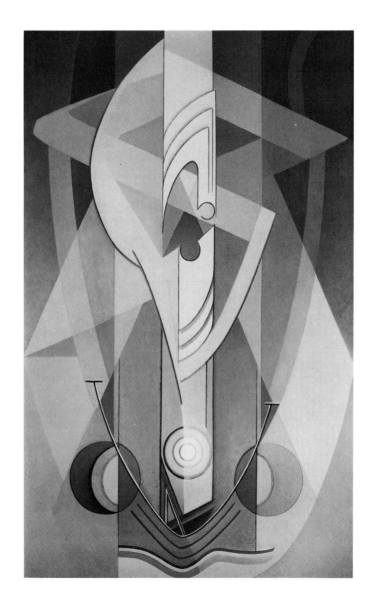

Oil on canvas, 141.0 x 87.6 cm
The National Gallery of Canada, Ottawa, gift of the
estate of Bess Harris and of the three children of Lawren S.
Harris, 1972 (17,161)

PROVENANCE
Gift of the artist to Bess Harris.

LITERATURE
Harris-Colgrove 1969, repr. in colour p.15, as "Abstraction
1938."

EXHIBITIONS
Harris 1948, No.62, as "Abstract Painting." *Albuquerque
1982*, no No., repr. in colour (upside down), n.p.

The preparatory drawings are in this exhibition, No.31.

33

Painting No.4 **c. 1939**

(SEE COLOUR PLATE NO. 2)

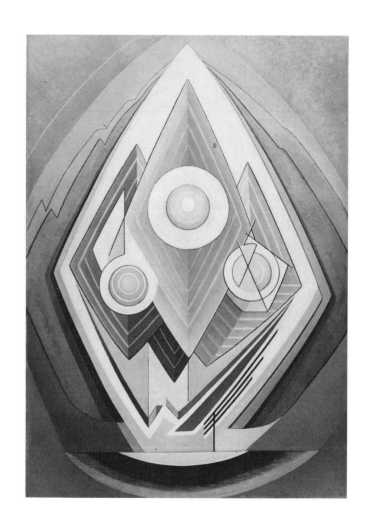

Oil on canvas, 129.5 x 93.0 cm
LSH 94
Art Gallery of Ontario, Toronto, purchased 1984 (84/864)

PROVENANCE
Estate of the artist. LSH Holdings Ltd., Vancouver.

EXHIBITIONS
Harris 1948, No.60, as "Abstract Painting." *Harris 1963*,
No.47, as "Abstraction, 1939–40, Coll. Bess Harris."

The work is signed and titled verso on the stretcher. A
preparatory drawing, *Abstract I.D. 583*, in a private
collection, Vancouver, is repr. in Joan Murray and Robert
Fulford, *The Beginning of Vision: The Drawings of
Lawren S. Harris* (Toronto, Vancouver: Douglas and
McIntyre, with Mira Godard Editions, Toronto, 1982),
p.203.

Composition No.1 1941

Oil on canvas, 157.5 x 160.7 cm
LSH 141
Vancouver Art Gallery, gift of Mr. and Mrs. Sidney Zack,
Vancouver, 1965 (65.35)

PROVENANCE
The artist.

LITERATURE
Sydney Smith, "The Recent Abstract Work of Lawren
Harris," *Maritime Art* 2 (February–March 1942), repr.
p.81. Paul Duval, "Lawren Harris's Switch to Abstract Art
Annoys Some, Stimulates Others," *Saturday Night* 54
(October 9, 1948), repr. p.2. Vancouver Art Gallery,
Annual Report (1965), repr. *Harris-Colgrove 1969*, repr.
in colour p.105, as "1940." Peter Mellen, *The Group of
Seven* (Toronto: McClelland and Stewart Limited, 1970),
repr. pl.219, p.191, as "1940." Dennis Reid, *A Concise
History of Canadian Painting* (Toronto: Oxford Univer-
sity Press, 1973), repr. in colour opp. p.177, as "1940." Barry
Lord, *The History of Painting in Canada; Toward a
People's Art* (Toronto: NC Press, 1974), repr. p.143, fig.134,
as "1940." Patricia Godsell, *Enjoying Canadian Paint-
ing* (Don Mills: General Publishing Co. Limited, 1976),
repr. p.142, as "1940." Peter Mellen, *Landmarks of
Canadian Art* (Toronto: McClelland and Stewart Limited,
1978), p.201, repr. in colour p.200, pl.91, as "1940."

EXHIBITIONS
Vancouver Art Gallery, April 29–May 14, 1941, *Lawren
Harris*, no cat. *Harris 1948*, No.66, as "Abstract Painting."
Harris 1963, No.48. *CGP*, Victoria, March 16–April 4,
1965, Kingston, June 3–27, 1965, No.22. Vancouver Art
Gallery, September 1966, *Images For a Canadian
Heritage*, No.83, as "1940." 57th *BCSA*, May 3–28, 1967,
No.21 in the "Retrospective Section 1909–1957," as
"1940." *Vancouver 1983*, p.387, no No., repr. in colour
p.24, as "c. 1940."

An oil sketch, on masonite, in the collection of Victoria
University in the University of Toronto, is inscribed verso: "To
John/an old friend,/from/Lawren". It was probably given
to Dr. John D. Robins in 1944.

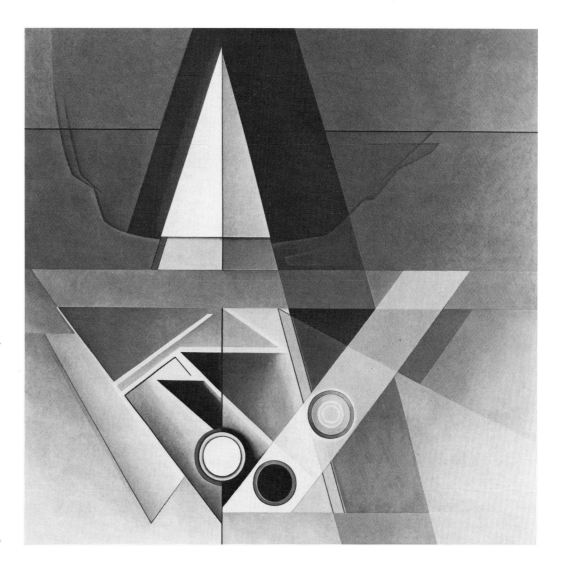

35

Abstract c. 1941

36

Painting No.2 1939-41

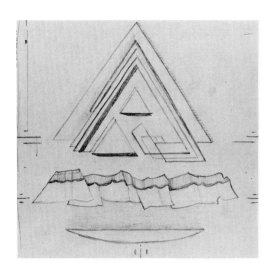

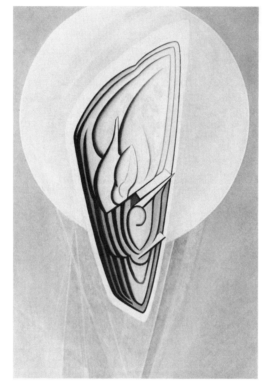

Graphite on paper, 20.0 x 21.0 cm
Art Gallery of Greater Victoria, Victoria, British Columbia,
gift of Mrs. Peggie Knox, 1981 (81.222.1)

PROVENANCE
Estate of the artist.

Oil on canvas, 130.5 x 91.9 cm
LSH 92
The McMichael Canadian Collection, Kleinburg, Ontario,
purchased 1984 (1984.25.2)

PROVENANCE
Estate of the artist. LSH Holdings Ltd., Vancouver.

EXHIBITIONS
CGP, Toronto, October 20–November 13, 1939, no No.,
as "Painting II."

Signed and titled, *Painting II*, verso, on the stretcher.
There is a related oil study in the same collection.

37

Mt. Ann-Alice c. 1941

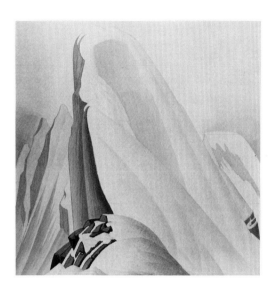

38

From the Harbour to the Open Sea 1941-52

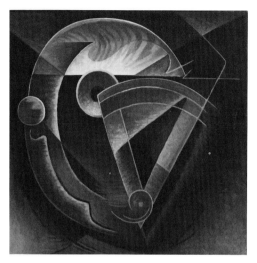

Oil on canvas, 124.5 x 125.7 cm
LSH 143
Private collection, Toronto

PROVENANCE
Estate of the artist. LSH Holdings Ltd., Vancouver. Acquired by the present owner 1976.

LITERATURE
Harris-Colgrove 1969, repr. in colour p.90, as "1941."

In an inventory of paintings in the collection of Lawren Harris, compiled in his home by Ian McNairn, May 31, 1963 (Central Registry, National Gallery of Canada, Ottawa), this work is listed as No.37, and as No.55, "Mountain Experience, 1943."

Unavailable for exhibition.

Oil on canvas, 102.2 x 103.5 cm
Mr. and Mrs. Michael Koerner, Toronto

PROVENANCE
The artist. Walter Koerner, Vancouver, c. 1945. Gift to the present owners c. 1963.

LITERATURE
Harris-Colgrove 1969, repr. in colour p.94, as "1952."

EXHIBITIONS
Harris 1955, No.4. *Harris 1963*, No.57, as "1941."

Inscribed verso on the stretcher: To my friend Walter Korner/I am very pleased he owns this painting — Lawren/Harris. There is a cancelled Santa Fe painting verso, related to a sketch in this exhibition, No.28.

39

Untitled c. 1942

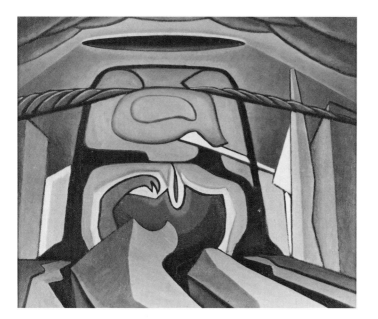

40

Untitled c. 1943

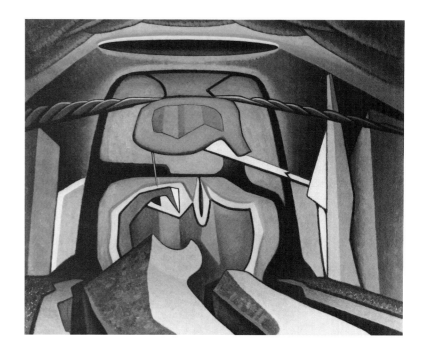

Oil on masonite, 50.8 x 61.0 cm
LSH 21
Joseph M. Erdelac, Cleveland, Ohio

PROVENANCE
Estate of the artist. LSH Holdings Ltd., Vancouver (Martin
Diamond Fine Arts, New York), 1982.

EXHIBITIONS
Albuquerque 1982, no No., as "c. 1938–1941."

The canvas is in this exhibition, No.40.

Oil on canvas, 81.8 x 101.2 cm
LSH 82
LSH Holdings Ltd., Vancouver

PROVENANCE
Estate of the artist.

EXHIBITIONS
Harris 1983, no cat., as "c. 1934."

The oil study is in this exhibition, No.39.

41

Abstract Painting No.20 c. 1945

Oil on canvas, 152.4 x 152.4 cm
The National Gallery of Canada, Ottawa, gift of the artist,
1960 (5016)

LITERATURE
Donald W. Buchanan, *The Growth of Canadian
Painting* (London and Toronto: Collins, 1950), repr. pl.29,
as "Abstract Composition." Northrop Frye, "The Pursuit of
Form," *Canadian Art* VI (Christmas–New Year, 1949),
repr. p.56, as "Abstract Painting." R.H. Hubbard, *The
National Gallery of Canada Catalogue of Paint-
ings and Sculpture, Volume III: Canadian School*
(Toronto: University of Toronto Press, 1960), p.114, repr.

EXHIBITIONS
38th *BCSA*, May 18–June 6, 1948, No.18. *Harris 1948*,
No.65, repr. pl.16, as "Abstract Painting." Calgary,
Glenbow-Alberta Institute, September 22–October 24,
1976, *Through Canadian Eyes*, No.65, repr. in colour.

42

Abstract (War Painting) 1943

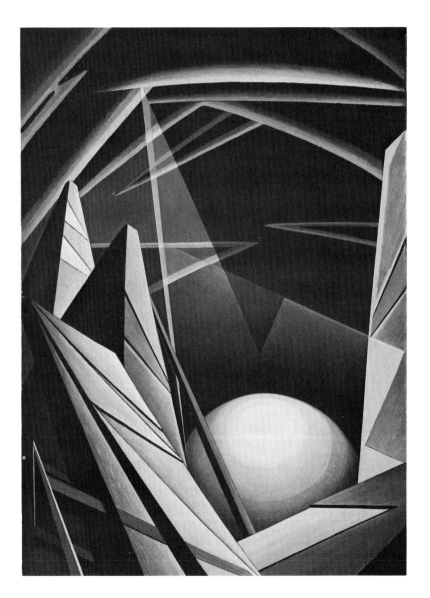

Oil on canvas, 106.7 x 76.2 cm
Hart House Permanent Collection, University of Toronto,
gift of the artist, 1949

LITERATURE
Yvonne McKague Housser, "Canadian Group of Painters
— 1944," *Canadian Art* I (April–May 1944), p.144, repr.
p.147, as "War Painting, 1943." *Canadian Art* IV (March
1947), repr. p.83, as "Abstract Composition." J. Russell
Harper, *Canadian Paintings in Hart House* (Toronto:
Hart House Art Committee, 1955), p.87, as "ca. 1948,"
repr. p.39. J. Russell Harper, *Painting in Canada: A
History* (Toronto: University of Toronto Press, 1966), repr. pl.
328, p.359, as "1942," and in 2nd edition (1977), repr. pl.
153, p.388, as "1942." Dennis Reid, "Lawren Harris,"
artscanada 25 (December 1968), repr. p.13, as "c.
1942." Jeremy Adamson, *The Hart House Collection
of Canadian Paintings* (Toronto: University of Toronto
Press, 1969), No.44, p.92, repr. p.64, as "1943." Paul Duval,
*Four Decades, The Canadian Group of Painters
and their contemporaries — 1930–1970* (Toronto:
Clarke, Irwin & Company Limited, 1972), repr. in colour
p.23, as "1942."

EXHIBITIONS
CGP, Toronto, April 21–May 14, 1944, no No., as "1943."
Harris 1948, No.58, as "Abstract Painting," repr. on cover.
Harris 1963, No.51, as "1941."

A sketch is described in William Hart, "1932–1948: Theory
and Practice of Abstract Art," *Lawren Harris Retrospec-
tive Exhibition, 1963* (Ottawa: National Gallery of Can-
ada, 1963), pp.36–37, present whereabouts unknown.

43

Abstract c. 1945

Graphite on paper, 21.4 x 27.7 cm
Art Gallery of Greater Victoria, Victoria, British Columbia,
gift of Mrs. Peggie Knox, 1981 (81.222.7)

PROVENANCE
Estate of the artist.

44

Untitled c. 1945

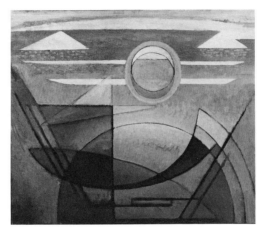

Oil on board, 38.0 x 45.5 cm
LSH 1
LSH Holdings Ltd., Vancouver

PROVENANCE
Estate of the artist.

EXHIBITIONS
Harris 1983, no cat.

The canvas is in this exhibition, No.45. There is a
cancelled painting of the same period verso.

45

Sun and Earth c. 1945

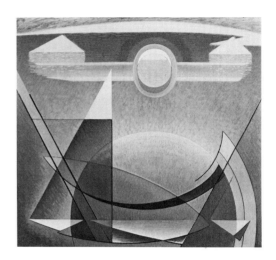

Oil on canvas, 98.2 x 111.5 cm
LSH 170
The Art Emporium, Vancouver (D371)

PROVENANCE
Estate of the artist. LSH Holdings Ltd., Vancouver.

EXHIBITIONS
Harris 1963, No.60. *Harris 1976*, no cat., repr. in colour on
brochure.

The oil sketch is in this exhibition, No.44.

46

Untitled (unfinished) c. 1945

47

Abstract Landscape c. 1947

48

Design for a Panel: Autumn c. 1945

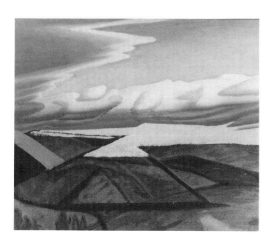

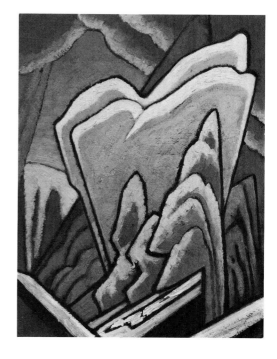

Oil on board, 38.0 x 46.0 cm
LSH 56
LSH Holdings Ltd., Vancouver

PROVENANCE
Estate of the artist.

An unfinished sketch of the early twenties (probably Lake Superior), partially reworked in the mid-forties.

Graphite on paper, 21.3 x 27.6 cm
Ontario Heritage Foundation, Firestone Art Collection, Ottawa

PROVENANCE
Estate of the artist. Lawren P. Harris, Ottawa. Acquired by the present owner 1977.

LITERATURE
Firestone Art Collection (Toronto: McGraw-Hill Ryerson Limited, 1978), Harris No.13, p.65, as "ca. 1946–1948."

Oil on board, 38.1 x 30.5 cm
Vancouver Art Gallery, gift of the Women's Auxiliary, 1968 (68.20)

EXHIBITIONS
Vancouver Art Gallery, Extension Dept., September 13–November 12, 1974, *100 Years of Canadian Art*, no cat. *Vancouver 1983*, p.387, no No.

A related work of the same size, also titled *Autumn*, was on the Toronto art market in 1980.

49

Mountain Experience I c. 1946

(SEE COLOUR PLATE NO. 3)

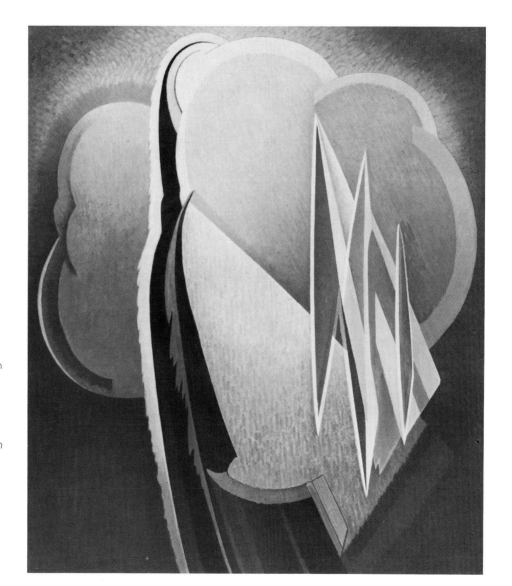

Oil on canvas, 130.5 x 113.3 cm
LSH 172
The Art Emporium, Vancouver (D372)

PROVENANCE
Estate of the artist. LSH Holdings Ltd., Vancouver.

LITERATURE
Harris-Colgrove 1969, repr. in colour p.93, as "Mountain
Experience 1954."

EXHIBITIONS
15th *BCAE*, September 21–October 13, 1946, No.53, as
"Abstract Painting of a Mountain Experience." Victoria,
Little Centre, October 29–November 17, 1946, *Exhibition
of Abstract Paintings by Lawren Harris*, No.19, as
"Abstract Painting of a Mountain Experience I." Art
Association of Montreal, March 21–April 20, 1947, *64th
Annual Spring Exhibition*, No.111, as "Subjective
Painting, Mountain Experience." *Harris 1948*, No.63, as
"Abstract Painting." *Harris 1955*, No.12, as "Mountain
Experience." *Harris 1963*, No.49, as "1950–52."

The work is signed verso on the stretcher.

50

Painting c. 1948

Oil on canvas, 81.8 x 109.7 cm
Art Gallery of Hamilton, Hamilton, Ontario. Bequest of H.S.
Southam, Esq., C.M.G., LL.D., 1966 (66.72.20)

PROVENANCE
Acquired from the artist c. 1950.

EXHIBITIONS
CGP Montreal, January, Ottawa, February 8–March 7,
1949, No.18.

There is a cancelled painting verso, an enlarged version
of No.28 in this exhibition. The work is signed and titled on
the frame, verso.

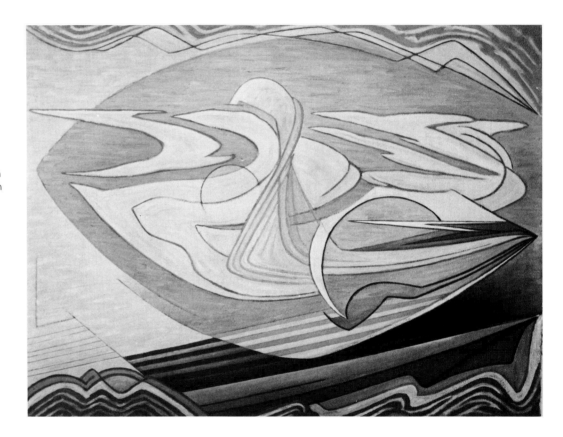

51

Untitled 1939-49

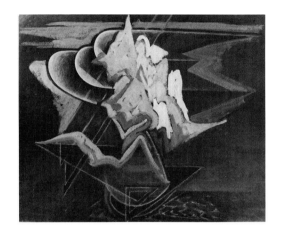

52

In Memoriam to a Canadian Artist 1950

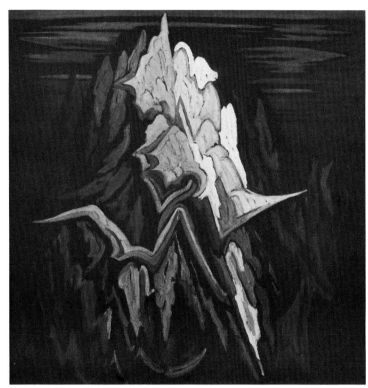

Oil on canvas, 101.6 x 101.6 cm
Mr. R.G.P. Colgrove, Sante Fe, New Mexico

PROVENANCE
The artist (Laing Galleries, Toronto). Mr. and Mrs. R.A. Daly,
Toronto, 1959. Gift to the present owner 1968.

LITERATURE
Lawren Harris, "What the Public Wants," *Canadian Art*
12 (Autumn 1954), repr. p.13. *Harris-Colgrove 1969*, repr.
in colour p.42, as "1950."

EXHIBITIONS
Harris 1955, No.3. *Harris 1958*, no cat. Toronto, Canadian
National Exhibition, August 20–September 6, 1958,
Canadian Paintings and Sculpture, No.83. Toronto,
Canadian National Exhibition, August 26–September 12,
1959, *Private Collectors' Choice in Canadian Art*,
no No.

There is a cancelled Sante Fe painting verso.

Oil on masonite, 45.5 x 56.0 cm
LSH 35
LSH Holdings Ltd., Vancouver

PROVENANCE
Estate of the artist.

A related canvas is in this exhibition, No.52.

53

Configuration in Space (Formative I)
c. 1950

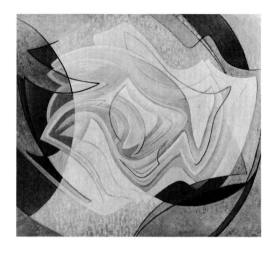

54

Painting (Formative III) 1950

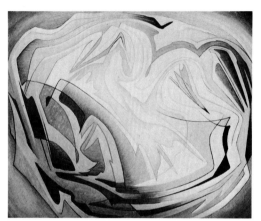

Oil on canvas, 108.4 x 133.4 cm
LSH 177
LSH Holdings Ltd., Vancouver

PROVENANCE
Estate of the artist.

EXHIBITIONS
40th *BCSA*, April 25–May 14, 1950, No.44, as "Formative I," repr. on cover. *Harris 1955*, No.19, as "Configuration in Space." *Harris 1958*, no cat. *Harris 1963*, No.80, as "Configuration in Space 1957."

There is a cancelled Sante Fe or early Vancouver painting verso. The work is signed and titled "Configuration in Space" verso, on the stretcher.

Oil on canvas, 103.8 x 129.0 cm
LSH 152
LSH Holdings Ltd., Vancouver

PROVENANCE
Estate of the artist.

LITERATURE
Vancouver Sun, December 13, 1951, repr., as "Formative III." *Harris-Colgrove 1969*, repr. in colour p.115, as "Abstraction 1951," although listed p.146 as "Forming toward Beneficence 1951."

EXHIBITIONS
CGP, Toronto, November 10–December 17, 1950, No.37, as "Formative III." *BCAE*, November 27–December 16, 1951, No.37, as "Formative III." *Harris 1955*, No.15, as "Forming Toward Beneficence." *Harris 1958*, no cat. *Harris 1963*, No.56, as "Formative II." *Vancouver 1983*, p.387, no No., as "Formative II (Painting), c. 1955," repr. p.90.

The work is signed and titled "Painting," verso, on the stretcher.

55

Painting (Annunciation) c. 1952

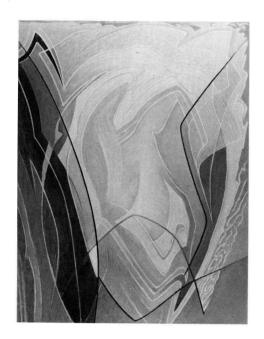

Oil on canvas, 129.5 x 101.0 cm
LSH 151
LSH Holdings Ltd., Vancouver

PROVENANCE
Estate of the artist.

LITERATURE
Harris-Colgrove 1969, repr. in colour p.107, as "Abstraction 1954," although listed p.145 as "Annunciation 1954."

EXHIBITIONS
Harris 1958, no cat. *Harris 1963*, No.69, as "Annunciation 1958–63."

The work is signed and titled "Painting," verso, on the stretcher.

56

Untitled c. 1952
(SEE COLOUR PLATE NO. 4)

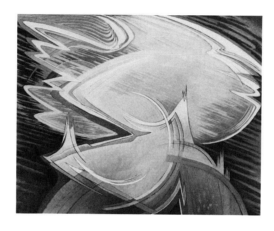

Oil on canvas, 114.0 x 146.8 cm
LSH 133
The Edmonton Art Gallery, purchased in 1982 with funds donated by the Women's Society of the Edmonton Art Gallery (82.2)

PROVENANCE
Estate of the artist. LSH Holdings Ltd., Vancouver.

LITERATURE
Christopher Varley, "Lawren Harris: The Pursuit of the Abstract," *Update* III (January–February 1982), repr. p.7 (positioned vertically).

EXHIBITIONS
Edmonton Art Gallery, September 2–October 10, 1983, and subsequent national tour until October 28, 1984, *Winnipeg West — Painting and Sculpture in Western Canada — 1945–1970*, no No., repr. p.4.

57

Northern Image c. 1952

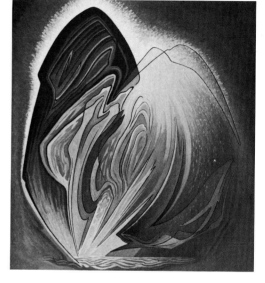

Oil on canvas, 127.6 x 120.0 cm
AMS Art Collection, Alma Mater Society of the University of British Columbia, Vancouver

PROVENANCE
The artist.

LITERATURE
Harris-Colgrove 1969, repr. in colour p.9, as "1950."

EXHIBITIONS
CGP, Toronto, November 1952, Montreal, January 1953, No.35. *CGP*, Toronto, November–December 1954, London, Ontario, January 1955, Hamilton, February, Ottawa, March 1955, No.22. *Harris 1955*, No.20. *Harris 1963*, No.65, as "1953–54," repr. colour frontis. *Vancouver 1983*, p.387, no No., repr. p.410.

58

Eclipse of the Spirit c. 1954

59

Migratory Flight c. 1954

60

Untitled c. 1955

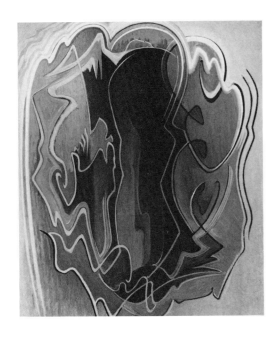

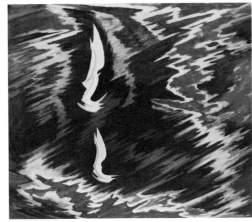

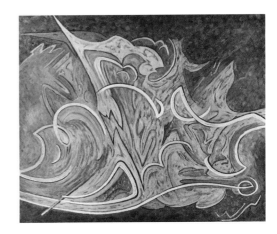

Oil on canvas, 109.3 x 93.5 cm
LSH 153
LSH Holdings Ltd., Vancouver

PROVENANCE
Estate of the artist.

LITERATURE
Harris-Colgrove 1969, repr. in colour p.127, as "Abstraction 1950," although listed p.146 as "Eclipse of the Spirit 1950."

EXHIBITIONS
Harris 1955, No.7. *Harris 1958*, no cat. *Harris 1963*, No.66, as "1957." *Harris 1976*, no cat.

The work is signed and titled verso on the stretcher.

Oil on canvas, 108.0 x 126.1 cm
LSH 158
The Art Emporium, Vancouver

PROVENANCE
Estate of the artist. LSH Holdings Ltd., Vancouver.

LITERATURE
Harris-Colgrove 1969, repr. in colour p.95, as "1950."

EXHIBITIONS
Harris 1955, No.21. *CGP* Toronto, November 9–December 26, 1956, Vancouver, January 1957, No.26, repr. *Harris 1963*, No.62, as "A Migratory Flight 1954–56."

The work is signed verso on the stretcher.

Oil on canvas, 100.5 x 125.7 cm
LSH 69
LSH Holdings Ltd., Vancouver

PROVENANCE
Estate of the artist.

EXHIBITIONS
Harris 1958, no cat.

The work is dated 1960 verso, on the stretcher. In an inventory of paintings in the collection of Lawren Harris, compiled in his home by Ian McNairn, May 31, 1963 (Central Registry, National Gallery of Canada, Ottawa), this work is listed as No.39, dated 1960.

61

Abstraction (Ritual Dance in Spring) c. 1955

(SEE COLOUR PLATE NO. 5)

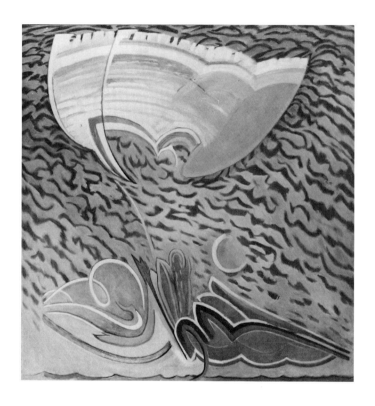

62

Lyric Theme c. 1955

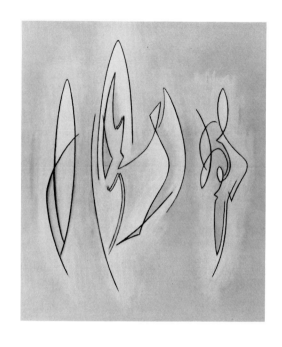

Oil on canvas, 131.5 x 124.8 cm
LSH 154
LSH Holdings Ltd., Vancouver

PROVENANCE
Estate of the artist.

LITERATURE
Harris-Colgrove 1969, repr. in colour p.113, as "Abstraction
1957," although listed p.145 as "Ritual Dance in Spring
1957."

EXHIBITIONS
Harris 1955, No.6, as "Ritual Dance in Spring." *Harris
1963*, No.78, as "Abstraction 1961–62." *Vancouver 1983*,
p.387, no No., as "c. 1955," repr. in colour p.90, as "1955."

A smaller work entitled *Ritual Dance in Spring* was
exhibited in *Harris 1963*, No.71. This could have been
Frolic, 1959, LSH 154, another version of No.61, collection
LSH Holdings Ltd.

Oil on canvas, 92.2 x 77.0 cm
Art Gallery of Greater Victoria, Victoria, British Columbia,
gift of Dr. J. Edelson, 1981 (81.225.13)

EXHIBITIONS
Harris 1955, No.1.

A related work, *Lyric Theme II*, LSH 125, is in the
collection of LSH Holdings Ltd., Vancouver.

63

Untitled c. 1956

64

Three Planes of Being c. 1956

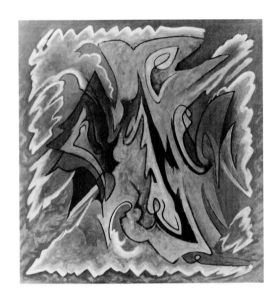

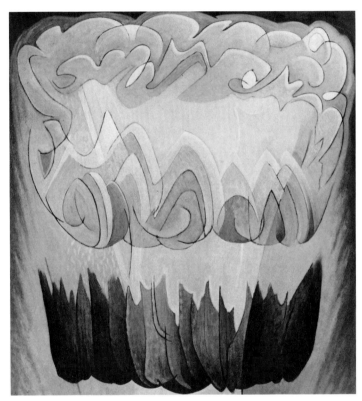

Oil on canvas, 104.4 x 101.5 cm
LSH 78
LSH Holdings Ltd., Vancouver

PROVENANCE
Estate of the artist.

There is a cancelled Sante Fe painting verso, related to
an untitled painting on masonite, LSH 22, LSH Holdings
Ltd., Vancouver. On the verso of LSH 88, in the same
collection, is its canvas.

Oil on canvas, 135.3 x 127.0 cm
LSH 155
LSH Holdings Ltd., Vancouver

PROVENANCE
Estate of the artist.

EXHIBITIONS
Harris 1963, No.67.

The work is titled verso on the stretcher.

65

Abstraction 1957

66

Abstraction 1957

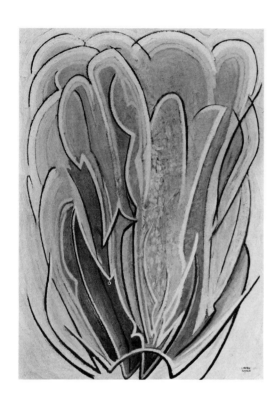

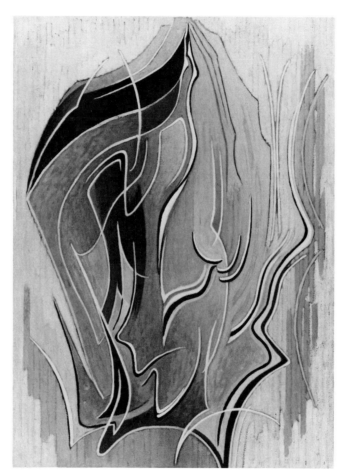

Oil on masonite, 76.2 x 56.5 cm
Signed lower right: LAWREN/HARRIS
Dominion Gallery, Montreal (E2146)

PROVENANCE
The artist, 1960.

The work is dated verso.

Oil on canvas, 103.5 x 77.0 cm
LSH 167
LSH Holdings Ltd., Vancouver

PROVENANCE
Estate of the artist.

EXHIBITIONS
Harris 1958, no cat. *Harris 1963*, No.59, as ``Abstraction
1950–54.''

67

Untitled c. 1957

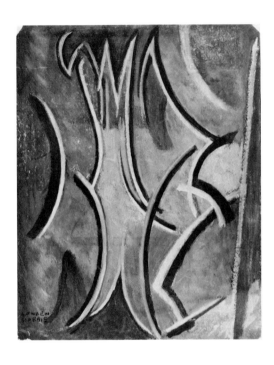

Oil on board, 38.0 x 32.0 cm
LSH 2
LSH Holdings Ltd., Vancouver

PROVENANCE
Estate of the artist.

68

Painting XIII (Abstraction) 1957-58

(SEE COLOUR PLATE NO. 6)

Oil on canvas, 120.0 x 94.2 cm
LSH 181
LSH Holdings Ltd., Vancouver

PROVENANCE
Estate of the artist.

LITERATURE
Harris-Colgrove 1969, repr. in colour p.17, as "Abstraction 1950."

EXHIBITIONS
Harris 1958, no cat. Toronto, Canadian National Exhibition, August 20–September 6, 1958, *Canadian Paintings and Sculpture*, No.81, as "Painting XIII." *Harris 1963*, No.64, as "Abstraction 1957–58."

The work is signed and titled "Painting," verso, on the stretcher.

69

Abstraction 1958

Oil on masonite, 57.8 x 76.2 cm
Signed lower right: LAWREN/HARRIS
Dominion Gallery, Montreal (C2146)

PROVENANCE
The artist, 1960.

The work is dated verso.

70

Study in Contrast 1958

71

Untitled 1958

72

Untitled 1958

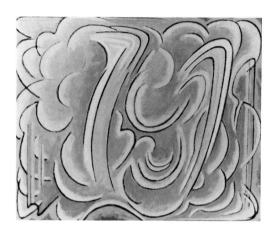

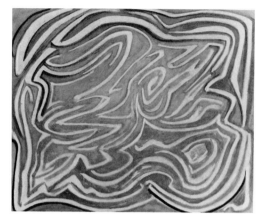

Oil on masonite, 60.8 x 76.0 cm
LSH 87
LSH Holdings Ltd., Vancouver

PROVENANCE
Estate of the artist.

The work is signed and dated verso. In an inventory of
paintings in the collection of Lawren Harris, compiled in
his home by Ian McNairn, May 31, 1963 (Central Registry,
National Gallery of Canada, Ottawa), this work is listed
as No.15, dated 1956–58.

Oil on masonite, 61.0 x 76.4 cm
LSH 85
LSH Holdings Ltd., Vancouver

PROVENANCE
Estate of the artist.

The work is signed and dated verso. A larger, later version
on canvas is in this exhibition, No.78.

Oil on masonite, 76.2 x 56.6 cm
Signed lower right: LAWREN/HARRIS
Dominion Gallery, Montreal (F2176)

PROVENANCE
The artist, 1960–61.

The work is dated verso.

73

Untitled 1958

Oil on masonite, 91.4 x 50.6 cm
LSH 106
LSH Holdings Ltd., Vancouver

PROVENANCE
Estate of the artist.
The work is signed and dated verso.

74

Untitled c. 1958

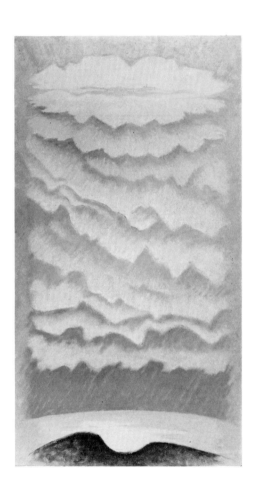

Oil on masonite, 91.2 x 51.0 cm
Mr. John Victor Watson, London, England

PROVENANCE
The artist (Laing Galleries, Toronto). Mrs. V.R. Smith, Toronto
c. 1959. By descent to Mrs. Phyllis G.S. Preston, Oakville,
Ontario. By descent to the present owner.

75

Abstraction c. 1958

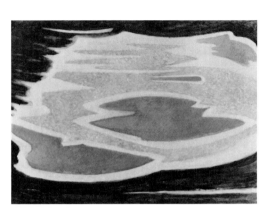

Oil on canvas, 101.0 x 137.3 cm
LSH 97
LSH Holdings Ltd., Vancouver

PROVENANCE
Estate of the artist.

LITERATURE
Harris-Colgrove 1969, repr. in colour p.129, as "Abstraction
1958."

A smaller version on canvas, dated 1958 verso, LSH 128, is
in the same collection.

76

Painting 1958-62

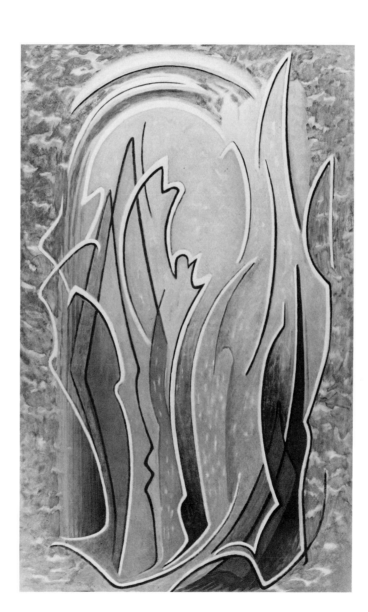

Oil on canvas, 165.1 x 106.5 cm
LSH 173
LSH Holdings Ltd., Vancouver

PROVENANCE
Estate of the artist.

EXHIBITIONS
CGP, Toronto, November 10–December 9, 1962, Ottawa,
March 7–April 7, 1963, No.12 (dimensions given in
horizontal position). *Harris 1963*, No.68, as "1958–62"
(dimensions given in vertical position).

77

Abstraction 1961

(SEE COLOUR PLATE NO. 7)

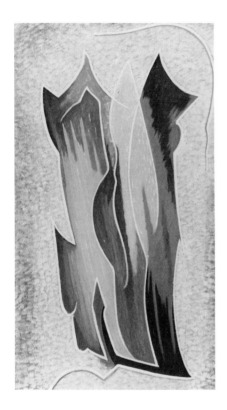

Oil on canvas, 164.0 x 93.5 cm
LSH 174
LSH Holdings Ltd., Vancouver

PROVENANCE
Estate of the artist.

EXHIBITIONS
Harris 1963, No.77, as "Abstraction 1961."

A smaller version of 1958, *Untitled Abstraction*, is with
the Dominion Gallery, Montreal (D2176).

78

Painting c. 1962

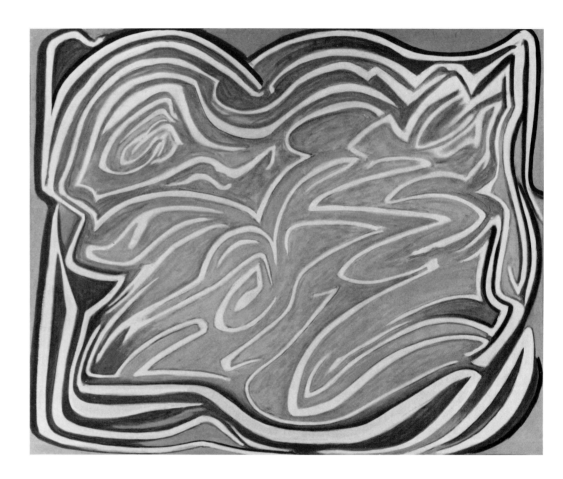

Oil on canvas, 101.4 x 136.9 cm
LSH 101
LSH Holdings Ltd., Vancouver

PROVENANCE
Estate of the artist.

EXHIBITIONS
CGP, Toronto, November 10–December 9, 1962, Ottawa,
March 7–April 7, 1963, No.13, repr.

A smaller, earlier version on masonite is in this exhibition,
No.72.

Atma Buddhi Manas 1962
(SEE COVER)

The Spirit of Remote Hills 1957-60

Abstraction (Day and Night) 1962

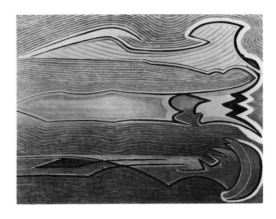

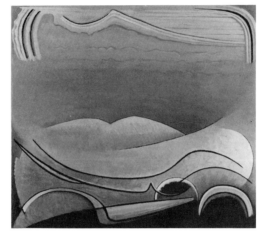

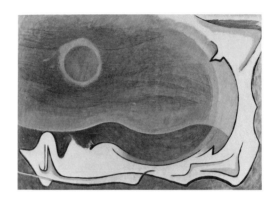

Oil on canvas, 101.8 x 139.4 cm
LSH 180
LSH Holdings Ltd., Vancouver

PROVENANCE
Estate of the artist.

LITERATURE
Harris-Colgrove 1969, repr. in colour p.119 (in vertical position), as "Abstraction 1958," although listed p.146 as "Three Planes of Being 1958."

EXHIBITIONS
Harris 1963, No.79, as "1962." *Vancouver 1983*, p.387, no No., repr. p.128.

The work is titled verso on the stretcher. Another version, smaller, and partially scraped off, is LSH 148, LSH Holdings Ltd. In a private collection, Vancouver, is a larger version, c. 1965.

Oil on canvas, 112.0 x 127.0 cm
LSH 161
LSH Holdings Ltd., Vancouver

PROVENANCE
Estate of the artist.

EXHIBITIONS
26th *BCAE*, November 12–December 8, 1957, No.26.
Harris 1963, No.70, as "1959–60."

The work is titled verso on the stretcher.

Oil on canvas, 91.5 x 131.5 cm
LSH 113
LSH Holdings Ltd., Vancouver

PROVENANCE
Estate of the artist.

LITERATURE
Harris-Colgrove 1969, repr. in colour p.117, as "Day and Night 1960."

EXHIBITIONS
Harris 1963, not catalogued, although labelled as "Abstraction, 1962." *Harris 1976*, no cat.

82

Untitled Landscape c. 1963

83

Untitled c. 1964

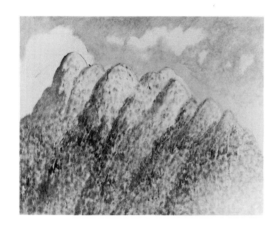

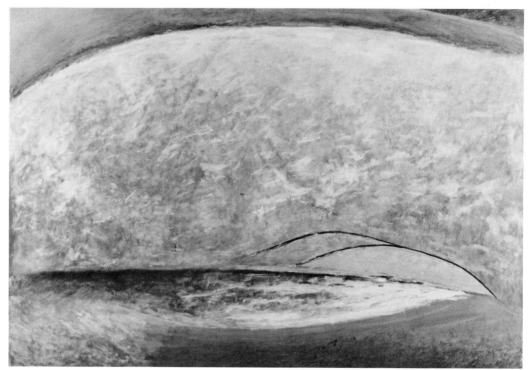

Oil on canvas, 99.2 x 126.7 cm
LSH H
Private collection, Kinmount, Ontario

PROVENANCE
The artist. LSH Holdings Ltd., Vancouver. Mr. Howard Harris,
Vancouver. By descent to the present owner.

Oil on canvas, 116.3 x 164.4 cm
LSH U
Collection of the Harris family

PROVENANCE
The artist. LSH Holdings Ltd., Vancouver. Mr. Howard Harris,
Vancouver. By descent to the present owners.

84

The Rising Sun c. 1967

Oil on canvas, 116.5 x 165.0 cm
LSH D
Collection of the Harris family

PROVENANCE
The artist. LSH Holdings Ltd., Vancouver. Mr. Howard Harris,
Vancouver. By descent to the present owners.

LITERATURE
Harris-Colgrove 1969, repr. in colour p.135, as "The
Rising Sun 1967." Miriam Waddington, "Space as
Morality," *artscanada* 27 (April 1970), repr. p.63.

85

Abstraction c. 1967

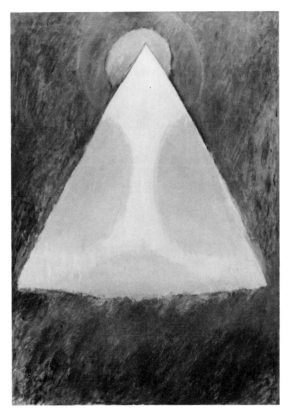

Oil on canvas, 160.0 x 110.0 cm
LSH N
Private collection, Vancouver.

PROVENANCE
The artist. LSH Holdings Ltd., Vancouver.

LITERATURE
Dennis Reid, "Lawren Harris," *artscanada* 25 (December
1968), repr. p.15, as "Abstraction 1967." *Harris-Colgrove
1969*, repr. in colour p.132, as "Abstraction 1967." Eli
Mandel, "The inward, northward journey of Lawren
Harris," *artscanada* 35 (October–November 1978), repr.
in colour p.23. Lawren Harris, "An Essay on Abstract
Painting," *artscanada* 39 (March 1982), repr. in colour
p.43, as "Abstraction, 1967."

86

Untitled c. 1968

(SEE COLOUR PLATE NO. 8)

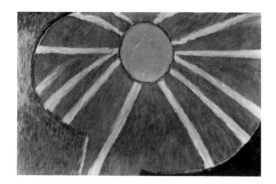

87

Untitled c. 1968

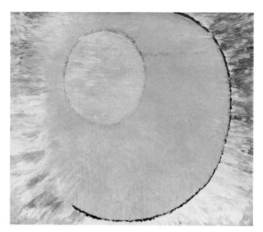

88

Untitled c. 1968

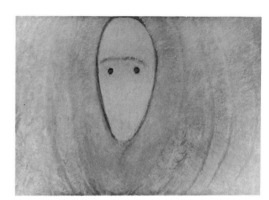

Oil on canvas, 111.0 x 163.0 cm
LSH P
Private collection, Vancouver

PROVENANCE
The artist. LSH Holdings Ltd., Vancouver.

Oil on canvas, 103.8 x 122.4 cm
LSH S
Private collection, Vancouver

PROVENANCE
The artist. LSH Holdings Ltd., Vancouver.

Oil on canvas, 117.2 x 165.2 cm
LSH E
Private collection, Vancouver

PROVENANCE
The artist. LSH Holdings Ltd., Vancouver.

Chronology

compiled by Peter Larisey, s.j.

During his last year and a half in Toronto (January 1933 to July 1934) Harris did no painting. He deepened and extended his personal involvement with the Toronto Theosophical Society, however: he lectured, gave classes and radio talks, and published articles. In the summer of 1934 he travelled to Reno, Nevada, and married Bess Housser after obtaining a divorce from his first wife. They travelled in the United States and in the late fall arrived at Dartmouth College, Hanover, New Hampshire, where they made their home until the spring of 1938.

On his arrival in Hanover, Harris immediately overcame his blockage of two years' standing and started to draw and paint. He worked on landscapes at first — mainly of the White Mountains — but soon gave up representational painting and began his first abstractions. As "unofficial artist in residence" Harris participated in the intellectual and artistic life of Dartmouth College's Art Department, which was keenly interested in modern art. They often invited modernist guest lecturers and Harris participated in discussions with them. Lawren and Bess took frequent train trips to New York City to see exhibitions and collections of mainly modern art in galleries and museums.

Driving through the Southwest in the spring of 1938, the Harrises discovered Sante Fe, New Mexico, and decided immediately to move there. Between the fall of 1938 and the summer of 1940, they lived in this city of old adobe buildings where Harris, continuing his abstract painting, became a founding member of the Transcendental Painting Group. During this period the couple's travels continued: to Maine for summer vacations, to New York in the winters, and to California. They also travelled frequently to nearby Taos, New Mexico, where Bess was studying Dynamic Symmetry with one of their new friends, the painter Emil Bisstram.

The last trip the Harrises took from Sante Fe was back to Canada in the fall of 1940. They spent some time in Toronto and then moved to rented quarters in Vancouver. They quickly got involved in the artistic and social life of the city, especially at the Vancouver Art Gallery, where Harris, in 1941, became an Elected Representative on the Council and in 1942 began a fourteen-year tenure as the Chairman of the Exhibition Committee.

From 1940 to 1957, the Harrises spent part of each summer in the Rocky Mountains. During the mid-1940s, as President of the Federation of Canadian Artists, Harris travelled much back and forth across Canada campaigning for the Federation's causes. From 1947 to 1956, he frequently went to New York to see contemporary art.

After his appointment as the first artist member of the Board of Trustees of the National Gallery of Canada in 1950, Harris travelled by railroad to Ottawa twice a year. The meetings were usually held in the spring and in the fall.

Harris never fully recovered his strength after a heart operation in 1958. His recorded activities became fewer; his travel became less demanding. But he continued to paint, even from his sickbed, until shortly before his death.

PL
June 1985

1933

MARCH 7
Resigned from the Ontario Society of Artists.

JUNE 10 – 11
Attended First North American International-Intertheosophical Convention at Niagara Falls, Ontario. Read paper on "Theosophy and Art."

FALL
Conducted Young Peoples' Classes at the Toronto Theosophical Society. Organized series of radio talks for the Toronto Theosophical Society on the theme of "The One Immutable Law, Re-Incarnation and Karma." The radio series continued until at least January 21.

NOVEMBER
Long talks with Emily Carr, who visited Toronto at the middle of the month.

1934

MARCH
Conducted another series of classes for the Toronto Theosophical Society.

JUNE 13
Separated from his wife, Beatrice.

JULY 6
Left Toronto with Bess Housser, who had recently filed for divorce from Fred. Harris also filed for divorce in Reno, Nevada.

AUGUST 29
Married to Bess, probably in Nevada. The two travelled in the United States for a few weeks.

NOVEMBER 13
Arrived at Hanover, New Hampshire, to visit Harris's uncle, William Kilbourne Stewart, a professor at Dartmouth College. Spent about a week sketching in the White Mountains. Within two or three weeks began painting abstractions. Decided to take up residence in Hanover, where Harris soon developed an unofficial association with the Art Department of Dartmouth College.

DECEMBER
The day after Christmas Lawren and Bess travelled to New York for a week, where they met Toronto painting friends, Mr. and Mrs. Peter Haworth.

1935

JANUARY 2
The Haworths returned to Hanover with the Harrises. They were the first Torontonians to see Lawren's abstractions.

JUNE 7
Lawren and Bess obtained visas for permanent residence in the United States.

OCTOBER
Sketched at Gray Rocks Inn, Maine, early in the month.

1936

FEBRUARY
To Ottawa for the Group of Seven retrospective.

DECEMBER
Visited in Hanover by the musicians Harry and Fran Adaskin, friends from Toronto.

1937

NOVEMBER
Harris exhibited abstracts in Canada for the first time, at the third exhibition of the Canadian Group of Painters in Toronto.

1938

MARCH 18
Arrived in Sante Fe, New Mexico, for the first time. Decided to stay, and soon met painters with whom he founded the Transcendental Painting Group later in the year. Found a house to rent, and arranged to have a studio addition built.

JULY – AUGUST
Lawren and Bess vacationed at Prouts Neck, Maine.

SEPTEMBER
Harris travelled to Montreal to sit for a portrait by Lilias Torrance Newton, commissioned by Harry Southam of Ottawa. Also visited his daughter, Peggie, in St. Catharines, Ontario.

OCTOBER
Moved into their house at 1 Plaza Chamisal, Sante Fe.

1939

JANUARY 16 – 30
Spent two weeks in New York. Met Harris's mother there and made arrangements for her to live in Pasadena, California, for her health.

1940

JANUARY
In Pasadena, California, early in the month.

OCTOBER
Bess and Lawren visited British Columbia to look for a new home. Called on Emily Carr in Victoria October 23.

NOVEMBER
Lawren and Bess stayed at the Windsor Arms Hotel in Toronto and renewed old friendships and acquaintances.

DECEMBER
Departed Toronto for Vancouver early in the month; en route spent a few days at Banff. Rented a house at 4749 Belmont Avenue, Vancouver. At Christmas travelled to Victoria to visit Harris's mother, and called on Emily Carr.

1941

JUNE
Elected to the Council of the Vancouver Art Gallery Association, a position he would retain until 1957.

JULY – AUGUST
Lawren and Bess spent six weeks in the mountains, at least three with Jock and Barbara Macdonald at Lake O'Hara Lodge, Hector, B.C.

1942

BY LATE FEBRUARY
Purchased a house at 4760 Belmont Avenue, and arranged for his mother to rent 4749.

MAY 1 – 2
Attended the First Annual Meeting of the Federation of Canadian Artists at the Studio Building, Toronto. Harris elected Chairman of the B.C. region.

JUNE
Harris appointed Chairman of the Exhibition Committee of the Vancouver Art Gallery, a position he would retain through 1956.

AUGUST
Likely vacationed in the mountains.

NOVEMBER 25
Harris, with Ira Dilworth, became a founding trustee of the Emily Carr Trust, a position he would retain until 1962.

1943

AUGUST 1 – 14
In the mountains.

1944

MARCH
Elected President of the Federation of Canadian Artists, a position he would retain until 1947.

MAY 1 – 15
Visited Toronto, then Ottawa, returning via Toronto.

JUNE
Early in the month to Edmonton for meetings.

AUGUST 4 – 18
Vacationed near Lake Louise.

NOVEMBER
Late in the month lectured in Calgary, Regina, Saskatoon, and Winnipeg.

1945

APRIL 1 – 30
In Toronto, at the Park Plaza Hotel. Briefly in Ottawa, 23-24.

MAY 17
Back to Ottawa. Returned to Vancouver by May 21.

AUGUST
Vacationed at Mount Temple Chalet, Skoki Lodge, and later in the month at Lake Louise.

1946
MAY 16
LL.D. from the University of British Columbia, Vancouver.

MAY 17
To Toronto and Ottawa, returning June 6.

AUGUST
Vacationed at Lake O'Hara Lodge.

1947
MARCH 27 – APRIL 10
In Toronto.

APRIL
In New York.

AUGUST
Vacationed at Lake O'Hara Lodge.

1948
SPRING
To New York.

AUGUST 17 – 31
Vacationed at Lake O'Hara Lodge. Also visited Lake Louise.

SEPTEMBER
Visited Chicago at the end of the month, en route to Toronto.

OCTOBER
In Toronto until October 16 for his retrospective exhibition at the Art Gallery of Toronto. Then travelled to Montreal, and in New York with Bess by October 21.

1949
AUGUST
Vacationed at Lake O'Hara Lodge.

1950
SPRING
Appointed to the Board of Trustees of the National Gallery of Canada, a position he would retain until 1961, attending meetings in Ottawa twice a year.

AUGUST
Vacationed at Lake O'Hara Lodge.

AUTUMN
Bess and Lawren to Toronto for a few days to visit family; Sackville, N.B., to visit Lawren P. Harrises; Hanover, N.H., to visit Lawren's aunt Ethel Stewart; and New York.

1951
JUNE 8
LL.D. from the University of Toronto.

1952
AUTUMN
Bess and Lawren to Toronto, Ottawa, Montreal, Sackville, N.B., and New York.

1953
FEBRUARY – MARCH
Left about the middle of the month to drive to Los Lomas Ranch near Tucson, Arizona, returning mid-March.

SEPTEMBER 26
LL.D. from the University of Manitoba, Winnipeg.

OCTOBER
To Toronto for the opening of the A.Y. Jackson retrospective.

1954
FEBRUARY – MARCH
Vacationed at Tucson, Arizona.

OCTOBER
To New York.

1955
MARCH
Vacationed at Yuma, Arizona, where they encountered Isabel McLaughlin and Yvonne McKague Housser from Toronto.

1956
MARCH – APRIL
Bess and Lawren travelled to Europe via the Italian line from New York. Stopping first at Lisbon, they sailed on to Italy. Visited Florence, where they stayed two weeks, and among other centres, Assisi, Siena, Arezzo.

1958
APRIL 10
Harris was operated on for an aneurism of the aorta, followed by a long period of convalescence.

SEPTEMBER 9
Was well enough to attend the first exhibition of the Canadian Group of Painters to be opened west of Toronto, at the Vancouver Art Gallery.

DECEMBER 31
Appointed Honorary Vice-President and Guarantor of the Vancouver Art Gallery, a position he would retain for the rest of his life.

1959
FEBRUARY – APRIL
Sailed on a Holland-American Line passenger-freighter to England via the Panama Canal, travelled

in Europe, and returned to New York via the *Andrea Doria*.

MAY
Bess visited Toronto early in the month while Lawren went on to Vancouver.

JULY 1
Travelled to Ottawa in order to dine with Queen Elizabeth. His host, Governor General Vincent Massey, had been a friend since childhood.

1960
JANUARY
Bess to Toronto briefly, and Lawren to Ottawa.

1962
FEBRUARY 19
Canada Council Medal for 1961, accepted in Ottawa by Bess on Lawren's behalf.

1963
JUNE
Although too unwell to travel to Ottawa for the opening of his retrospective exhibition at the National Gallery of Canada June 6, Harris was able to view it later in the month.

1964
AUGUST
Bess visited Toronto briefly.

1966
AUTUMN
Harris hospitalized for a month.

1967
JUNE
Harris to Ottawa, accompanied by Lawren Jr., and met there by his daughter Peggie and her husband.

1969
MARCH
Harris hospitalized for a period of time.

SEPTEMBER
Bess hospitalized, and died September 29 of an aneurism of the aorta. She and Lawren had received the first copy of her book, *Lawren Harris*, only two days before.

1970
JANUARY 29
Died at Vancouver in his eighty-fifth year. His ashes were buried with those of Bess in the McMichael Canadian Collection grounds at Kleinburg, Ontario.

OCTOBER 28
Companion of the Order of Canada, conferred posthumously.

Bibliography

Compiled by Carol Lowrey

The following bibliography and listing of exhibitions is to be used in conjunction with Dennis Reid's *A Bibliography of the Group of Seven* (Ottawa: National Gallery of Canada, 1971). Titles omitted from that work have been included here in addition to selected material appearing since its publication. Following the format of the original work, this bibliography has been divided into two sections: individual citations and exhibitions with reviews.

1914 Harris, Lawren. "The Federal Art Commission." *Globe* (Toronto), 4 June 1914.

1923 F[airley], B[arker]. "*Contrasts* by Lawren Harris." *Canadian Forum* 3 (January 1923): 120, 122.

1926 Harris, Lawren. "Strength." *Canadian Theosophist* 7 (15 July 1926): 104.

1928 Aylen, Elise. "Above Lake Superior. (On a Picture by Lawren Harris)." *Canadian Forum* 9 (December 1928): 123.

1931 Harris, Lawren. "Science and the Soul." *Canadian Theosophist* 12 (15 December 1931): 298-300.

1933 Harris, Lawren. "Different Idioms in Creative Art." *Canadian Comment* 2 (December 1933): 5-6, 32.

1939 Harris, Lawren. "Letters to the Editor." *Santa Fe New Mexican*, 16 March 1939.

1942 Harris, Lawren. "The Function of an Art Gallery." Vancouver Art Gallery, *Bulletin* 10 (October 1942): [2].

_____."The Function of an Art Gallery." Vancouver Art Gallery, *Bulletin* 10 (November 1942): [2].

_____."The Function of an Art Gallery: Art Galleries in New York City." Vancouver Art Gallery, *Bulletin* 10 (December 1942): [2-3].

1943 Harris, Lawren. "The Function of an Art Gallery: Art Galleries in the United States." Vancouver Art Gallery, *Bulletin* 10 (January 1943): [2-4].

_____."The Function of an Art Gallery: Canada's Art Galleries — The National Gallery." Vancouver Art Gallery, *Bulletin* 10 (February 1943): [2-3].

_____."The Function of an Art Gallery: Art Galleries in Canada." Vancouver Art Gallery, *Bulletin* 10 (April 1943): [2-3].

_____."Canada and the Arts." *France-Canada* (December 1943): 18-19.

1944 McCarthy, Pearl. "Nation-Wide Plan by New President." *Globe and Mail*, 6 May 1944.

Johnson, Fred. "Why Go Abroad? Canadian Art Schools as Good as Any." *Winnipeg Tribune*, 2 December 1944.

1948 Duval, Paul. "Lawren Harris's Switch to Abstract Art Annoys Some, Stimulates Others." *Saturday Night* 54, 9 October 1948: [2-3].

1954 Scott, Jack. "Our Town: Painter's View." *Vancouver Sun*, 1 December 1954.

1955 Delzell, Sylvia. "Art Brushes." *Hamilton Spectator*, 12 June 1955.

1962 Trimbee, Bob. "Rebel Painter Harris." *Montreal Gazette*, 31 March 1962.

1970 "Artist Moving Spirit of Group of Seven." *Globe and Mail*, 30 January 1970.

1973 "You Asked Us: About Group of Seven Artist Lawren Harris." *Canadian Magazine*, 7 April 1973: 14.

1974 Wong, Maureen L. "A Study of the Painting of Lawren Harris." M.A. thesis, Bowling Green University, 1974.

Larisey, Peter. "Nationalist Aspects of Lawren S. Harris's Aesthetics." National Gallery of Canada, *Bulletin* 23 (1974): 3-9, 31.

_____."A Portfolio of Landscapes by Lawren S. Harris." National Gallery of Canada, *Bulletin* 23 (1974): 10-[16].

1978 Pfaff, L.R. "Portraits by Lawren Harris: Salem Bland and Others." *RACAR* (Revue d'art canadienne/Canadian Art Review) 5 (1978): 21-27.

1980 Street, Linda M. "Emily Carr: Lawren Harris and Theosophy, 1927-1933." M.A. thesis, Carleton University, 1980.

Jones, Donald. "Divorce drove artist from Toronto home." *Toronto Star*, 5 July 1980.

1982 Varley, Christopher. "Lawren Harris: The Pursuit of the Abstract." *Update* III (January-February 1982): 7-8.

Larisey, Peter Daniel. "The Landscape Painting of Lawren Stewart Harris." Ph.D dissertation, Columbia University, 1982.

Harris, Lawren. "FitzGerald's Recent Work." *artscanada* 39 (March 1982): 27; reprint of the article in *Canadian Art* 3 (November 1945).

_____."An Essay on Abstract Painting." *artscanada* 39 (March 1982); 39-43; reprint of the article in *Canadian Art* 6 (Spring 1949).

Murray, Joan, and Fulford, Robert. *The Beginning of Vision: The Drawings of Lawren S. Harris*. Toronto: Douglas and McIntyre in association with Mira Godard Editions, 1982.

Sandra Shaul. "Lawren Harris and the Dilemma of Nationalism vs. Abstraction," in *The Modern Image, Cubism and the Realist Tradition* (Edmonton: The Edmonton Art Gallery, 1982): 11-18.

Worts, Douglas. "Lawren S. Harris: Transition to Abstraction, 1934-1945." Final paper,

Master of Museum Studies Programme, University of Toronto, 1982.

Gorman, Julia. "Lawren Harris and Paul-Emile Borduas: Abstract Art, The Audience and Public Art Galleries in Canada 1920-1950." Final paper, Master of Museum Studies Programme, University of Toronto, 1982.

1984 Pfaff, L.R. "Lawren Harris and the International Exhibition of Modern Art: Rectifications to the Toronto Catalogue (1927), and Some Critical Comments." *RACAR* 11 (1984): 79-96.

Exhibitions

1939
Sante Fe, New Mexico
Arsuna School of Fine Arts, 1939, *Lawren Harris.*

REVIEW
Morang, Alfred. "Lauren Harris, Tireless Experimenter." *The Santa Fe New Mexican,* 1939.

1940
Toronto
Art Gallery of Toronto, 1-31 March 1940, *In the Print Room: Emily Carr, Lawren Harris, Fritz Brandtner, Charles Comfort.* A handlist was published.

1944
Winnipeg
Winnipeg School of Art, October 1944, (*Lawren Harris*).

REVIEW
"At the Winnipeg School of Art." *Winnipeg Free Press,* 7 October 1944.

WORKS MENTIONED
Lake McArthur; Mountain Sketch; Rockies, Labrador; North Shore, Lake Superior; Abstract Composition; Abstract Composition.

1946
Kingston
Queen's University, Senate Room, November 1946, (*Lawren Harris*).

REVIEW
"Paintings on Display." *Kingston Whig-Standard,* 13 November 1946.

WORKS MENTIONED
Bylot Island; Scene near Lake Harbor, Baffin Island.

1949
Vernon
Vernon-Okanagan Exposition, May 1949.

REVIEW
"Harris Pictures Give Exposition Visitors 'Treat.'" *Vernon News,* 19 May 1949.

1976
Vancouver
Art Emporium, 1-15 November 1976, *Lawren Harris.* Exhibition and sale of works from the Lawren Harris estate.

REVIEWS
Parton, Lorne. "Lawren Harris." *Vancouver Province,* 6 November 1976.

Fox, Mary. "A Trove of Paintings by the Late Lawren Harris." *Vancouver Sun,* 13 November 1976.

Cummings, Steve. "Lawren Harris." *artscanada* 33 (December 1976/January 1977): 60.

WORKS MENTIONED
Houses, Wellington Street.

1978
Toronto
Art Gallery of Ontario, 14 January-26 February 1978, *Lawren S. Harris: Urban Scenes and Wilderness Landscapes, 1906-1930.* A catalogue by Jeremy Adamson was published.

REVIEWS
Dault, Gary Michael. "Canadian Revolutionary:

Lawren Harris in Retrospect." *Toronto Star,* 14 January 1978.

Purdie, James. "Tribute to a Mystic." *Globe and Mail,* 14 January 1978.

"Lawren Harris: First Major Showing of Representational Works." *Cobourg Daily Star,* 29 January 1978.

Inglis, Grace. "Painter is Shown as a Dynamic Force in Canadian Art." *Hamilton Spectator,* 4 February 1978.

Mandel, Eli. "The Inward, Northward Journey of Lawren Harris." *artscanada* 35 (October 1978): 17-24.

Mesley, Roger J. "Lawren Harris' Mysticism: A Critical View." *Artmagazine* 10 (November/December 1978): 12-18.

1978
Toronto
Loranger Gallery, from 14 January 1978, *Selected Works by Lawren S. Harris.*

Toronto
Roberts Gallery, 17-28 January 1978, *Lawren Harris Drawings.*

1980
Calgary
Glenbow Museum, 1 March-27 April 1980, *Lawren S. Harris Sketches.*

REVIEW
Cochran, Bente Roed. "Harris Impressed by Rockies." *Edmonton Journal,* 16 April 1980.

WORKS MENTIONED
In the Ward, Toronto; Algoma Woods I; Falls, Montreal River, Algoma; Mount Robson from Berg Lake.

1981
Travelling Exhibition
Art Gallery of Ontario, for Festival Ontario, *Lawren Harris: Ontario Landscapes.* A catalogue by Irene Szylinger was published.

Shown at Thunder Bay National Exhibition Centre, 15 May-14 June; Peterborough, Art Gallery of Peterborough, 19 June-26 July; Simcoe, Lynnwood Arts Centre, 31 July-23 August; Sault Ste. Marie, Art Gallery of Algoma, 4-27 September; Sudbury, Laurentian University Museum and Arts Centre, -25 October 1981.

REVIEWS

"Harris Encouraged Criticism of Work." *Sault Ste. Marie Star*, 4 September 1981.

Derro, Paul. "Museum Environmental Controls Cited as Top Art Collection Shown." *Sudbury Star*, 7 October 1981.

1982
Toronto
Mira Godard Gallery, 25 November-24 December 1982, *The Beginnings of Vision: The Drawings of Lawren S. Harris.*

Also shown at Oshawa, Robert McLaughlin Gallery, and in Vancouver, Calgary, Lethbridge, Saskatoon, St. Catharines, and Halifax.

REVIEW

Kritzwiser, Kay. "Drawings are like the Diary of an Introspective Mind." *Globe and Mail*, 26 October 1982.

1983
Halifax
Dalhousie Art Gallery, Dalhousie University, 4 November-11 December 1983, *Selections from the Sobey Collections: Part II: Lawren Harris, F.H. Varley, and Franklin Carmichael.* A catalogue by Gemey Kelly was published.

New York
Martin Diamond Fine Arts, 8 November-10 December 1983, *Lawren Harris: Paintings of the Late Thirties.*

REVIEW

Gallati, Barbara. "Lawren Harris." *Arts Magazine* 58 (January 1984): 50

The following reviews are in addition to those listed in the *Exhibitions* section of *A Bibliography of the Group of Seven.*

1946
Victoria
"Lawren Harris Paintings Here Tuesday." *Victoria Daily Colonist*, 27 October 1946.

1948
Toronto
"Famous Artist Draws Smallest Crowd Here." *Victoria Daily Colonist*, 11 May 1949.

S.J., "Lawren Harris Exhibition to be Discussed." *Saskatoon Star-Phoenix*, 18 October 1949.

1954
Western Art Circuit

WORKS MENTIONED
Pic Island, Lake Superior; Mt. Temple, Rocky Mountains; Newfoundland Coast; North of Lake Superior; South Shore, Bylot Island; Sketch from Sentinel Pass; Algoma Sketch.

1963
Ottawa
"Boldest of 'Group' Being Honored." *Ottawa Citizen*, 1 June 1963.

Some Notes on Other Sources

The major collection of Harris papers is in the Social and Cultural Archives and Manuscript Division of the Public Archives of Canada (MG30 D208). Acquired in 1976, it consists of correspondence covering the years 1925 to 1966 (the majority of letters dating from the 1940s to the 1960s); business papers (1939-1960); subject files (1944-1967); transcripts (c. 1969) and printed material in the form of catalogues, pamphlets, clippings, and scrapbooks. A series of notebooks from circa 1910 to 1954 includes notes, addresses, quotations, poetry, and essays, and the manuscript group, dating from 1905-1954, consists of essays, speeches, letter drafts, radio talks, and miscellaneous notes. A finding aid to the collection has been prepared by the Archives staff.

Harris material can also be found within other PAC collections, notably the papers of artists J.E.H. MacDonald, Thoreau MacDonald, Carl Schaefer, and Yvonne McKague Housser, and in those of C.A.G. Matthews, a partner in the Toronto printing firm of Sampson-Matthews. The collections of Victor Odlum and William Hogarth (both collectors of Harris's work), and that of the author Duncan Campbell Scott, also contain letters from Harris.

Smaller yet equally important collections of material relating to Harris are found in both Canada and the United States. The Emily Carr papers in the British Columbia Provincial Archives, Victoria (on permanent loan from the Public Archives) include the correspondence between Carr and Harris, which began around 1928 and continued until about 1942. In these letters Harris talks about the creative process in conjunction with some of the problems Carr was encountering in her own work. He also discusses his own artistic development as well as that of other artists, in addition to making references to theosophy, the Group of Seven, and the Canadian Group of Painters. The papers are available on microfilm and as photocopies at the Public Archives.

The correspondence between Harris and Katherine Dreier regarding both Harris's painting and the Société Anonyme's 1927 exhibition at the Art Gallery of Toronto is among the Society's papers at the Beinecke Rare Book and Manuscript Library at Yale University. An important letter from Harris to the AGT Exhibition Committee concerning the same exhibition is in the Archives of the Reference Library at the Art Gallery of Ontario.

For information about the Hanover years, researchers should consult the papers of Clyde Dankert, a former Professor of Economics at Dartmouth College who knew both Harris and Carl Schaefer. The Dankert collection is in the Public Archives of Canada and consists of fourteen letters (1937-1955) from the Harrises to the Dankerts as well as five pages of plans drawn up by Harris for Dankert's house in Hanover. Also important for this period is the correspondence between Bess Harris and Doris Huestis Speirs, in the collection of Mrs. Speirs. The thirty-eight letters cover the years 1919 to 1969, and in several Bess Harris frequently refers to her own development as an artist in relation to her husband's artistic philosophy. This is especially evident in the letters from Sante Fe. Similarly, the letters from Vancouver contain many references to Harris's work there as well as to the Canadian Group of Painters. Photocopies of the Harris/Speirs correspondence are available for consultation at the Reference Library of the Art Gallery of Ontario.

The papers of Raymond Jonson (Raymond Jonson Estate, Albuquerque, N.M.), Chairman of the Transcendental Painting Group, reveal much about Harris's activities while in Sante Fe and immediately following his return to Vancouver. They can be viewed on microfilm at the Washington, D.C., branch of the Archives of American Art.

Other useful sources include the papers of the Toronto Theosophical Society, the Arts & Letters Club, and at the Ontario Archives, also in Toronto, those of the Ontario Society of Artists. A small collection of letters, photographs, and memorabilia is available in the Archives of the McMichael Canadian Collection in Kleinburg, Ontario. The libraries and archives of other institutions in Canada also contain Harris material, usually in the form of correspondence (the National Gallery of Canada, for example, has numerous letters between Harris and Eric Brown), ephemeral material, and files of clippings, memos, and other miscellanea. Researchers will find that collections of papers of many of Harris's contemporaries, especially members of the Group of Seven, often include relevant information.

Suggestions for General Reading

The following list contains a sampling of titles from Dennis Reid's *A Bibliography of the Group of Seven* (Ottawa: National Gallery of Canada, 1971) that has been selected according to its usefulness and accessibility to the non-specialist reader interested in the later work of Lawren Harris.

BOOKS AND ARTICLES

1926 Harris, Lawren. "Revelation of Art in Canada." *Canadian Theosophist* 7 (15 July 1926): 85-88.

1927 Harris, Lawren. "Modern Art and Aesthetic Reactions: An Appreciation." *Canadian Forum* 7 (May 1927): 239-41.

1929 Harris, Lawren. "Creative Art and Canada." In *Yearbook of the Arts in Canada*, pp. 179-86. Edited by Bertram Brooker. Toronto: Macmillan, 1929.

1933 Harris, Lawren. "Theosophy and Art." *Canadian Theosophist* 14 (15 July 1933): 129-32.

_____."Theosophy and Art." *Canadian Theosophist* 14 (15 August 1933): 162-66.

_____."Theosophy and the Modern World: War and Europe." *Canadian Theosophist* 14 (15 November 1933): 281-88.

1942 Smith, Sydney. "The Recent Abstract Work of Lawren Harris." *Maritime Art* 2 (February-March 1942): 79-81.

1948 Frye, Northrop. "The Pursuit of Form." *Canadian Art* 6 (Christmas 1948): 54-57.

1949 Harris, Lawren. "An Essay on Abstract Painting." *Journal of the Royal Architectural Institute of Canada* 26 (January 1949): 3-8. Reprinted in *Canadian Art* 6 (Spring 1949): 103-107, 140; and in *artscanada* 39 (March 1982): 39-43.

1954 Harris, Lawren. *A Disquisition on Abstract Painting.* Toronto: Rous and Mann, 1954.

1963 McNairn, Ian, ed. *Lawren Harris Retrospective Exhibition, 1963.* Ottawa: National Gallery of Canada, 1963. Contents: "The Development: 1913-1921" by Russell Harper; "From Nature to Abstraction: 1921-1931" by Paul Duval; "Theory and Practice of Abstract Art: 1932-1948" by William Hart; "The Vancouver Period: 1940-1963" by John Parnell.

1968 Reid, Dennis. "Lawren Harris." *artscanada* 25 (December 1968): 9-16.

1969 Harris, Bess, and Colgrove, R.G.P., eds. *Lawren Harris.* Toronto: Macmillan, 1969.

MAJOR EXHIBITIONS

1948 Toronto, Art Gallery of Toronto, October 16-November 14, 1948, *Lawren Harris: Paintings 1910-1948.* Catalogue by Sydney Key, with a foreword by A.Y. Jackson.

Also shown at: Ottawa, National Gallery of Canada, December 1948. A selection of works from the exhibition was circulated to various centres across Canada.

1963 Ottawa, National Gallery of Canada, June 7-September 8, 1963, *Lawren Harris Retrospective Exhibition, 1963.* Catalogue edited by Ian McNairn.

Also shown at: Vancouver Art Gallery, October 4-27, 1963.